THE MODERN DRAWING

THE MODERN DRAWING

100 Works on Paper from The Museum of Modern Art

John Elderfield

The Museum of Modern Art, New York

Distributed by New York Graphic Society Books, Little, Brown and Company, Boston

The text for
The Modern Drawing
is set in Perpetua
Type set by Concept Typographic Services Inc., New York
Design by Christopher Holme and William Thomason
Photography by Mali Olatunji
Production by Tim McDonough
Color separation by L. S. Graphic Inc., New York
Printed by Arti Grafiche Brugora, Milan / L. S. Graphic Inc., New York
Bound by Torriani & C., Milan

Published by The Museum of Modern Art, New York, 1983
All rights reserved
Library of Congress Catalog Card Number 83-61942
Clothbound ISBN 0-87070-302-1
Paperbound ISBN 0-87070-301-3

The Museum of Modern Art
11 West 53 Street, New York, N.Y. 10019
Printed in Italy

Contents

Introduction
7

The Modern Drawing
13

Index of Artists
215

Publication of this book was made possible by the generous support of
Ronald S. Lauder and The Lauder Foundation.

Research on the works in this book has been aided by a grant from
the National Endowment for the Arts.

Introduction

This book consists of pictures and essays: pictures of one hundred modern drawings, broadly defined as works on paper, in The Museum of Modern Art; and essays, in their original sense of trial efforts, on the subject of each of these drawings and, collectively, of the modern drawing itself and its place in modern art.

In using a singular title, *The Modern Drawing,* I assume total coherence for my subject. I assume that the pictures in this book show not merely an accumulation of one hundred modern drawings but an order of modern drawing: that together they reveal a coherence that is partly a function of their historical sequence, that is partly suggested by their level of ambition and quality, and that is partly inherent in their structures of form and imagery. The history, the aims and achievements, and the structures of modern drawing (and, by extension, of modern art generally) are therefore included in the subject of this book. But this book is not a systematic or a synoptic study of any of these topics. Its first aim is quite simply to provide visual delight. Its second is to reveal something of the range, character, and intent of the Museum's drawings collection. Beyond this, it offers a tentative and highly abridged version of modern drawing in one hundred pictures and essays that are as various in form and in tone as their collective subject but together project a single large view of it. In doing so, it also suggests that a systematically argued and synoptic version of modern drawing is attainable. Some of the reasons for this view are disclosed toward the end of this introduction.

The version of The Museum of Modern Art's drawings collection presented here is also, of necessity, highly abridged. The first drawing to enter the collection (by George Grosz) was among the Museum's very first acquisitions, made in October 1929, only a few days after the Museum had opened its doors. Fifty-four years later, the drawings collection numbers over six thousand works on paper. Only one out of every sixty works in the collection therefore appears in this book.

Drawings have long been admired, studied, and collected as independent works of art. But still it was a particularly daring proposition to suggest, in 1929, that a museum should make a serious commitment to modern drawings. Serious commitment to drawings of any period was very late to develop in the United States, and modern drawings long have remained a relatively neglected field. More than any other person, the donor of the Museum's first drawing, Professor Paul J. Sachs, was responsible for establishing the serious study and collection of drawings in this country. At Harvard University, he inspired three generations of students in the connoisseurship of drawings and formed a major collection of Old Master drawings at the Fogg Museum. He was part of a group that in 1916 encouraged The Metropolitan Museum of Art to seriously collect drawings and prints. As one of the founders of The Museum of Modern Art, he supported its programs and collections for almost three decades. Along with

three other of the Museum's founders, Lillie P. Bliss, Abby Aldrich Rockefeller, and A. Conger Goodyear, and John S. Newberry (one of his former students), he was an especially generous early donor of drawings to the Museum.

Even before his donations, however, Professor Sachs's first service to the Museum was nominating as its founding director another of his former students, Alfred H. Barr, Jr., whose chief scholarly work prior to 1929 had been in Quattrocento drawings. And Mr. Barr's belief in the interdependence of modern visual arts meant that the new museum paid serious attention to all of the six fields that are now studied, collected, and exhibited by its separate curatorial departments: painting and sculpture, drawings, prints and illustrated books, architecture and design, photography, and film.

This is not to say, however, that each of these fields was given similar or equal attention from the start. Those whose designations are given in plural form (an indication, perhaps, of their traditional interpretation as less singularly independent) were first collected in order to support the painting and sculpture collection, whether to add studies for specific works in that collection or to fill important gaps in it, and were the last in the Museum to achieve departmental autonomy. (Insofar as the drawings collection is concerned, this produced certain imbalances in its proportionate representation of different artists that still have not been entirely redressed.) It was not, in fact, until 1947 that the Museum presented a special exhibition of its drawings. At that time the collection numbered 227 works on paper. In 1960 a second such exhibition took place. By then the collection consisted of 530 works. In 1964 the Museum inaugurated the Paul J. Sachs Galleries, especially devoted to exhibition of drawings and prints from its collection. And finally in 1971, the Department of Drawings was established as an autonomous curatorial unit, directed by William S. Lieberman, yet another student of Professor Sachs and a longtime assistant to Mr. Barr. Under Mr. Lieberman's guidance, and with the collaboration of Bernice Rose, now Curator of Drawings, the collection grew rapidly in size, by 1974 consisting of over twenty-five hundred works. Most significant among the many important additions was The Joan and Lester Avnet Collection, which was itself formed with the needs of the Museum specifically in mind.

Since Mr. Lieberman's retirement from the Museum at the end of 1979, the current director of the Department of Drawings has pursued the idea of a historically synoptic collection of works of important quality, being supported in this by many generous donors, especially from the Museum's Committee on Drawings. The first and defining function of an art museum is collecting works of art. Beyond that, a museum must decide whether to attempt to form a collection of masterpieces, with quality the only guide for acquisition, or whether the function of its collection should be broadly educational, attempting to cover as completely as possible its chosen area. It was Alfred Barr's conviction that while quality was of crucial importance, a museum collection should not be built up on the same principle as a private one, subject only to personal taste, but should, rather, be catholic—and systematically seek to be so. I share this conviction. (It has informed the selection of works for this book.) And I furthermore share Mr. Barr's understanding that, finally, there is no essential conflict between the demands of quality and of providing a historical and educational survey. Both functions can equally be fulfilled by attempting to assemble a comprehensive collection of the finest possible works. This is a process that can never end. This book therefore provides an interim report on what, so far, has been achieved.

Next to collecting works, making them accessible to its public is the most important function of an art museum. This book appears on the eve of the completion of expanded premises for The Museum of Modern Art. These will provide, for the very first time, a fully equipped study center where by

appointment visitors can examine drawings in the collection, and provide new galleries devoted exclusively to drawings. At long last, there will always be a generous selection from the drawings collection on view in the Museum. Additionally, this book itself—which is the first publication of its scope devoted to the drawings collection—is intended to begin a program of publications that will show in greater detail what is shown here only in outline.

Because the one hundred works shown here stand for a much larger collection, they necessarily provide a highly distorted view of it. In making my selection, I adopted the following principles.

The first principle was the guiding principle of collection acquisition itself, that is, to aim at providing a historically synoptic selection of works of important quality, within the limitations imposed by the book's format. A great deal of study material has come, and continues to come, into the Museum collection, much of it fascinating and useful. It was excluded from this book in the interest of works of exhibitable quality. Likewise, although this book necessarily gives some idea of the areas of particular strength in the collection, no attempt was made to reflect the relative proportion of different artists' or movements' representation in the collection. Certain very large bodies of material, including a separate Theater Arts Collection held by the Department of Drawings, are therefore represented in only the most minimal way. The works were chosen from the historically and qualitatively most important the Museum owns with the aim of expressing the essential scope and character of modern drawing as I understand it.

The second principle was to include a broad range of different kinds of works on paper rather than to concentrate on a narrow interpretation of drawing. Of all our modern arts, drawing is most resistant to definition. The Museum of Modern Art simply calls every unique work on paper a drawing. This book therefore includes works in the traditional drawing media—pencil, ink, charcoal, and so on—but also watercolors, pastels, *papiers collés*, and other related forms. But it is not only for the sake of administrative convenience that the Museum collects, as drawings, such diverse works. There is historical justification for a view of drawing as an activity that begins in the purer forms and moves, with an artist's increasing experience, to more complex ones. While modern drawing refuses the hierarchical implications of such a view, it does accept its ecumenical basis. Now, certainly, a drawing is widely considered to be almost anything that is on paper—and many things that are not. Works on paper-based supports (like cardboard) and on new paper-substitute supports (like plastic sheet) are collected by the Museum as drawings (and so are works on paper laid down on other supports), and some are included in this book. Also included are two works directly made on canvas. While technically these do fall outside the province of the drawings collection (and do qualify the subtitle of this book), they are included here because one (p. 165) is probably the greatest of all Miró's pencil drawings and the other (p. 79) among the most authoritative of Braque's *papiers collés*. They testify to the ambitiousness of modern drawing, as it challenges modern painting even on its own ground.

The third principle of selection was to be as broadly inclusive as possible, thus to provide as comprehensive as possible a survey of modern drawing, while recognizing the fact that the achievements of modern drawing have not been spread equally among those who have participated in its history. My initial aim was to represent each artist by a single work. However, I broke this rule when I felt it would be a gross distortion of history not to do so, and when the works in the collection allowed me to do so. Still, I am fully aware just how summary is the representation of the major figures, and how restricted a version of modern drawing this is that excludes so many distinguished artists.

Unrepresented, in principle, are artists who came to maturity later than the 1950s. Where to begin this book posed no problem. It begins, as does the Museum's collection, in the 1880s. While any date set forth as the beginning of modern drawing is bound to be arbitrary, there are, in fact, a number of compelling reasons (some of which are given here in the earliest essays) for choosing the period of Post-Impressionism. My exclusion of artists who emerged later than the 1950s is not intended to suggest that the modern period ended then. I do believe that the 1960s saw changes that require its art, and subsequent art, to be addressed somewhat differently from that which preceded it. I refer particularly to the establishment of more fully autonomous abstract art than modernism had previously seen and to the appearance of drawings that seek to displace painting and sculpture from the foreground of the avant-garde. This is not to say, however, that modern drawing itself was suddenly ended and that some other designation is required to describe drawing now. (The later essays here implicitly suggest otherwise.) My principal reason for closing this book with work by artists who emerged in the 1950s is that their work (even recent examples, such as I have occasionally included) seems to have settled in history to a sufficient extent for it to fit comfortably in a book that begins in the 1880s. The same is not yet quite true of later artists, or not true in the same way. They still belong to that recent branch of the modern called the contemporary, and a companion volume to this is planned to accommodate them.

Also unrepresented are very many distinguished artists whose works are part of the Museum's drawings collection. They are omitted with genuine regret. Every student of this subject will want to argue these omissions. Not until the checklist of the drawings collection, now being researched, is published will those less familiar with the Museum's holdings be able to judge their extent. Those who do know the collection well will undoubtedly miss a number of their favorite works. However, those who know it very well will realize the difficulty of my choices and will understand that I surrendered some superb and important works only because one hundred is too small a number of illustrations to fully represent the riches of the collection.

Finally on the question of selection: some omissions, like some inclusions, are necessarily due to the limitations in taste or historical judgment of the author. It was Oscar Wilde who said that only an auctioneer could be equally appreciative of all kinds of art. This might be construed as a defense of discriminating collectors. But Museum collections, unlike private ones, cannot reasonably accept such a defense. Northrop Frye, to whom I owe the foregoing quotation, insists that on an ethical level at least every increase of appreciation has been right and every decrease wrong: that criticism should advance to ever greater catholicity. The same is true of the branch of criticism which museum collecting comprises. At the same time, the branch of criticism which selection and abridgment comprise necessarily forces the issue of discrimination. This issue is forced already in museum collecting, if for no other reason than that limited resources require it; but in choosing, for exhibition or publication, from a collection it becomes a primary issue. In the end, the pictures in this book show a version of the Museum's drawings collection, just as the essays attached to them propose a version of modern drawing.

Drawings, I said earlier, have long been admired, studied, and collected as independent works of art. However, their admiration, study, and collection have long been considered specialized provinces of the artistic world, to be entered only by those who are prepared to learn the unusual dialects that are spoken there. This has been advantageous to the appreciation of drawing because it has required firm and serious commitment from its devotees, because it has guaranteed the continuing existence of a belief in the

priority of connoisseurship, and because it has tended to insulate this field from many of the temporary shifts in taste and fashion that have plagued appreciation of more popular arts. But a price has been paid for this specialization. Insofar as modern drawings are concerned, it has meant that there are very few private collections solely devoted to them and that many major museums collect them only sporadically if at all. This is partly attributable to the fact that modern drawing constitutes a specialized field both of drawing and of modern art, and therefore receives only limited attention from specialists in either discipline. But it is also a function of the frequent emphasis on innovation over quality in the appreciation of modern art and of the belief that drawings are inevitably minor and subsidiary forms of artistic expression. I will not rehearse here the arguments that I make in many of the individual essays, but only say that one of their functions is to demonstrate that while modern drawing is indeed often a smaller expressive field than modern painting or sculpture, it is one that can be as deeply cultivated for its own unique yield. These essays are intended to suggest the crucial role that works on paper have played in the development of modernism, and to suggest that the greatest of such works carry a level of ambition, and quality, no less than any other form of art, only different in kind.

The essays in this book also respond to the intellectual effects of the specialized status of drawing appreciation. Drawings have not, by and large, been subjected to as keen and rigorous art-historical scrutiny as they deserve. At times they have been treated solely as subsidiary works, and only their functions have been examined. At others, they have been treated as craft objects, and only their technical properties have been examined. Both of these approaches have produced much valuable material. But they constitute a documentation of drawing and not a criticism of it. With certain notable exceptions, the critical methodology for drawing, and especially for modern drawing, lags seriously behind that for painting (whose own criticism, I should add, while more rigorous than most sculpture criticism, is still far less methodical than that of literature). As often the case in these matters, its strength is also its weakness: in this instance, the emphasis on connoisseurship. While this has indeed been advantageous in keeping concerns with quality to the forefront, it has too often allowed in its name the vaguest kind of judgments in critical language frequently of the most rudimentary kind, and has tended to disguise the fact that the actual study of art (as opposed to its admiration) cannot be founded on value judgments. These might narrow the field that we want to explore and might even direct us to the source of its beauty. We might want to assert them. But since we cannot demonstrate them, we cannot base any systematic criticism on what they tell us. Modern drawing is fast becoming a more popular field of study, largely because of drawing's own popularity and importance as an avant-garde art. As this happens, it is becoming exposed to shifts in taste and fashion to an extent far greater than ever before. It is to be hoped that connoisseurship, and its emphasis on value judgments, will not be compromised. But also that critical principles are shaped to inform drawing's systematic study.

This is a field in which there has been great endeavor, with many useful beginnings to place its study on secure foundations. Writing this book made me realize just what had been achieved. My debts are enormous, and I regret that the format of this book has allowed me to do no more than mention by name of author, within the body of the essays, some of my more important sources. Many of these, in fact, come from fields other than drawing—which makes me realize what has yet to be achieved, namely, systematically argued and synoptic studies of the nature of modern drawing. A few authors have begun this work, but much remains to be done. At best, this particular book offers a sequence of interconnected thoughts, provoked by some of the greatest of all modern drawings, that might suggest something of the

range of issues that need to be addressed. I am, I hope, fully aware of the scholarly studies and revisionist theses which qualify or question much that I have written. Abridgment means simplification which means distortion. And yet, to have emphasized novel or unorthodox interpretations at the expense of more basic ones would have created more serious distortion. The basics, it often seems, are not spoiled by repetition. All art is framed in an interrogative mode, and some questions it asks more insistently than others. It is these that I have attempted to address.

Pages would be required to acknowledge adequately those who have contributed, either by donation or by their curatorial skills, to the growth of the drawings collection of The Museum of Modern Art. Innumerable donors have made important contributions to the collection, in the form of drawings from their own collections or through purchase funds for new acquisitions. The names of a few of them are acknowledged in the credit lines of the works reproduced here. Many of those who serve, or have served, on the Museum's Committee on Drawings—whose current membership is listed on page 216 —have been among the most generous donors to the collection. I thank all of these devoted supporters of the Department's work not only for their generosity, but also for their counsel, their conviction, and their constancy. The former and the current chairmen of the Committee, Lily Auchincloss and Ronald S. Lauder, deserve especially grateful thanks. Mr. Lauder is additionally to be thanked for another reason. Support for research on the works included in this book has been provided in part by a grant from the National Endowment for the Arts. However, it could never have been published, certainly not in the form in which it now appears, without the generous support of The Lauder Foundation.

Finally, acknowledgment has to be made to past as well as to current staff members, whose curatorial skills have helped shape the collection and whose day-to-day work has preserved, cataloged, researched, and exhibited it, making it available to the broad audience that the Museum serves. My own experience of the collection is of shorter duration than most of these. I feel that I have been immeasurably enriched by contact with the collection, and have reason to believe that everyone who has worked with it feels the same. I began this introduction by saying that this book projected a single large view of modern drawing. Some of the reasons for this view are that modern drawing is accessible to inductive study; that it needs study and criticism in order for it to preserve its cultural memory and thus thrive; and that great modern drawings, like any great works of art, simultaneously combine numerous patterns of meaning and ask for their disentanglement. My belief in the importance and the urgency of these tasks has been strengthened by the commitment of my colleagues. It has also been strengthened by my experience of the sheer splendidness of the collection. This motivated the present publication—which cannot explain such an experience; but, I hope, it allows it to be shared.

It remains only to add these explanatory notes. Complete sheets are reproduced except in those instances where it was totally clear that the artist intended only a circumscribed image to be seen. In the captions, sheet dimensions are given, in inches and centimeters, height preceding width; dates enclosed in parentheses do not appear on the works themselves. All works are on white or near-white paper unless otherwise indicated. The works are arranged in general chronological order, the hundred spanning nearly a hundred years.

THE MODERN DRAWING

Georges Seurat
FRENCH, 1859–1891

STONE BREAKER, LE RAINCY. (c. 1881.) Conté crayon, 12⅛ x 14¾″ (30.7 x 37.5 cm)
Lillie P. Bliss Collection

Modern drawing begins with Post-Impressionism in the 1880s. It begins after the most radical Impressionists had all but repudiated those two central norms of Western pictorial art since the Renaissance: discrete image-making and the illusion of sculptural form. Drawing is crucial to both of these—which accounts for its traditional place at the very foundation of the visual arts. Earlier artists had drastically modified one or the other of these norms, but none had come as close to canceling both together as did the Impressionists, when they rendered nature in their paintings as an allover molecular field that fractured the imagist unity of objects and narrowed value contrasts to such an extent as to squeeze volumes virtually out of existence. Without either discrete images or sculptural forms, drawing was made homeless in advanced art, and was required, in effect, to begin over again.

While image-making and the creation of sculptural illusion are often perceived as mutually dependent, and were so within the Renaissance tradition, they are in fact separable, and often are separated in modern drawing—often by the exclusion of the latter. Image-making without sculptural illusion, which finds its most basic expression in purely linear drawing, tends to the symbolic or hieratic. It was through sculptural illusion that depicted postures traditionally took on individual gravity and human significance. The principal thrust of Seurat's great sequences of drawings, the earliest of which began with the date of this work, was the creation of a new kind of hieratic image-making, but one that subordinated linear drawing to tonal shading and gave to the entire composition a traditional sense of human gravity: by reimagining sculptural illusion in a highly abstracted form within a radiant, molecular field built after the Impressionist model.

This drawing—whose contemporary proletarian subject recalls Courbet or Millet— shows Seurat at an excitingly transitional moment when line drawing, in the form of allover cross-hatching and tightly packed parallel and swirling lines, is used to create a kind of tonal shading, but one that does not model fully in the round. Rather, as applied to the figures in free space, it provides only a slight and highly schematic roundness, as form seems to emerge from within the modulations of the broken ground, set off from it by that kind of flattened chiaroscuro Seurat called "irradiation," by which light and dark tones each are exaggerated when they meet. And more generally, the linear hatching is used to animate the whole surface with a softly trembling light that clings to and radiates from the very pores of the rough paper itself. It creates the depicted incident. But it also covers and envelops that incident. The taut geometry of the depicted scene is thus complemented by a nondescriptive flux of velvety shading, which provides a searching, meditative density of effect traditional to sculptural illusionism—but abstracted from it, to give to space itself a fullness and opulence such as normally reserved only for objects of the world.

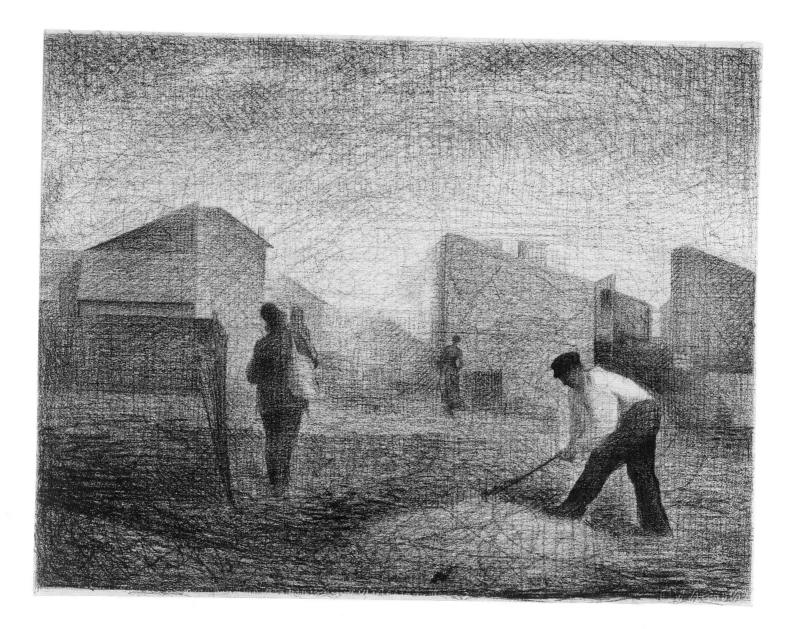

Edgar Degas

FRENCH, 1834–1917

At the Milliner's. (c. 1882.) Pastel, 27⅝ x 27¾" (70.2 x 70.5 cm)
Gift of Mrs. David M. Levy

While drawing has traditionally often used color, the extent to which color belongs to the history of modern drawing is certainly unusual. (No book on earlier Western drawing would be forced to reproduce as many colored subjects as this one does.) It is an index of the importance of color to modern painting; also, a response to the very freedom of color from drawing achieved by painting at the beginning of the modern period. The more extreme Impressionists had shown that drawing was potentially a restraint to color, masking its purity in tonal shading as well as containing in contours its ability to spread out flatly, and thus display its coloredness, across the surface. It was therefore necessary that drawing and color be somehow realigned, if color was to be used in drawing in other than a traditional way, which no longer apparently carried conviction.

This wonderful, virtuoso pastel by Degas seems traditional in its subordination of color to tonal shading. The coherence of the work is not, principally, a function of color, or hue, itself, but of the tonal armature that, running through the work (even across the most vivid contrasts) like a connecting tissue, mutes down to subtly modulated variations between black and dark green or between brown and ocher the areas of color that define the subject. This said, however, color does not read simply as an attribute of modeled form. Not only are few areas of the pastel in fact fully modeled, but shifts of tonality, or value, read also and coincidentally as shifts of color, so that the composition of the work is given as a bold and flattened patterning of strongly contrasting color values. Color achieves its effectiveness not through purification, not through escape from tonality. It is not by expelling but by exaggerating and by balancing the tonal components of color that Degas makes it effective in a new way.

By drastically narrowing the range of tones visible in any single color area, Degas (like Manet before him) flattens each area to the surface. Since color is a property of surfaces, he thereby draws attention to the coloredness of these areas; even the darkest of them reads as colored. By counterposing such areas, however, he retrieves his work from the airlessness that can stultify an allover flattened surface. The contrasts of value give and take space across the spread of the surface, being assisted in this by the oblique viewpoint of the drawing, which pries the subject from frontality, allowing air to circulate among the forms. But the surface is insisted on: by the cropped-out nature of the composition, which draws attention to its edges, flattening whatever is near to them; by the central focus of interest, that empty, floating, and flattened bonnet, which advances to the surface even as the customer is waiting to try it on (she is, in fact, the American painter Mary Cassatt); and by the connecting fibrous substance of the pastel medium itself.

Pastel assumed new importance for drawing toward the end of the nineteenth century as part of a new preoccupation with color. Here it clings tangibly to the surface like accumulated dust, carrying within its very particles the delicately tonal color from which the work is constructed. Its inherent fragility is entirely appropriate to the fleeting and fugitive moment that it shows.

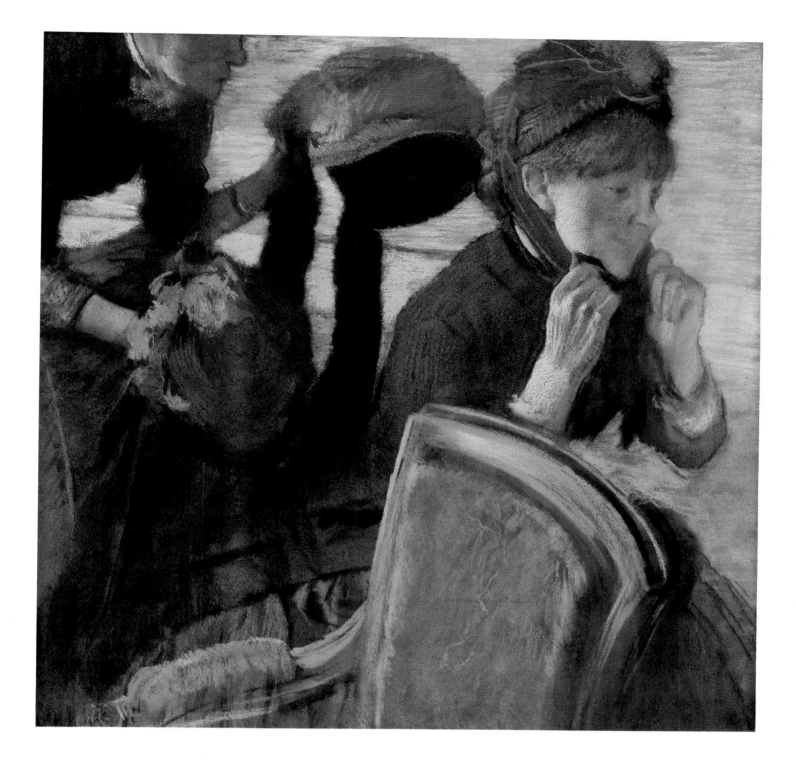

Georges Seurat

FRENCH, 1859–1891

SEATED WOMAN. (1884–85.) Conté crayon, 18⅞ x 12⅜″ (48 x 31.4 cm)
Abby Aldrich Rockefeller Bequest

Line all but disappears in the sequence of mature drawings that Seurat began in 1884, the year he started working on probably the most important of all his paintings, *A Sunday Afternoon on the Island of La Grande Jatte*. This study for the seated woman with a parasol just right of center in the painting is constructed not from lines (though some do appear) but from particles of tonal matter: delicately accumulated deposits left by a greasy conté crayon rubbed over the rough surface of the Michallet paper, sometimes with repeated pressure to increase their density and ever so slightly model the form, but never with so great a pressure as to close the grain of the paper (which reads analogously to the texture of canvas). The result is a drawing that seems to be caught on the tufts of the surface, smoothed out across the flatness of the surface, as thin as a wafer: almost a shadow except that it is filled and bodied with an internal light.

Whereas the earlier Seurat drawing in the Museum collection (p. 15) provides a sense of stopped time—of energized matter somehow frozen in a moment in its animated hatchings—this seems quietly removed from the very contingencies of time: outside of it altogether. In part this is due, no doubt, to the isolation of the figure (the absence of an environmental context) and to the silhouetted crispness that characterizes much of the contour drawing, whose geometric simplifications refer the eye to the geometry of the sheet as a whole, thus reinforcing that compositional effect of the figure as not so much within the space implied by the white sheet as resting, or hovering, on its bottom edge. It is also attributable, however, to a curious sense of the figure as having been created almost by expansion—spread out, as it were, from the inside, to reach its limits as if of its own accord—which marks its existence as not of the prosaic world but rather as something that has grown here on this sheet, apart.

The "reality" of this drawing is not, finally, for all the talk of science that has attached to Seurat's art, an empirical one such as is presumed by the inductive sciences—where "reality" is conceived as existing "out there" in the world, separate from the observer, subsequently to be ordered and given shape. Seurat—the detached, "impersonal" character of his art notwithstanding—is an inheritor of Romanticism in conceiving of reality as something actually brought into being by the very act of construction. Nature is not "out there" but "on the inside"—which is why it seems removed from the contingencies of time. Reality is internalized in Seurat's art: the outside world defers to and gains its significance from the reality-constructive power of the mind. This links it to a Symbolist art like that of Redon (p. 27), whose preoccupation with masking is the counterpart to Seurat's "impersonality," and who shared his absorption in the suggestive, poetic nuances of tonal drawing. Seurat's art, however, is a cooled Romanticism in a way that Redon's is less obviously so. Its artisanal sobriety reacts against that tendency, in deteriorating Romanticism, to take too much for granted what shapes and reifies the internalized image. The explicitness with which it finds inspiration in the very substance of the medium marks it as a modern art.

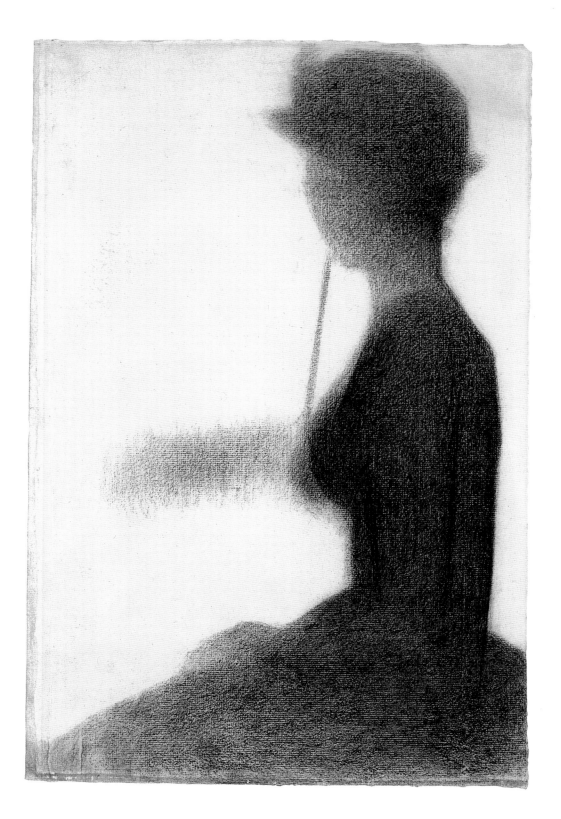

Paul Cézanne

FRENCH, 1839–1906

MERCURY (AFTER PIGALLE). (c. 1887–90.) Pencil, 15 x 11″ (38 x 27.8 cm)
The Joan and Lester Avnet Fund

The most basic definition of drawing is: the record of a tool moving across a surface. Drawing at its most basic, that is to say, is line drawing. Drawing at its most basic is therefore drawing at its most conceptual, for drawn lines are symbolic and conventional. They contour the identity of things in the world but in the world do not properly exist.

In premodern drawing, line is usually supported by tonal shading or itself constitutes tonal shading (either explicitly, in the form of hatching, or implicitly, by virtue of its inflections in density or thickness, which evoke the presence of volume). The conceptual, image-making component of drawing is thus bonded to the illusionistic component, which individualizes the conceptual, making it tangibly real. As noted elsewhere (p. 14), modernism often separates these two components, most frequently jettisoning the latter. Nevertheless, it is a surprise to find Cézanne seeming to dismiss them both: "Line and modeling do not exist," he wrote. "Drawing is a relationship of contrasts or simply the relationship between two tones, black and white."

Cézanne neither drew linear images nor did he model fully in the round. He never spoke of drawing without mentioning color, and he drew as a colorist in contrasting shades of black, constructed from lines, that pictorially animate the white of the sheet, giving a sense of substance to its very blankness. Clement Greenberg has observed that "Cézanne was the first to worry consciously about how to pass from the outlining contour of an object to what lay behind or next to it, without violating either the integrity of the picture surface as a flat continuum or the represented three-dimensionality of the object itself (which Impressionism had threatened)." He sought, in effect, to restore the premodern sense of tangibly real form but without surrendering modern flatness in doing so; and he achieved this in drawing by identifying volume with the flat whiteness of the sheet, which is the arbiter of coherence for whatever it contains. And to define this volume—which he defines by proxy, as it were, from the outside—he made the symbolic component of drawing (line) the skeptical substitute for its illusionistic component (tonality): skeptical, because line in Cézanne's drawings is allowed neither a conceptual, contouring function nor an individualizing one. It neither makes images nor identifies forms. Rather, it expresses in its very discontinuity the inherent difficulty of representing the unseen three-dimensionality of objects in the world. It hovers away from forms, partially independent of the implied mass, connecting as much as separating, for it is a kind of lost-and-found drawing that lets objects elide one into the next and into the surrounding space. Three-dimensionality itself is not to be drawn because it cannot be seen; only what reveals it can be drawn. It is as if Cézanne only drew shadows.

His preoccupation with drawing from sculpture is obvious. It allowed him to study the transitions of solid and void, the relationships of overlapping and protruding volumes through which the three-dimensional can be measured. The Museum's drawing is one of the most complete of a series, made in the years 1879–90, from Jean-Baptiste Pigalle's eighteenth-century marble, *Mercury Fastening His Heel Wings,* in the Louvre, or from a plaster cast of this work in the Trocadéro. Cézanne, seeking a continuation of past values in the modern present, seemed fascinated by this winged messenger.

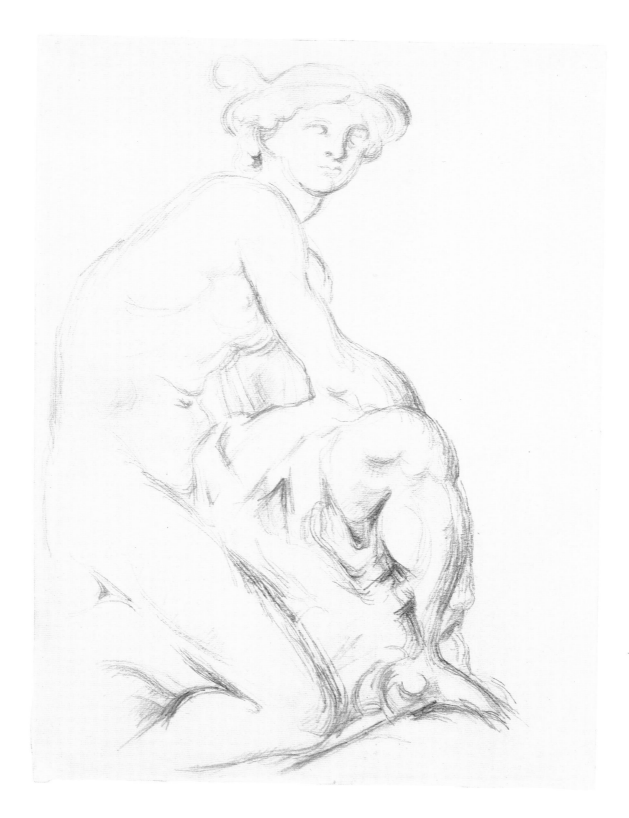

Vincent van Gogh

DUTCH, 1853–1890

STREET AT SAINTES-MARIES. (1888.) Brush, reed pen and ink, traces of pencil, 9⅝ x 12½″ (24.5 x 31.8 cm)
Abby Aldrich Rockefeller Bequest

Drawing is freed by van Gogh from its obligation to render tonal distinctions. Line, or a vocabulary of marks condensed from lines—neither compacted into nor supported by tonal shading, but released from it—becomes the sole agent of pictorial expression. Van Gogh's great contemporaries Seurat and Cézanne revolutionized drawing by subordinating line to tonality: the former by narrowing tonal contrasts to the flatness of the sheet; the latter by exaggerating contrasts, emptying volumes of tonality, and compressing shading into the interstices between them. One produced virtually a shadow of a traditional drawing; the other, almost a ghost of one. Van Gogh's method, which excised from traditional drawing all of its connecting tonal tissue, leaves bared on the white sheet, in shorthand form, its simplified skeleton.

By virtue of this reduction to line, the symbolic component of drawing achieves extraordinary prominence. The street at Saintes-Maries, near Arles, is not so much described as summarized. A sequence of discrete graphic devices—parallel strokes, dots, dashes, curves, and so on, all of varying size, density, and interval—symbolize the separately identified parts of the scene. This is a coded abstraction of nature.

The code, moreover, is a deliberately ambiguous one: not vague, but ambiguous in the Empson sense of something that "gives room for alternative reactions to the same piece of language." Each graphic device, as set down by the repetition of similar marks within the summary contours, fulfills at least five distinct functions. First, it names the class of object shown, each class—roof, path, grass, wall, and so on—having its characteristic sign. Second, it indicates—by the relative sizes of the marks and the intervals between them—the spatial position of objects and the distances they cover, the marks becoming smaller and/or denser the farther away the objects they describe. Third, it gives us the materiality of each class of object— its relative constancy of form—in the character of the mark, objects more susceptible to being changed in form by atmospheric conditions being given by longer, more cursive, and often lighter signs. Fourth, it suggests the texture of each class of object in the relative hardness or softness, rigidity or looseness, and openness or closedness of the marks that comprise its sign. And fifth, through these same attributes, the sensation of light upon the various objects is indicated; and by implication, we receive a sensation not only of the tonality of these objects but of their coloredness: the flicker of marks stimulates responses in the eye that correspond to the sensations of color in van Gogh's paintings.

None of this, however, should suggest anything coldly theoretical about van Gogh's concept of drawing. The drawing itself tells otherwise. Its ambiguity of descriptive functions unbalances it toward the irrational, for the functions assumed by each sign are sometimes contradictory. And each of the marks that cluster with others to make up a sign has yet a further purpose: the spontaneous record of feeling. Swarming around the simplified perspective like particles of energy, the marks not only tell of the street at Saintes-Maries but defy this external reality, decomposing its very substance to release from it an emotional charge.

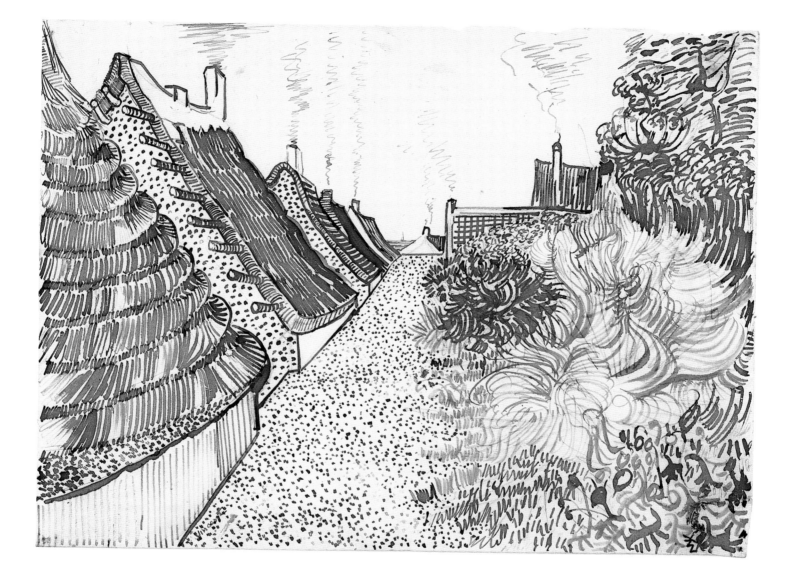

Paul Gauguin

FRENCH, 1848–1903

JACOB MEYER DE HAAN. (1889.) Watercolor, traces of pencil, 6⅜ x 4½" (16.4 x 11.5 cm)
Gift of Arthur G. Altschul

This conspicuously enigmatic watercolor was made in the Breton village of Le Pouldu, probably at Mlle Marie Henry's inn, where Gauguin and his friends (among them Meyer de Haan) covered virtually all of the dining room with painted decorations—including even the cupboard doors, where an oil version of this subject (now a gift to the Museum) was originally located.

Gauguin's recorded aim was a self-sufficient artistic abstraction in which rhythm, pattern, and color become meaning. Hence, his boldly simplified contour drawing that clenches the symbolic identity of things and flatly divides the surface for artificial and emotive color to be filled in. External reality is condensed into visual metaphors that do not describe but suggest. Clarity of style is therefore often matched by obscurity of content. Here, the act of condensation that clarifies the style confers importance on and implies causality between those details allowed to remain: they evoke puzzlement, present themselves as analogous, and invite us to interrogate them for their analogies. Their meanings, however, cannot (and should not) be specifically pinned down. Exactly what connects them can only be surmised...

Hovering over the work is Gauguin's preoccupation with a lost paradise and the Satanic temptation to lust that forfeited it; also with a redeeming spiritual order within nature, and with the artist as seer who illuminates it. Meyer de Haan (although in fact a deformed dwarf) appears cunning and devilish. Before him are Carlyle's *Sartor Resartus* and Milton's *Paradise Lost*. The former has as its hero an angelic-demonic split personality; it refers to the ambivalence of appearance—which, like clothing, simultaneously reveals and conceals naked reality. The latter begins by telling "Of Man's first disobedience and the fruit / Of that forbidden tree..." Beside these books we see such fruit, linked by color to de Haan; opposite them, a lamp, formally analogous to the apples but coloristically and symbolically contrary.

A part of the context is Gauguin's ambivalence about women, which saw them alternatively as sexual objects and symbols of pure love. In the latter category came his friend Emile Bernard's sister, Madeleine, to whom he wrote about the temptations of the flesh. The verso of our watercolor shows it was cut from an odd text, on a similar subject, in Gauguin's hand. In the former category came presumably his mistress, the maid of the inn, and certainly Mlle Henry, the plump innkeeper, whom Gauguin jealously pursued, losing her however to de Haan, who then left her when she became pregnant. The painting of de Haan as a lustful devil matched one of Gauguin, ironically portrayed as Milton's fallen angel, on the other cupboard door.

Just at this time, Gauguin sent to Madeleine Bernard, as a pledge of "fraternity," a modeled pot showing himself as a grotesque savage with his thumb in his mouth. It was based on a self-portrait in a Le Pouldu carving which grasps despairingly at a plump (possibly pregnant) "sexual" woman (Mlle Henry?), saying to her: *Soyez amoureuses et vous serez heureuses.* Was it, perhaps, an act of wish-fulfilling transference, or guilt, that fused this image with that of the actual seducer in our watercolor, making it, and the painting of it, an autobiographical companion to the self-portrayal as Satan? The question cannot be answered, for it asks about the unknowable. The demonstrable is silent and refuses to tell.

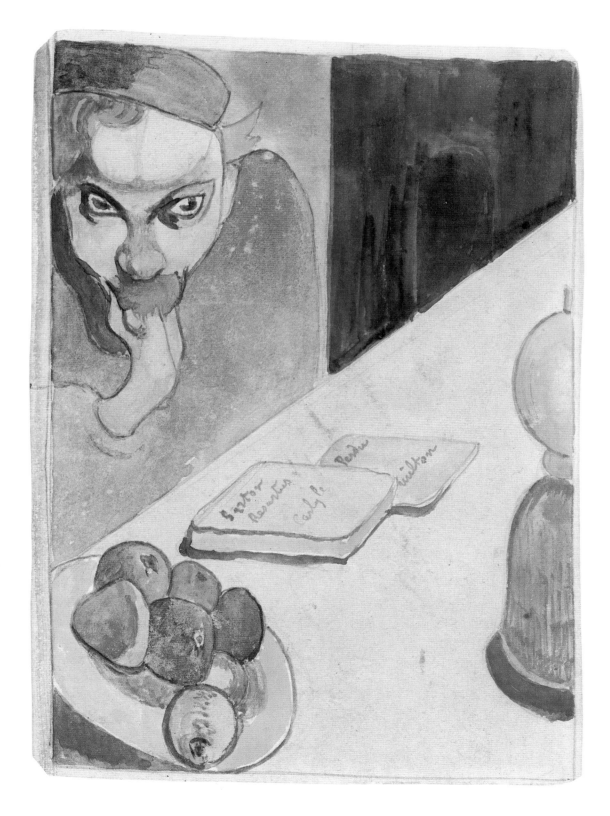

Odilon Redon

FRENCH, 1840–1916

THE MASQUE OF THE RED DEATH. (1883.) Charcoal on brown paper, 17¼ x 14⅛″ (43.7 x 35.8 cm)
John S. Newberry Collection

Redon's drawing takes its subject from Edgar Allan Poe's story of a grotesque masked ball, held in an abbey that has been sealed against a pestilence known as the Red Death. As midnight sounds, a figure is observed whose horrible disguise actually represents a victim of that disease. The host rushes to unmask this figure, only to fall dead in the presence, of course, not of a masked guest but of death itself. One by one his companions suffer the same fate.

The relationship of image to textual source is frequently problematic even in traditional representations based on written texts, such as dominated Western art from antiquity to the eighteenth century. But it is particularly so with modern art, whose preoccupation with the visual has tended to sever its connections with the literary, as has its unwillingness to conceive of the work of art as a screen for meanings that lie outside the work itself—especially meanings that require specific explication for the work properly to be understood. Hence the pejorative associations that now attach to the word "literary" in matters artistic; as indeed they do to "illustrational," illustrations seeming to belong, in the modern scheme of things, to some minor category of artistic expression.

And yet, many modern works—including this one, and others that are reproduced in this volume—do "illustrate" texts without seeming minor, literary, or merely illustrational. It was one of the triumphs of a Symbolist art like Redon's to have replaced that earlier representational mode in which images signal to a commonly held fund of beliefs, embedded in texts its audience could be expected to know, with a new mode (responsive to the absence of such beliefs and to ignorance of such texts) in which the meaning of the work can be grasped without knowledge of the text and without specific explication. This is not, of course, to say that earlier art cannot be understood unless it is explained, but rather that modern art—unlike earlier art, which took upon itself the function of textual explanation—cannot afford the duality of visible image and invisible text characteristic of earlier art. When it bases itself on texts, which are likely to be obscure, it saves itself from obscurity only by finding a form not merely unnecessary of explication but actually resistant to it: a form that is not simply imitative of the text but that so fuses the literary subject and its artistic expression that (to borrow Walter Pater's famous phrase) they "inhere in and completely saturate each other." That, at least, was one of the principal messages of Symbolism.

While Redon obviously capitalizes on the sense of obscurity produced by presentation of a subject whose textual meaning is hidden from us, making that obscurity and concealment a part of the expressed and aesthetic meaning of the work, he also makes it obvious that a work of art like this can function without explicit meaning and can be comprehended without the benefits of exegesis. It does confirm our understanding of the work to realize that Poe's work tells of temporality and decay, of the ambiguity of appearances, of representation and reality, of masks as images that both hide and reveal. But it is these thematic elements of the story, and not its narrative facts, that principally aid our understanding of Redon's work, and these we have already intuitively grasped from the work itself.

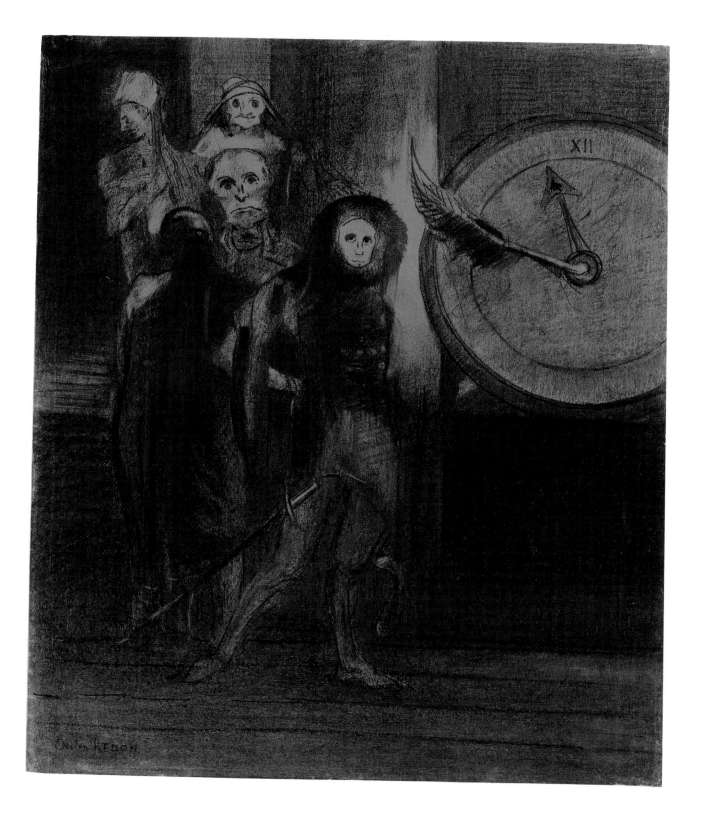

Alfred Kubin

AUSTRIAN, 1877–1959

UNTITLED (THE ETERNAL FLAME). (c. 1900.) Gouache, wash, brush and ink, 13 x 10¾″ (32.9 x 27.2 cm)
John S. Newberry Collection

Kubin did have bad dreams, did read fairy tales, and did draw fantastic pictures when he was a child. But so do many children. Why Kubin persisted in these things is not our concern here (although the answer, I suspect, is more likely to be found in his adult interests—Bosch, Goya, Redon, and so on—than in his childhood ones). What concerns us here (and one late childhood experience is crucial, I think, to this) is why so literal an imagination as his obviously was (how narrowly this drawing misses service as a poster for a Halloween ball) still manages to escape the realm of melodramatic illustration. Not all of Kubin does; much of his work is simply nasty. But at his best, as here, he takes possession of the unreal in such a manner as almost to certify its existence. He escapes the illustrational, that is to say, not by suppressing the literal (as is usually the way in drawing) but by isolating and transfixing it.

By this, I do not simply refer to that floated skull and flaming triangle of light (like light spilled out by a suddenly opened door). Their isolation is important, obviously: they constitute the visibly unreal in a real-enough space that hardly is visible. But everything seems transfixed, frozen in a flash that illuminates the significant detail.

The metaphor refers to photography; and Kubin, we know, was apprenticed at fifteen to a relative who was a photographer. The fascinations of the darkroom, where he had visions, the pictures of faraway lands he saw there magically developing an emulsified life—the effect of such experiences on the eerie unreality of his work has occasionally been noticed. What they tell us, however, has more to do with the character of his imagination, and like his healthy dread of mathematics, they themselves are not so unusual. The experience of photography is indeed relevant, but more crucially because the very pictorial conception of works like this is photographic. Its literalness does not seem illustrational because it is the same literalness that photographs have. Light is opened on the subject, fixing, dramatizing, and conferring mystery on that single suspended moment from the distance of the Symbolist voyeur. Something inherently unpleasant is both dignified and memorialized, and converted—notwithstanding the grotesque detail of that skull—into a silently detached image.

That Symbolist preoccupation with the unthinking inwardness of things—which finds iconographical expression here in the dead face, whose "life" is different from human life associated with intellectual activity—finds its pictorial expression in the sense of detachment the whole drawing provides. It is present to us but we are removed from it, held back by the dramatic framing of the scene, being allowed only to overlook it, as it were, from a distance. A certain, but undefinable, sense of indifference to our presence characterizes many modern drawings: they seem to exist as if independent of an audience. Kubin's is not quite like this. It assumes our complicity and teases us with our separation. This is something that Symbolism bequeathed to Surrealism (and that was developed also within photography). It disappears from the best of later drawing, which takes instead from Symbolism its detachment while expelling its theatricality.

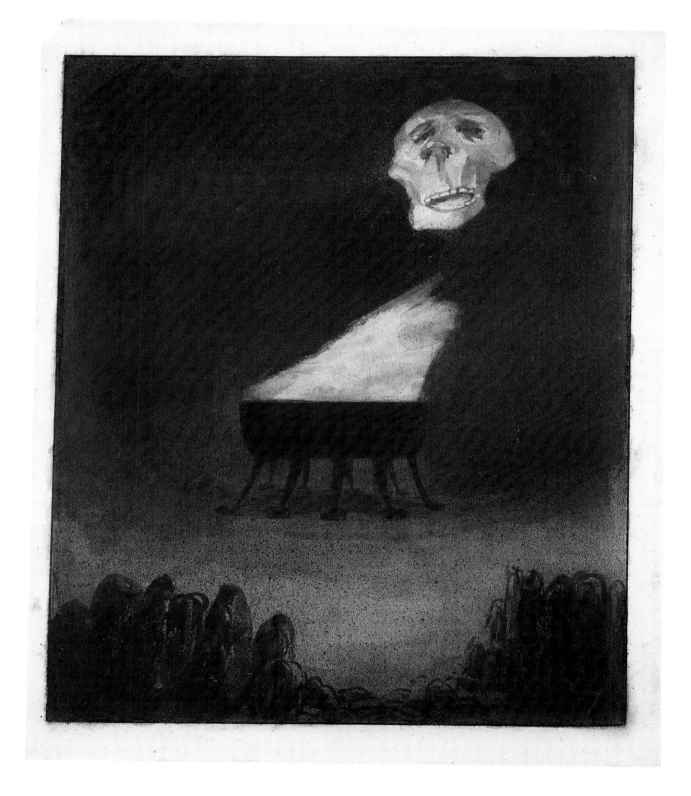

Vincent van Gogh

DUTCH, 1853–1890

HOSPITAL CORRIDOR AT SAINT-RÉMY. (1889.) Gouache and watercolor, 24⅛ x 18⅝" (61.3 x 47.3 cm)
Abby Aldrich Rockefeller Bequest

We know so much about van Gogh as a personality, and know that his art takes its themes from what was close to him and its obsessions from his inner psychological life; so much greater is the temptation, therefore, to forget the art for the artist or too literally to seek his presence in his work. Knowledge of van Gogh's life benefits us. Looking at the picture reproduced opposite, we want to know about the grimness of the Saint-Rémy asylum for the insane, where van Gogh was committed in May 1889, and about the disastrous seizures that sent him there; also about the urgency with which he worked at Saint-Rémy, during his periods of clarity, realizing that he would perhaps never completely recover his mind. We find in such details at least a partial explanation of the character of the art. And yet, this same knowledge may disadvantage us: our feelings for the art can become confused with what we feel about the man.

The triumph of van Gogh's art, however, is to be found in the way it refuses so purely "personal" a reading, the way in which intensely private feeling achieves so finally disinterested an artistic form. This is not merely to say that his art succeeds in expressing his feelings: such a formulation assumes a mimetic function for art, only to transfer that function from recording the external to the internal world. Rather, the profundity of van Gogh's art is commensurate with his realization—often not grasped by his Expressionist followers—that art cannot be the exhibition of private feeling, but requires pictorial correlatives that will release such feeling from its privacy and give it tangible form. It is, despite all the journalistic rhetoric, an art as touchingly disinterested in tone as this statement from Saint-Rémy, which explains the kind of correlatives for feeling that van Gogh sought: "You will realize that this combination of red ocher, green saddened by gray, and the use of heavy black outlines produces something of the sense of anguish, the so-called *noir-rouge,* from which certain of my companions in misfortune frequently suffer." That "saddened by gray" poignantly tells all.

At Saint-Rémy, however, it was not only color that would form feeling; it was line—and line used as never quite before in van Gogh's art. Color is given as line; the brush draws; painting and drawing are one. The influence of his earlier reed-pen drawings (p. 23) is apparent in the active contours that push jaggedly about the foreground and in the broken strokes of color that warp the plane of the corridor floor. These bunched parallel lines read almost as exposed muscular fibers, straining against the relentless force of the perspective, which—far from being used as a rational descriptive convention—projects onto the surface the vertiginous reality of the scene. (More even than Munch, it was van Gogh who saved perspective as an expressive device for modern art.)

Drawing, van Gogh wrote, "is working oneself through an invisible iron wall that seems to stand between what one feels and what one can do." Throughout this work, it is the rough pressure of the line, retaining in its very awkwardness the struggle to give shape to emotion, that externalizes emotion and objectifies it.

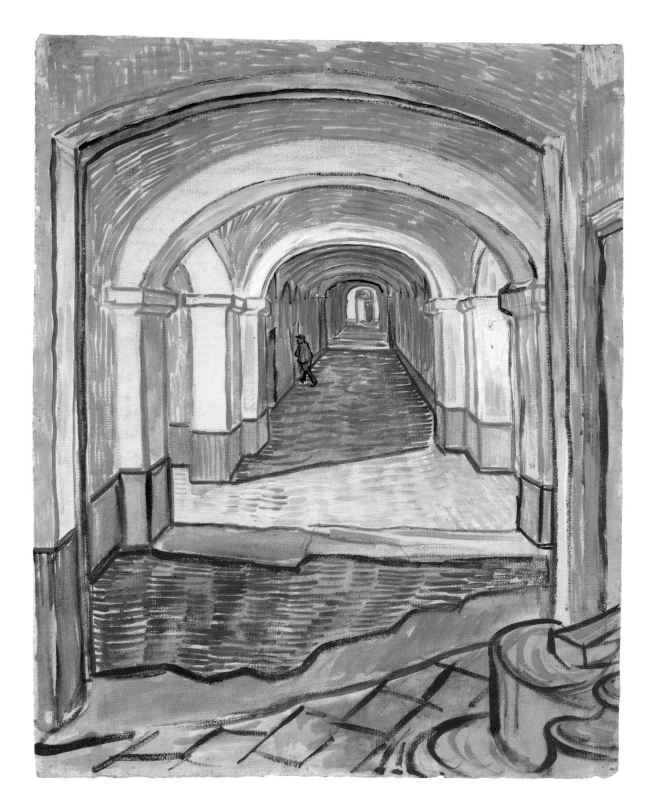

Paul Cézanne

FRENCH, 1839–1906

FOLIAGE. (1895-1900.) Watercolor and pencil, 17⅝ x 22⅜″ (44.8 x 56.8 cm)
Lillie P. Bliss Collection

By some inherent but also conventional norm of visual representation, black-and-white is the natural medium for identifying things in the world: conventional, because it was through tonal modeling that form was traditionally made credible in Western art; inherent, however, because color is indeed secondary to our recognition of the identity of objects and to our practical dealings with them. Cézanne's art does not identify; as he puts it, it realizes. It makes real his sensations before nature, sensations which precede the division of the world into separate, useful things. Black-and-white, finally, would never do.

Cézanne's drawings in black-and-white (p. 21) seek less to identify objects than to render, through an exaggerated form of tonal modeling, the unseen three-dimensionality of objects. Objects mattered; even more so, however, did volume itself, and especially depth, that constant of nature, which though itself invisible had somehow to be drawn in order to give objects their reality. The bunched lines that Cézanne used (and used in his watercolors too) were never equated with the form of an object, for this changed according to even the slightest changes of viewpoint on it; they never specified form, only spatial position. The object was fugitive, and Cézanne finally accepted this. But depth remained. In order fully to possess that depth, only color would do. The black-and-white axis was simply too dramatic: too theatrical ever to be real; too divisive of nature into objects that interrupted depth and separated themselves from it. Only "the contrast and connection of colors" ("—there you have the secret of drawing and modeling") could realize the spatial totality of the world.

Cézanne's watercolors are acts of construction in color. He applied discrete unblended lines and patches of color around lightly sketched contours and built depth from color by translating dark-light gradations into cool-warm ones. By constantly revising the cooler (often blue) marks around the contours (which therefore disappear as contours), layering onto them new marks (which never exactly cover their predecessors), while at the same time moving toward larger (and warmer) marks in the open territory on each side of the contours, he made a mosaic of colored lines and planes, of overlapping shades that together fix the depth of the subject onto the white surface. And the white surface is the final arbiter of pictorial coherence. Drawing has never been bothered by "unfinish" as painting has. But Cézanne, as never before, makes the whole surface of his art (colored and uncolored alike) pictorial.

The whiteness of the sheet is the colorless light of the world that replaces shadow, and tonality, as the connecting tissue of art's representation of the world. It opens, with Cézanne, a nonobjective world that emerges from the shadow of man's works and gives up the comforting security of objects as the necessary price to be paid for a particular kind of freedom, and with it elation, that tells of what the visible world is like: not about the world of objects and utility but about a world released from these things in a way that prosaic existence never allows.

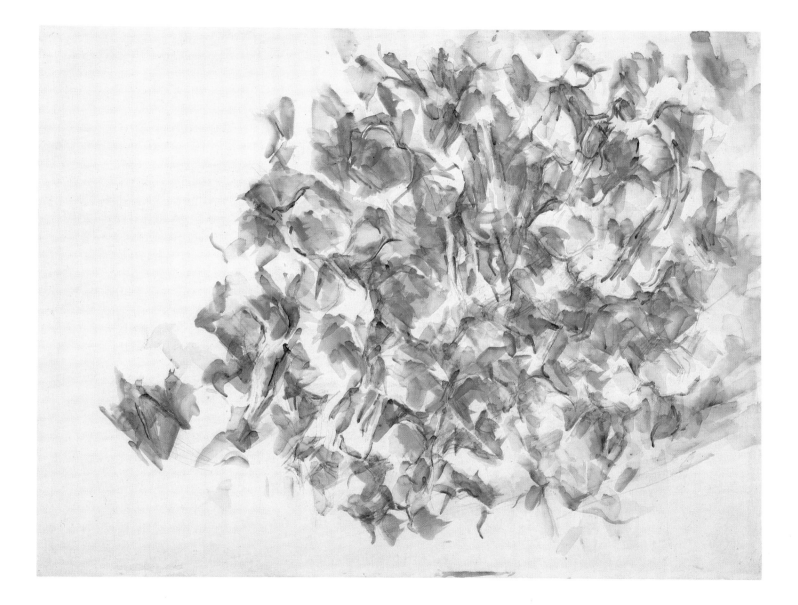

Jean Delville

BELGIAN, 1867–1953

EXPECTATION. (c. 1904.) Pencil and charcoal, 39¾ x 17½" (100.8 x 44.5 cm)
The Joan and Lester Avnet Collection

Drawing is both an act and the product of an act. The greatest modern drawings achieve their modernity in the act of drawing. Innovation there usually brings with it innovation in those areas, like format or design, that drawing shares with other pictorial arts. Admittedly, what is unique to drawing itself is not easily decided. In practice, however, we recognize that a Cézanne or a van Gogh, say, by reimagining some essential component of drawing, such as the descriptive contour, is led thereby to recast the whole of drawing, even parts of it (like color, for example) that clearly belong also to another art. Some modern drawings, however (and they can achieve considerable quality), like this Delville, are modern despite the relatively conventional character of the drawing that produced them. This is not entirely to say that their modernity is borrowed from arts other than drawing; more important than that, their drawing is a vehicle for their modernity rather than the instrument of it.

The Delville is not, however, as conventional in treatment as it first might seem. Although based in tonal modeling of a kind that more ambitious modernists had already repudiated, it keeps to the middle-light side of the tonal range, and except in two areas of the drawing suppresses strong contrasts of light and dark (and the sudden "jumps" or jarring of the surface such contrasts produce); it thus creates a relatively homogeneous, close-valued space from which cutting silhouettes, and with them fully sculptural illusions, have been all but expelled. In its own modest way, this drawing engages an issue crucial to early modernism: the reimagination of sculptural illusions on a sensitively flat surface that endangers their continued existence.

What distinguishes Delville's approach to this issue from, say, that of Cézanne (p.21), to choose an artist for whom it was a basic concern, is this. In Cézanne, the formal "problem" itself is not, finally, a matter of style. It institutes a radically new style, but is itself addressed as a profound search into the very structure of visible reality and how that reality can be artistically possessed. (The art itself, not just the artist, tells us that.) The formal "problem" is engaged as a source of meaning and therefore of value. In Delville, it manifests itself primarily as a stylistic concern: as a way of creating a particular effect. (A vehicle, not instrument, as I said earlier.) This is an exceedingly sensuous and beautiful drawing. It exhibits a highly sophisticated understanding of modernist form, but also a refusal fully to be engaged in form itself, treating it as a specialized and refined kind of language rather than an actual source of value.

This does not mean, of course, that it escapes value. Rather, it finds value in the use of a modern idiom to modify the conventional character of the drawing, thereby creating an unsettling emotional tension in the work. This is reinforced by design elements more startlingly modern than the tonal modeling: the very odd perspective (witness especially the irrational organization of the tiled floor) and that amazing (and big: the work is nearly forty inches high) picture-frame doorway: a quintessentially Symbolist alliance of subject and form. But it is also integral to the modeling itself, whose delicate nuanced beauty makes the architecture paper-thin, then suddenly cuts back (as if with scissors) behind the pregnant woman's head, and more mysteriously at the base of her gown. The flower she holds is like a doorknob, but is unreachable, like the space of the room, and the space of the drawing. Modern flatness keeps us out.

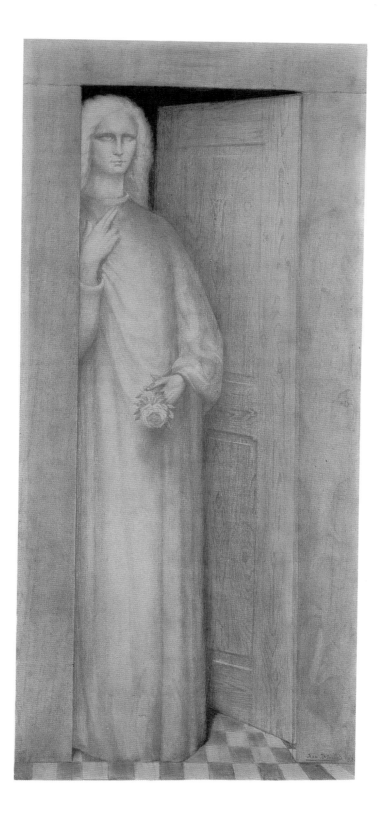

Gustav Klimt

AUSTRIAN, 1862–1918

WOMAN IN PROFILE. (1898–99.) Colored pencil, 16⅞ x 11⅜" (42.8 x 28.7 cm)
The Joan and Lester Avnet Collection

Klimt's beautiful and tender drawing in colored pencil is a masterpiece of virtuosity. This I accept as understood—and want to inquire, rather: Why is it, despite its realistic detail, so strangely unreal, the figure it represents seeming to belong to some mode of existence separate from but confusable with what we understand to be the "real" world? This is partly due, no doubt, to two typically Symbolist devices: Klimt's floated isolation of the detailed head and hair, which seems to leave disembodied the figure beneath; and his almost animate treatment of the hair itself, which shrouds mysteriously within its tresses the introverted face. Its unreality is also somehow connected to that quintessentially Symbolist blue. This connotes an antinatural state of dreamy otherworldliness, into which state this figure, by virtue of its blueness, seems to have been transposed.

Transposition, however, implies some previous—in this case, more "real"—state: here, the "reality" of black-and-white. As we have already seen (p. 32), black-and-white is the natural medium of conceptual understanding of things in the world. But more than this is involved here. Not only do we sense a great detachment from practical reality in the use of a heavenly color for earthly representation: that is true of its use in Symbolist art generally. In addition, Klimt's use of this color—and this would obtain for virtually any color—in a decidedly precise and linear drawing is what renders strangely artificial the realistic precision of its linearity. Because linear drawing itself, as we have also seen (p. 20), is highly conceptual in character, giving us symbolically the very identity of things, we expect it to be in the black-and-white medium of conceptual understanding. And the more precise the drawing the more we expect it. The use of color in such a context seems strange and alien; and not, essentially, because the color is an inaccurate transcription of natural color: we readily accept, as natural, inaccurately colored representations in the looser media of chalk or pastel. Nor is it this particular color alone that creates such an effect: Klimt's similar drawings, even in full and naturalistic color, confirm that this is so. It is not, finally, the blueness but simply the coloredness—when allied to the means of a linear, conceptual drawing—that seems so oddly unreal, seeming at once to tell us of what we know and to have transposed that known reality into an order that is artificial.

This specific form of transposition is technically unique to modern drawing, for the simple reason that such fluent and precise drawing in color required the commercial production of colored pencils, which began in the latter part of the nineteenth century. No previous "hard" drawing medium offered quite comparable effects, and the Austrian Symbolists, especially, responded enthusiastically to their production; or perhaps it was that their production was itself a response to the latent need for a new drawing medium that could tell so easily of the world we know but in a language of make-belief. That, certainly, is characteristic of the medium. (Hence, presumably, its popularity in children's drawings.) It became available just in time for Klimt to evoke the kind of fantasy we find here: fantasy not in the sense of the incredible; fantasy not as something entirely separated from reality but what reality can be confused with, as it is here.

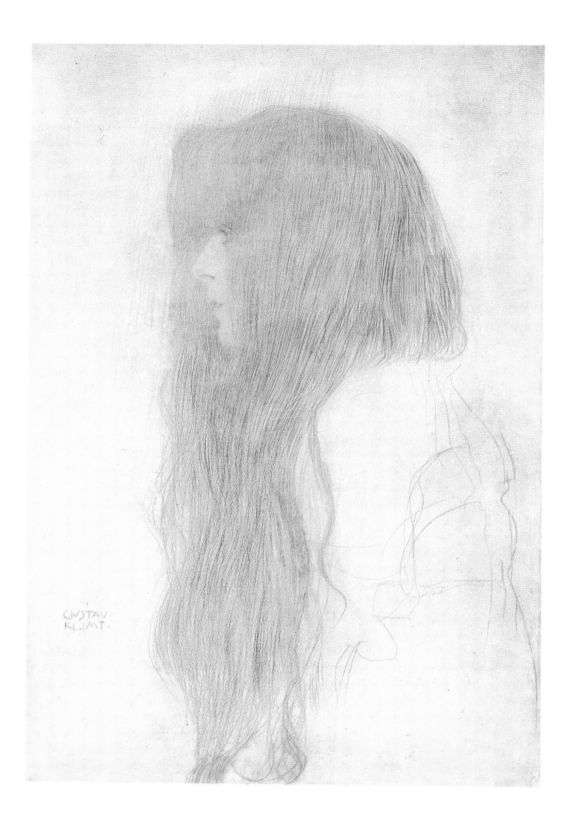

Auguste Rodin

FRENCH, 1840–1917

NUDE WITH SERPENT. (c. 1900–05.) Watercolor and pencil, 12⅝ x 9¾" (32 x 24.7 cm)
Gift of Mr. and Mrs. Patrick Dinehart

"The only way of expressing emotion in the form of art," wrote T. S. Eliot in 1919, "is by finding an 'objective correlative'; in other words, a set of objects, a situation, a chain of events which shall be the formula of that *particular* emotion; such that when the external facts, which must terminate in sensory experience, are given, the emotion is immediately evoked." In formulating this famous axiom of modern criticism, Eliot was thinking specifically of drama. With the proviso (which also applies to drama) that the emotion an artist wishes to express cannot fully be known beforehand but is discovered only in the process of composition, the concept would seem applicable to the visual arts as well. It applies not only to the actual situation depicted: in this case, a pose of sensual indolence in which the literally radiant figure leans blissfully back out of the water that surrounds her, as a submerged serpent slithers away from between her opened legs. Given the foregoing proviso, it applies also to the manner of the depiction. The treatment no less than the form of the subject is part of the "objective correlative," whose emotive implication is in this case uninhibitedly erotic in character.

The drawing was made in three stages. First, the outline and features of the figure were given in a few continuous fine pencil lines, and the radiating strokes, which relate this image to Rodin's late series of female sun symbols, were added. At this stage, the figure would have seemed as pure and spontaneous as the method of her creation, entirely innocent of her exposed sexuality. This reading, however, is modified by the second stage of the drawing and radically altered by the third. The second stage involved the addition of a gold-brown wash to the figure's hair and puddled blue-gray tones, descriptive of water, across the base of the sheet. If the accenting of the hair serves to reinforce the meaning of the figure as a radiant sun image, the treatment of the water connotes something more overtly erotic: an almost sexual wetness, staining as it spreads across the white sheet, is discovered in the watercolor medium. Finally, in a violent reworking of the lower right corner, using a heavier pencil and more abrupt strokes than before, Rodin inserted the fantastic motif of the serpent. This motif relates the drawing to another of the artist's series besides that of the sun symbols, namely the earlier drawings suggestive of witches' Sabbaths and sexual assault, to which the uninhibited pose of the figure also refers.

The full eroticism of that pose, only latent in its first-drawn outline, is thus realized in the completion of the work, but without actually canceling its connotations of original innocence. Rodin, that is to say, by modifying the form of his technical as well as imagist expression, developed the initial theme of sensual innocence into one of sexual experience, while yet allowing their coexistence in this mysteriously ambiguous work as superimposed layers of opposing meaning.

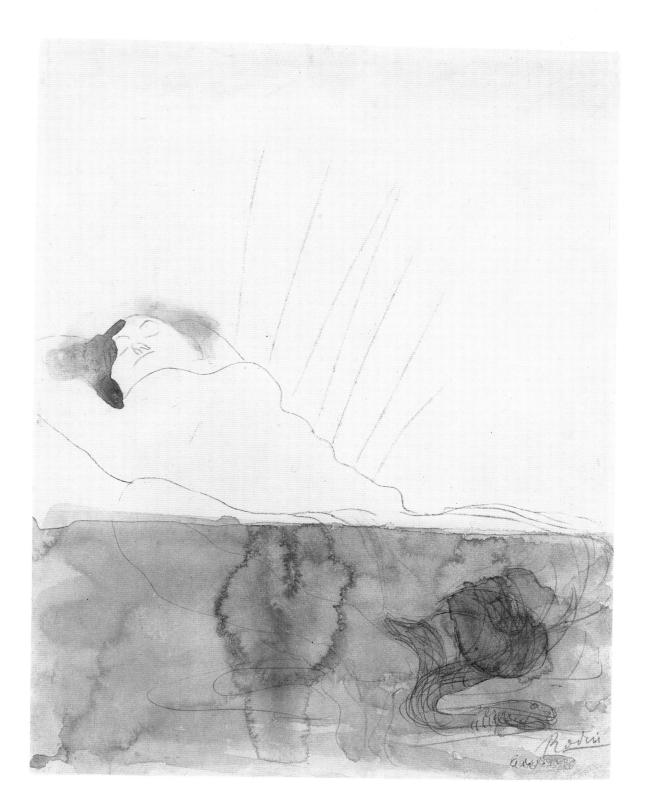

André Derain

FRENCH, 1880–1954

BACCHIC DANCE. (1906.) Watercolor and pencil, 19½ x 25½″ (49.5 x 64.8 cm)
Gift of Abby Aldrich Rockefeller

The dancer and the tree; two pairs of complementary colors (kept cleverly apart): these form the subject and the means that express it here. The dance unfolds from the red dancer having to reach out to the green, and the blue having to discover the orange, hidden up in the corner and lost in the cream-white sheet. And the white of the sheet stands both for figure (the two reclining figures) and for ground (oddly around the dancer as well as the tree). Something boldly elemental inhabits the luminous substance of Derain's watercolor, its subtleties and ambiguities notwithstanding. We look back to Gauguin (p. 25) for the simplified contours and infilled color. But the contours move smoothly, unimpeded by Gauguin's heavy emotional weight, and the color is simply guilt-free. We are at the beginning of a new century, primitives of a new culture; and if renewal must begin in regression, then it is a kind of regression that can rejoice (as Gauguin never quite could) in moving, if need be, to some simpler and rejuvenating island apart. Such seems to be the message of Derain's utterly optimistic version of Fauvism of which this watercolor is an outstanding optimistic example.

From 1904 through 1906, Matisse and Derain together liberated color as the natural expressive substance of modern pictorial art: from the vestigial tonality still to be found in Gauguin and from the restriction in range and intensity of color still characteristic of Cézanne. The juxtaposition of pure, discrete hues (each often denoting the whole local color of an object), clearly separated one from the next (often by white, which heightens their intensity as well as unifying them), is the basis of picture-making. Tonal modeling is totally expelled, and tonality itself is realigned as a function of color, the contrasts of tone produced by juxtaposing high-intensity colors (and such colors against white) being welcomed for the sense of energy they produce. Color dominates. But far from preempting drawing, its traditional antithesis, color reengages it in a more active form than had existed since the most radical Impressionists renounced it as a restraint to color's freedom. Drawing reasserts itself and rediscovers its own freedom in the vibrant meeting of such vivid, affective color. Graphic clarity of design is crucial to the patterned Fauvism of Derain's work.

Derain made several studies, and at least three paintings, on dance themes in his Fauvist years. They may well have influenced Matisse's more famous treatment of this subject. But dance was highly valued as an artistic subject around the turn of the century, and for many compelling reasons. It was organic, not mechanical; nonutilitarian; primitive, prescientific, out of time. It was suggestive rather than imitative; expressive, yet "impersonal"; resistant to explication; nondiscursive, lost in itself. And it was symbolic, being coextensive in subject and form ("How can we know the dancer from the dance?"). In short, it was like art itself as conceived by the Symbolist generation, and bequeathed to this modern century. Like the older, Romantic image of the tree (with which it is associated here), it expressed an ideal of autonomous creativity that has been the aspiration, and burden, of the most ambitious of modern art.

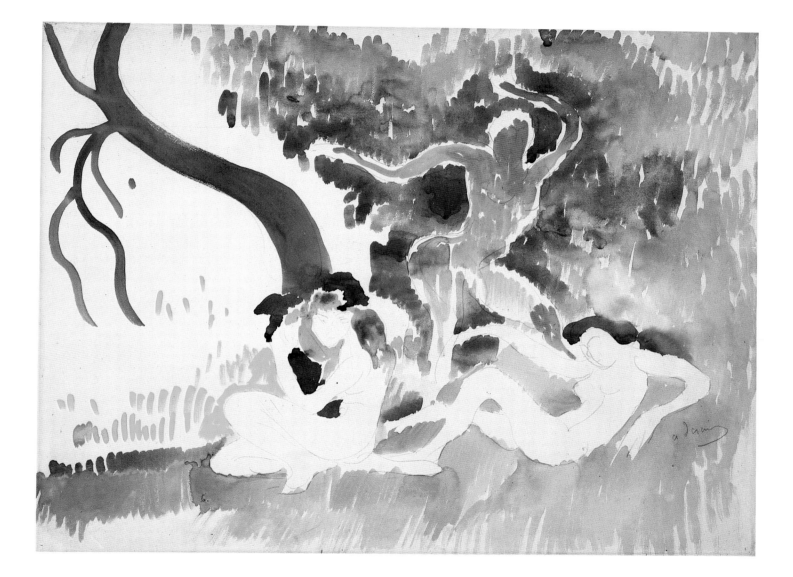

Henri Matisse

FRENCH, 1869–1954

JEANNE MANGUIN. (1905–06.) Brush, reed pen and ink, 24½ x 18½" (62.2 x 46.9 cm)
Given anonymously

This magnificent portrait of Jeanne Manguin, the wife of one of Matisse's fellow Fauve artists, is tangibly present to us; close and vividly real. It is indeed a portrait, not simply a drawing of a model. The character of the figuration solidly engages an intimate, unidealized, and manifestly human presence. We are utterly convinced that Matisse knew this young woman; that she sat, just there, opposite him, carefully overdressed for the occasion. And whether the wry irony subverting the modishness of the pose was in the dressing as well as the drawing (we suspect it probably was), we do enjoy it in the drawing, for the sense of collusive intimacy that it provides brings us even closer to this highly sympathetic portrayal.

What comes almost instantaneously upon our engagement with this figure, however, is the curiously illusive nature of her physical presence. She is indeed tangibly real to us, but the drawing is strangely devoid of a whole range of tactile connotations: because of its facture and because of its extraordinary openness.

Its facture is remarkable. Although partly indebted to van Gogh (p. 23), the sheer variety of marks, lines, spots, scribbles, and summary shading produced by the brush and the reed pen makes a virtue of its inconsistency in such a radical way as completely to overturn the notion of relatively uniform facture as necessary to a coherent art. Seurat and Cézanne had followed the Impressionists in stressing consistency of facture to an extent unusual in earlier art, to provide a sense of intrinsic material unity that revealed the common consistency of the visual world. Matisse, in his Fauve years of 1905 and 1906, exaggerated discordant facture as never quite before, seeking to rebuild the represented subject from the chaos of sensations, and in that rebuilding discover its emotional content. But far from varying his handling to focus attention on psychologically expressive features like face or hands, he deflects it from them: to spread "expression" through every part of the figure, and of the work. The very assertiveness of the facture assists this too. It forces attention to the surface of the drawing, holding even the contours there as they seem almost to gouge their way at times across the resistant sheet, like woodcutting tools throwing off fragments of matter, which lie scattered around them. They divide up space more than contain it, thereby allowing the whiteness of the sheet equal weight on each side of them. In the absence of tonal modeling, this drains the figure of enclosed tactile substance and reinforces the openness of Matisse's work.

By *openness* I mean two things: the sense of air-filled, breathing space that runs right through the whole drawing, joining figure to ground, and the compositional expansion of the drawing, which stretches to occupy the entire sheet. As in Cézanne, the white sheet becomes virtually a medium of existence—like air, space, light, and freedom—within which objects grow and gain their life. And it is the very body of the work of art, which tells of these elemental things when wakened from its passivity. For Matisse, realization of the motif does just that: it makes it seem to breathe, thereby giving life to representation. A radical concept, certainly; but also one that returns to the Pygmalion myth of older mimetic art, of which it is a uniquely modern version.

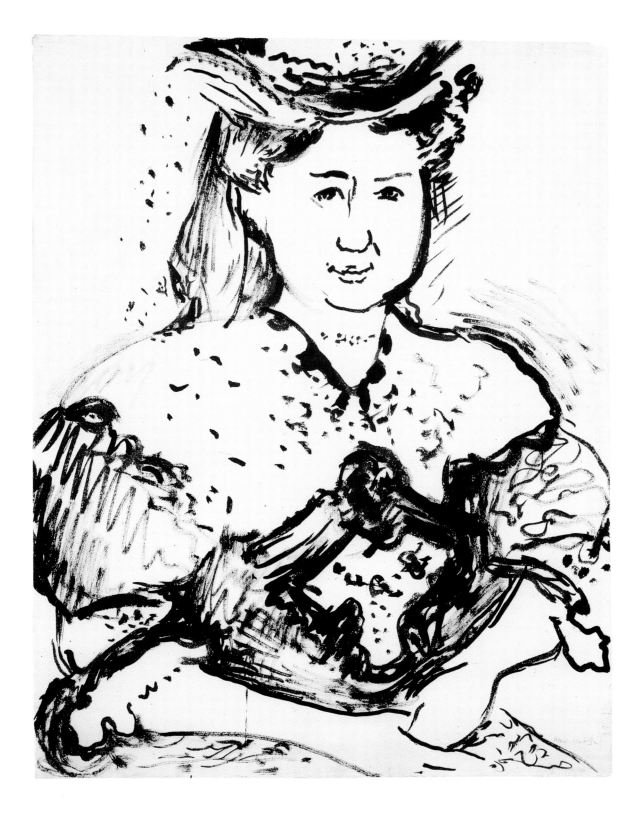

Georges Rouault
FRENCH, 1871–1958

WOMAN AT A TABLE (THE PROCURESS). 1906. Watercolor and pastel on cardboard, 12⅛ x 9½" (30.8 x 24.1 cm)
Acquired through the Lillie P. Bliss Bequest

Rouault developed to artistic maturity at the same time as the Fauves. He had been a fellow pupil with Matisse; he exhibited in the Salon d'Automne of 1905, where the Fauves burst on public attention; he has been popularly associated with them ever since. Rouault, however, was not a Fauve artist. The primitivized Rembrandtesque style he began to develop around 1902 has little in common, apart from the primitivism, with Fauve art. It is closer in many respects to Daumier, and exhibits a curious ambivalence in its relationship to the innovations of modernist art.

Whereas Derain's watercolor of the same year as this one (p. 41) is truly constructed in color, Rouault subsumes the purity of color to an essentially tonal conception of pictorial coherence, more traditional in its creation of a luminous and almost chiaroscuro space from the layering of variations on just two muted and somber hues, the blotted "gestural" black drawing, and the smudged pastel highlights. And whereas Matisse's drawing of a similar pose (p. 43) decisively rejected the idea of pictorial expression as based on representation of the "passions glowing in the human face," Rouault deliberately sought it: in the faces of clowns, criminals, prostitutes and their procurers. Later, this meant that Rouault often fell into a kind of gloomy pathos that we now find unconvincing—not only for its assumption that an intrinsically emotive subject will automatically be aesthetically moving, but also because Rouault became a virtuoso of gloom and the pathetic, producing merely ornamental pictures made all the more distasteful by the "seriousness" of their content. Before 1914, however, and especially when working in forms like watercolor that do not allow too much revision, he achieved a remarkable directness of expression in his harshly realistic images that did sustain, with a modernist idiom, the traditional moralistic content of an earlier art.

In this watercolor, the expression is embodied not only in representation of face and gesture, but also within the tonal tissue itself that binds together every part of the work. Hence Rouault's unwillingness to free color from that tonality: to have done so would have been to dissolve the very substance through which the drama of character and context was made comprehensible, and psychologically real. This is the curious ambivalence of Rouault's modern-ism: at his best, he was able to produce modern subject pictures that drew on modernist techniques, but which used these techniques within a more traditional concept of picture-making, and to powerfully traditional effect. One of the first sacrifices of modernism was of that earlier, tonally conceived and mysterious chiaroscuro space which carried with it almost metaphysical connotations. Before Analytical Cubism reimagined such a space, Rouault, briefly, managed to reuse it.

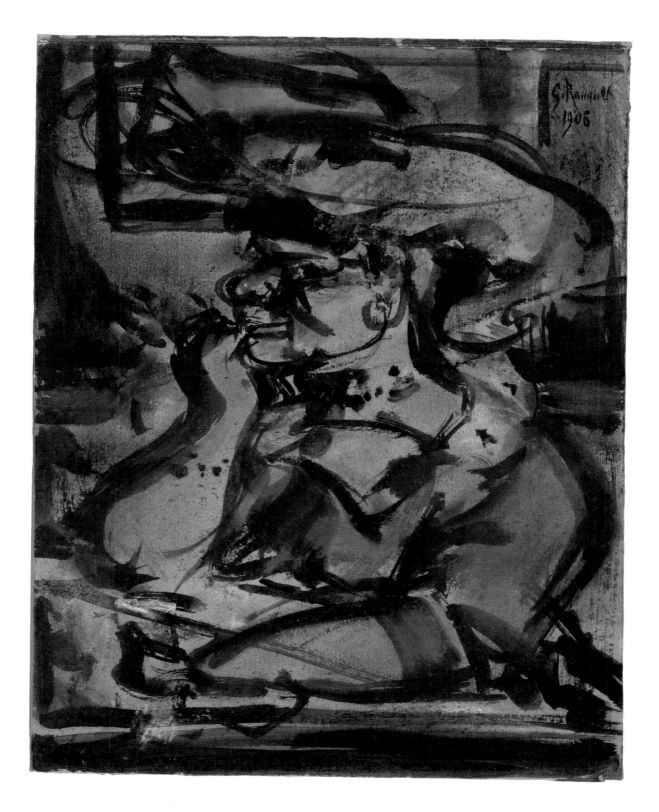

Lovis Corinth

GERMAN, 1858–1925

SLAUGHTERED PIG. (1906–07.) Pastel, 9⅞ x 13⅝″ (25.1 x 34.4 cm)
Mr. and Mrs. Walter Bareiss Fund

The modernity of Corinth's pastel is not exclusively, not even principally, to be found in its somewhat unsavory subject (where meat comes from is not, it seems, what all of us like to know), but thinking about its subject will help to define that modernity. The choice of such a subject tells us certainly of the persistence into the twentieth century of the kind of Realism that prefers the mundane to the exalted; also, of the disrepute into which beauty has fallen, once even the highest of qualities to which art could aspire.

The paradox implied in making beauty of the unbeautiful has attracted artists in the same way that the oxymoron has attracted writers. This subject was once Rembrandt's subject (which is partly why Corinth chose it). But it assumes a different significance now, in a period when mere beauty (the qualification telling all) is felt to be ingratiating; and more even than this (which began within Romanticism), when art is commonly assumed to fulfill some function that exceeds giving pleasure. Things less than beautiful are culturally that much more germane, for art's very authenticity (as Lionel Trilling, among others, has observed) now requires that it challenge the taste and approval of its audience, not defer to them. It does so by dealing as aggressively with beauty (necessarily a matter of received taste) and pleasure (necessarily a matter of habitual sensibility) as with the past from which such taste and such sensibility derive.

In one sense, this attack on beauty and pleasure, like the attack on the past, turns out in the end to be only a modern roundabout way of renewing these things. Corinth's pastel is obviously beautiful and obviously, if unexpectedly, modern. Its deeply traditional chiaroscuro may indeed defer to his enthusiasm for Rembrandt, but it draws right back to the surface—itself geometrically stabilized by that firmly frontal table-edge—and the fleshy weight of the beast is softened by a sketchy pearlescent luster: a moody, Northern counterpart of that sensuous, Southern plasticity we associate with Renoir. And if Corinth opposes the flat and disembodied modernism that dominated the beginning of the century with an earthy, and older, materiality, then the sense of inwardness within materiality implied by a work like this—which closely relates it to the life-in-death concerns of Symbolists such as Kubin (see p. 28)—brings it into the modernist orbit.

This concern with inwardness is another reason why things less than beautiful are culturally that much more germane, at least in early modernism. It inherits from Romanticism (the following are Hegel's words) its concern to "bring interiority into juxtaposition with all that is accidental in exterior formations, giving unlimited place to features characterized by what is the antithesis of the beautiful." The appearance of spirit within the prosaically real will evoke a sublimity that exceeds mere beauty. Oddly enough, when the real is actually realistic—and this applies no less to a spiritual documentary realist like Schwitters (p. 137), say, than to a descriptive one like Corinth—what actually is evoked is a feeling of nostalgia. The Romantic sublime gives way to a modern sense of vulnerability.

46

Oskar Kokoschka

AUSTRIAN, 1886–1980

NUDE. (c. 1907.) Watercolor, crayon, pencil, pen and ink, 17¾ x 12¼″ (45.1 x 31.1 cm)
Rose Gershwin Fund

The history of depicted postures in modern art has yet to be written. When it is, it will need to pay especial attention to the Expressionists (and Kokoschka must be counted an Expressionist, although his art was originally formed in Symbolist Vienna), for the viewer's relationship to their art is, to an extent unusual in modern art, a function of his or her relationship to the figures represented in it. Manipulation of those comparisons we inevitably make between how people present themselves to us, either socially or privately, and how they are represented in figurative art is no less a part of the artist's medium than the very stuff from which such art is made. In certain forms of art, including Expressionism, it assumes a larger significance. Our psychological relationship to the represented subject, established by means of depicted postures, is our relationship to the work of art as a whole: intimate, formal, empathetic, estranged... The figure in this drawing by Kokoschka turns the drawing itself away from us. The drawing itself speaks through the posture of the figure; or rather, refuses to speak, retreating into itself, emotionally suppressed, remote, and yet painfully exposed.

The sense of disjunctive unease characteristic of much Expressionist art is that of emotion uncomfortably contained, the disjunction it presents being between suppressed emotion and the brittle, easily shattered form in which it is encased. Despite the name that has attached to it, it is an art of latent, not expressed, emotion. When its subjects do look at us, they look not frankly, openly, disclosing themselves, but with a suspicious glance or estranging glare that hides them in their own images. Often they retreat from our gaze into their intense privacy. In so doing, however, they expose the insecurity of their withdrawal. Kokoschka's nude is a descendant of one of those naked figures in Gothic paintings—like roots or bulbs pulled up into the light, Kenneth Clark calls them; so utterly different from the confident bodies of Mediterranean art. A sense of nakedness, and therefore of defenselessness and deprivation, is revealed in the posture of hiding. Whatever conceals reveals. Turning away suppresses emotion but shows just how close to the surface that emotion is.

The line is Gothic too: wiry, nervous; a line more descriptive of some internal nerve or tendon than of any substantial form. At first, the drawing of the feet and lower legs appears uncomfortably casual—less tensely abbreviated than in the rest of the figure—and the red accents that mark their meeting with the ground, obvious and contrived. The drawing here is indeed slacker. And yet, strangely, it serves perfectly to begin the eye's journey up the length of the figure—which flattens to the sheet as it rises, losing corporeality, as if its concealment is within the very paper itself. But suddenly a reversal occurs. For as the figure flattens, it draws not away but toward us. Its withdrawal is returned to us, and is present to us on the flattened surface of the sheet. Then, of course, we reach that astonishingly inventive treatment of the hair, which conceals what, we hoped, could have specified the emotion of this figure, but does not; it is impossible to tell whether Kokoschka actually drew in the head.

Egon Schiele

AUSTRIAN, 1890–1918

WOMAN WRAPPED IN A BLANKET. 1911. Watercolor and pencil, 17⅝ x 12¼″ (44.7 x 31.1 cm)
The Joan and Lester Avnet Collection

Even the signature of Schiele's watercolor enforces its vertical orientation, which misleads us to expect a standing figure. But this figure is obviously asleep, laid down on some unknown support that cannot be distinguished from the sheet of the watercolor itself. An unidentifiable pale substance, hardly a pillow, is shown to the right of her shoulder, and shadows surround the exposed contours of her face and legs. But far from finding space beside the body, they further flatten it to the sheet. Between the bared legs, an unsettling reversal occurs. What should be space seems solid, or almost solid, as the legs themselves flatten and finally fuse around what therefore reads as a limp, phallic appendage hanging from beneath the blanket — which itself seems only almost solid, for the sense of body implied by the tonal modeling is dissolved in its staining into the sheet. Only the rigid, doll-like face is at all naturalistic; only by reference to the turn of the head that it reveals can we read the posture of the concealed, lost body. We look right down upon the figure, almost directly from above, for there is hardly any foreshortening. But it also seems to hang in front of us, an insubstantial puppet suspended from the top of the sheet.

The most deep-seated of connotations attach to the motif of the sleeping female figure, for it returns us atavistically to the realm of fairy tale and primal myth. The sleeping beauty is dead but potentially alive; she is cold and frigid but inviting of eroticism; untouchable because unconscious, but vulnerable and provocative for exactly the same reason. Schiele's version of the motif stresses the association of sleep and death in the shroudlike concealment of the blanket. The verticality of the drawing reinforces this, for it suggests some stiffened, mummified form, propped up and displayed. This same verticality, however, helps to awaken the figure, which seems, therefore, not merely somnolent but somnambulistic, seen lifting its dress in walking sleep. And whether the figure is "dead" or "alive," its innate eroticism is revealed in this implied action; also, in the hidden phallus, in the area of succulent red that abuts it (for it suggests exposure of latent sexuality in showing the warm interior of the body's cool covering), and in the fluid wetness of the covering itself.

Of the many inherent possibilities of the watercolor medium, one is evocation of sexuality. Many modern artists, from Rodin (p. 39) to Grosz (p. 157), have capitalized upon this potential. Schiele's treatment of the blanket over the body clenches the emotional tone of the work in its bleeding, cold color. Its fluidity evokes the sensual; its color, however, refuses that suggestion, connoting instead something harder and not quite welcoming, like tree bark, or the stiffened garments of figures in paintings by Grünewald or El Greco. To learn of the complexity of Schiele's sexual attitudes, and of the guilt that attached to them (also, of his very explicitly erotic works), helps us to understand what is being subsumed here, in this hanging, depersonalized, doll-like fetish. But we grasp the sublimation, abstractly, in that pent-up flood of watercolor: two browns, a green, put together while wet, two patches of red, held inside a contour that hardly can contain them.

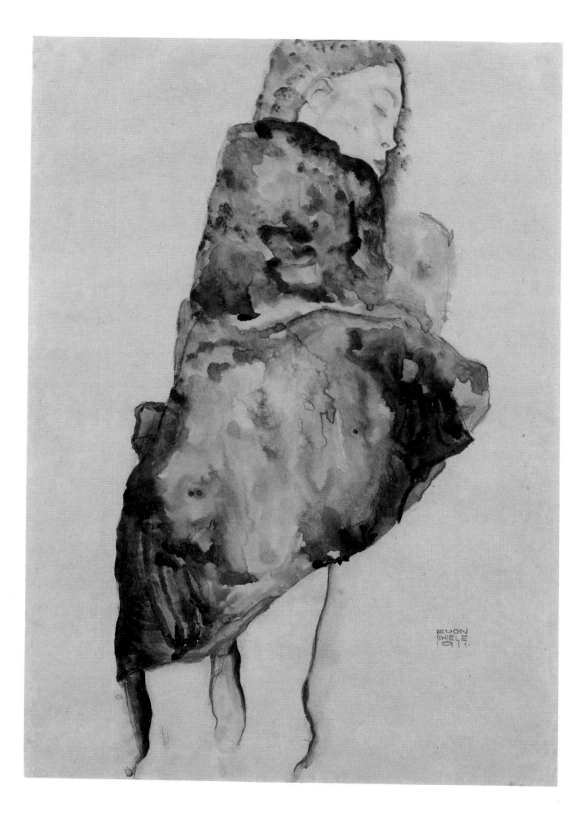

Max Pechstein

GERMAN, 1881–1955

RECLINING NUDE WITH CAT. (c. 1910.) Watercolor and ink, 13¾ x 18¼″ (34.7 x 46.4 cm)
Gift of Sheldon Solow

Because the female nude figure is such a staple of Western pictorial art, we should not therefore assume either that it is a conventional pretext for purely stylistic investigations (that obviously is untrue) or that it reveals only attitudes toward women, or what is considered beautiful, expressive, sensual, and so forth. Beyond any such functions, it has traditionally revealed— overtly at times—the very broadest of cultural meanings. Pechstein's watercolor, like images of nudes immemorial, is less a window on a particular female body than a mirror reflecting back, in this conventional form, the artist and his audience, and some of their most basic concerns. It is indeed a representational art, but the means of its mimesis is synecdoche. This single figure, excerpted from sense of context, contains in its simplicity and isolation a wealth of contextual meaning, most importantly doubts, nostalgia, and feelings of loss, both of innocence and instinctiveness, in a modern, civilized world.

Pechstein, though living in Berlin when he made this work, was associated with the Dresden artists' group, founded in 1905, known as Die Brücke (The Bridge). From Post-Impressionist and then Fauvist sources (and later from Cubist ones) they created a rougher, more obviously subjective art that used modern stylistic liberties not for the sake of pictorial harmony (as finally did the Fauves, their contemporaries), but in a deliberately abrasive and antihedonistic manner that links their art to the introspective Gothic tradition and to the so-called primitive art that they admired. Stylistically, Pechstein's nude looks back to those in the work of Fauves like Matisse or Derain (and before that to Gauguin) in its boldly simplified contours and summary color infilling. But instead of the sense of Arcadian dream that we find, say, in Derain's nudes (p. 41), with their fluid lines and intense, optimistic color, the Pechstein presents something more strained, something that reminds us of van Gogh's art (p. 31). There is an inelegant Northern asceticism, almost, in its handling: the angularized line resists describing anything too sensual; the color seems rudimentary, harsh, and rather cold. No confident Mediterranean nude, this is taut, introspective, and of a cruder and more animal beauty, for all the unconstraint of its pose.

Absorbed in contact with that curious sage-green cat, the figure enjoys the unembarrassed freedom of its nudity. The briefly stylized setting, though obviously an interior, connotes landscape, which accentuates the sense of pastoral, cut off from the exigencies of the modern world. The cat itself, even before Manet's *Olympia,* has traditionally evoked something both exotic and erotic when juxtaposed with a female nude. We are separated from the present and vicariously returned to some more innocent, spontaneous, and instinctive domain. Nostalgia attaches to this fictional return; and with it regret. The very roughness of this work, which carries right through to the crudely shaped sheet on which it is drawn, tells of a preindustrial, primitivist ideal, and of the loss of this supposedly more "natural" form of existence. Unlike Mediterranean versions of this theme, however, Pechstein's evokes the freedom and instinctive-ness that have always belonged to the idea of a pastoral Arcadia, but without the pastoral comfort that such an Arcadia had traditionally hoped to provide. Neither relaxed nor soothing in its simplifications, it retreats from the modern world only to remind us of it at the same time.

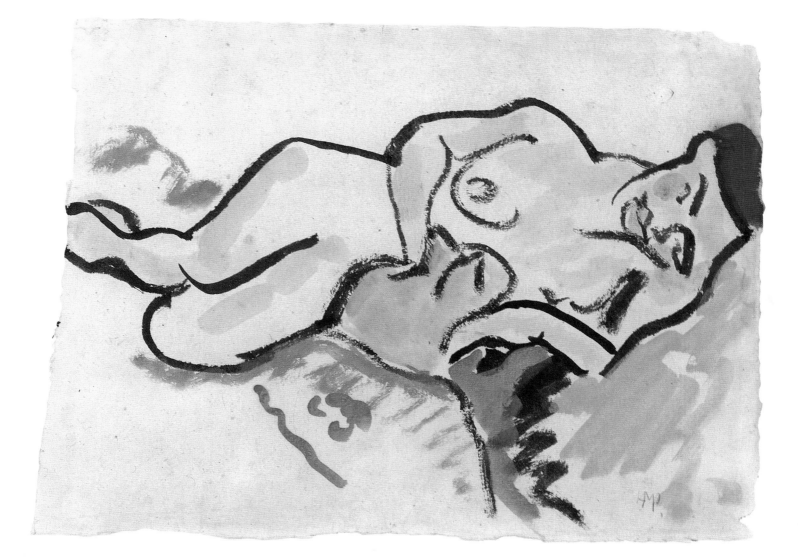

Pablo Picasso

SPANISH, 1881–1973

HEAD OF THE MEDICAL STUDENT. (1907.) Gouache and watercolor, 23¾ x 18½″ (60.3 x 47 cm)
A. Conger Goodyear Fund

It is within the capacity of great artists not only to create what we have never seen before, but also to destroy what had hitherto seemed indispensable to art, immune even from the most radical of change. In Picasso's case, accommodation of sculptural illusionism to the flat surface of painting and drawing led him eventually to show that objects could be realized in all their tangibility without giving us the discrete identity of these objects. The weight of images remains, but image-making itself—that is to say, iconic identification of the wholeness of things, probably the most long-standing norm of pictorial art—is shown to be dispensable in Picasso's Cubism, which was initiated by *Les Demoiselles d'Avignon* in 1907. The watercolor reproduced on the opposite page is a study for this painting. It shows the head of a "medical student," who in early compositional sketches entered the work from the left, only later to be replaced by a woman lifting the edge of a curtain.

The fractured linear motifs that thrust rigidly about the surface of the watercolor recall the "lost-and-found" drawing of Cézanne (p. 33), and likewise open contours, allowing the eye to pass uninterruptedly through them. Cézanne, however, refused line its traditional contouring function. Contours were abstractions, untrue to perceptual reality, which smoothed out the tactile separateness of things. Picasso, in contrast, clings doggedly to the tactile contour no matter how much he breaks its continuity. Whereas a watercolor by Cézanne surrenders the sculptural wholeness of objects in order more fully to realize the space in which they were perceived, Picasso's watercolor fractures the wholeness of the figure only to retain its sculptural presence. He retains it, principally, in the tactile forcefulness of line.

Line carries the iconic substance of the figure, diagramizing those features that allow its recognition (among them, the displaced scroll-like ear, derived from an Iberian sculpture that Picasso had just acquired). Line marks the salient tactile divisions of the figure: it denotes the recessive limits of planes, the advancing ridges of planes, and the fissures between planes, condensing in itself the graspability of the adjacent volumes, which drain of substance, therefore, flattening to the sheet around the linear skeleton. And at times, line constitutes a simplified form of hatching which suggests depth but also sits on the surface in a way that graduated modeling never quite can. As the figure breaks disjointedly to flatten over the surface, space is drastically flattened, and color—an abstracted form of local color—settles back into the shallow relief space, subordinate to line, especially to the superimposed lines of the pen. It is the urgent tactile presence of contour drawing that charges the work. Contours fracture, but without losing thereby their graspable identity.

"Obviously," Picasso is reported to have said, "only the line drawing avoids being imitative." He meant that only line, as an abstraction of reality, does not pretend to imitate the perceived world. For Picasso, the reality of the retina was not quite to be trusted; only the reality of tactile sensations was valid. His was forever a skeptical, doubting eye that required the confirmation of physical touch. Whenever modern flatness threatened to disintegrate objects beyond grasping, their tangibility was retrieved by an imagination as fully three-dimensional as modern pictorial art has ever seen.

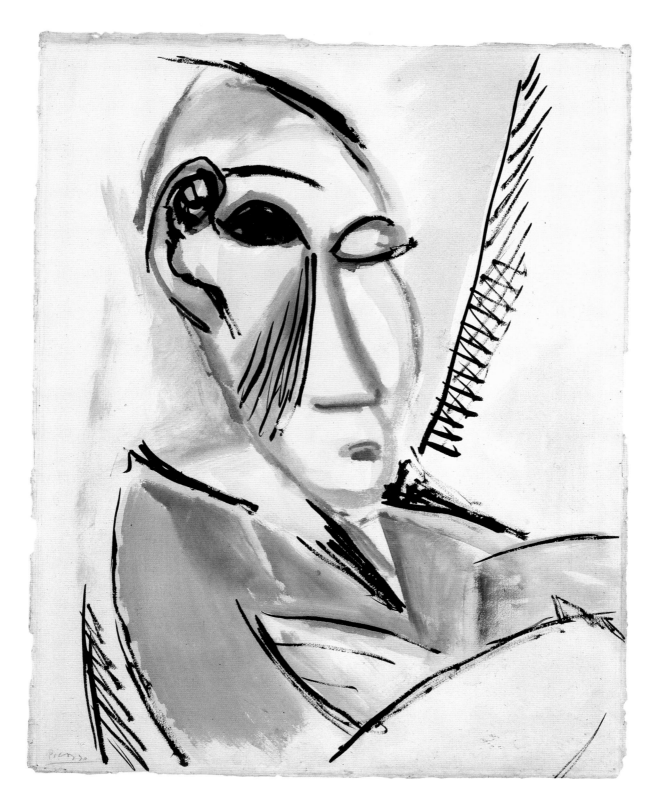

Henri Matisse

FRENCH, 1869–1954

GIRL WITH TULIPS (JEANNE VADERIN). (1910.) Charcoal, 28¾ x 23″ (73 x 58.4 cm)
Acquired through the Lillie P. Bliss Bequest

Jeanne Vaderin, the subject of this drawing, was also the subject of Matisse's great series of five *Jeannette* sculptures of 1910–15 and of the 1910 painting *Girl with Tulips,* now in the Hermitage Museum, Leningrad. The simplified, asymmetrical treatment of the head in the drawing relates it to the first two (1910) sculptures, and its subject to the contemporaneous painting. But there its affinities end, for it represents a unique conception of this particular motif: the discovery of pictorial analogies between woman and plant, and fusion of the two into a single image.

Matisse, the great modern master of virtuoso line drawing, and Matisse, the supreme hedonist of modern art: these often-repeated judgments could hardly be more misleading. Pure line drawing was where Matisse failed most, and when he succeeded there, his line is as stubborn and searching as any we know, as well as direct. Like any achieved act of condensation, it simply *seems* so fluently easy. This was the artist, we must remember, who wrote that he preferred "to risk losing charm in order to obtain greater stability"—exactly what we see here. The supposed elegance of Matisse's line, like the supposed hedonism of his work as a whole, is nothing less than the convincing clarity of an art that contains its creative struggle within the vividness, and grace, of its realization.

When we can see the struggle of realization (as often we can in his charcoal drawings), it manifests itself not as the creation of order from indecision; all seemed sure from the start. The line is indeed always under control. But it had to be repeated, redrawn, to probe the meaning of the pose and release from it an image that is complete only when the artist (in his own words) can "rejoin the first emotion that sparked it." By this he means: drawing is remembering, preserving, and realizing emotion before a subject; clarifying "unconscious sensations which sprang from the model" by finding for them a characteristic form. Here, Matisse "represents" not merely the appearance of the subject—that would make for only a fugitive and superficial image—but the artist's response before the subject. The subject is drawn and redrawn until it conforms to an internal image of itself which defies the contingencies of mere appearance.

The lightly drawn, shieldlike form in the top left corner is a clue to the kind of essential image that Matisse was seeking. It summarizes the shape of the tulip leaves, is repeated in the drawing of the girl's collar, and is also the whole shape of her head. These analogous forms comprise a growing vertical axis that rises to the facing but profile eye, and from this axis bloom the swerving lines that bend from the shoulders and serpentine down to the tulip-shaped hands. The tapered form of the torso is itself a version of the same module as well as an amplification of the pot from which the plant grows. Figure and plant grow together as one organism to that magnificently impassive head, which culminates what must be one of Matisse's, and this century's, greatest drawings. We see how he worried the features of the face until he established the conflation of profile and three-quarter views (as daring as anything in Cubism, and far more understated), and how concerned he was to return from the head the movement that rises there. Hence, those external guide lines that drop to the shoulders and draw in the whole figure, within a now-inverted form of the basic module, to produce a single, dense image of continuous as well as continual growth.

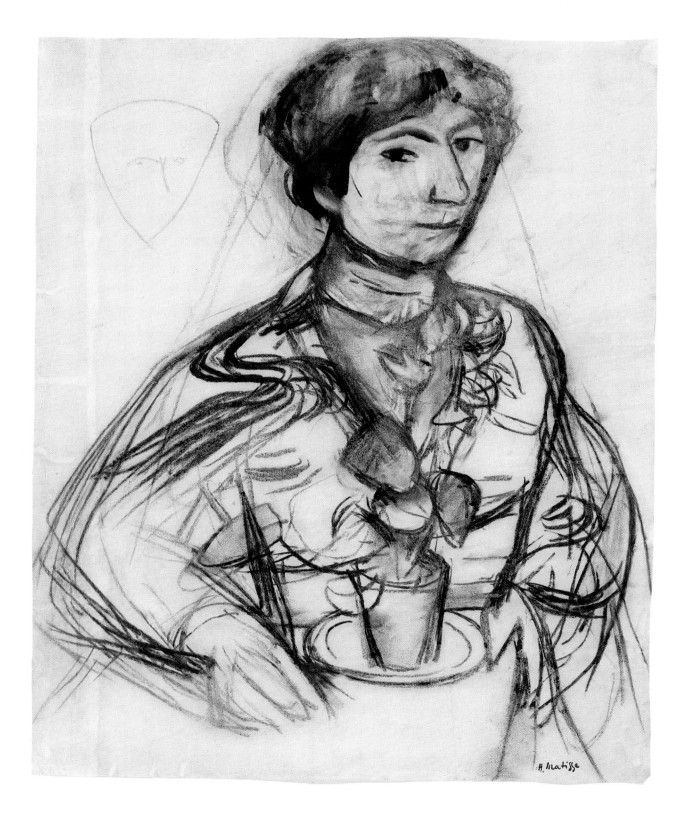

Robert Delaunay

FRENCH, 1885–1941

EIFFEL TOWER. (1911.) Pen and ink, traces of pencil on brown cardboard, 21¼ x 19¼″ (53.9 x 48.9 cm)
Abby Aldrich Rockefeller Fund

The Eiffel Tower—ubiquitous symbol of Paris (in golden miniatures), also of "the modern" when modern technology still seemed capable of creating a golden age—took two years to build but twenty to find its perfect interpreter. The tower was completed in 1889; in 1909, Delaunay made the first of his many representations of what was then the loftiest example of man's technological prowess, the tallest fabricated structure in the world. This drawing of 1911, made after a painting in the Guggenheim Museum, shows Delaunay in one of his most dynamic, fluxionary interpretations of this subject. The translation from oil to pen actually enhances the cacophonous vitality of the scene: the sharp, rigid, and mechanically severe hatching suggests comparison with steel engraving and serves to splinter tower and buildings alike into separately broken shards that shatter noisily across the drawing's surface. It is a utopian image of the dynamism of modern life.

While "modern" subjects (including this one) had regularly found a place in earlier modern art, it was not until Cubism that there emerged a formal language capable of expressing, within its very structure, the dissonant energy of the machine age. Cubism did not begin by addressing the subject of technology, but Cubism seemed exactly appropriate to it. Shifting viewpoints on forms could express the simultaneous rush for attention of different and conflicting images in the modern city. (Here, the tower is seen diagonally, frontally, and from three sides at once as we follow it upward, unable to fix it in a single glance.) The fragmentation of forms could evoke the effects of light and atmosphere on crowded buildings, blending and distorting their separate identities. (Bold clouds and shafts of light break through the contours of supposedly solid forms.) Forms presented as if in flux could suggest constant reconstruction. (The older houses here do seem to be jostled apart by the expansive force of the new tower.) And the submission of everything depicted to a vital, interpenetrating, and aggressively rhythmic continuity of form could tell of the underlying collective dynamism of urban experience. The Eiffel Tower was at one and the same time a new subject and a symbol of a new experience: life in the city of the machine.

Faced with new subjects or new experiences, artists usually begin by treating them in terms developed to treat some compatible but more familiar subject or experience. Hence, earlier images of this subject show it rising over the city analogously to a cathedral. And even when artists have new means at hand to describe the new, not only does some flavor of the older subject analogy often remain (here, a Gothic interpretation of Cubism), but also there still usually remains an experience analogy to which reference is implicitly being made. Thus Delaunay, in idealizing the modern experience, discovers beneath the machine-made forms the same underlying continuity, the same vitalist energy, the same sense of some dynamic, growing, and regenerative force that outlives the changing appearance of things—in short, the same kind of organic order that previously had been claimed (most recently by the Symbolists) for the pastoral Arcadia. Idealization of the city required that it take over these ideal attributes. The form they assume is altered with their new site, but the ideal itself—of organic vitality— remains essentially unchanged as it moves to the city, from garden to machine.

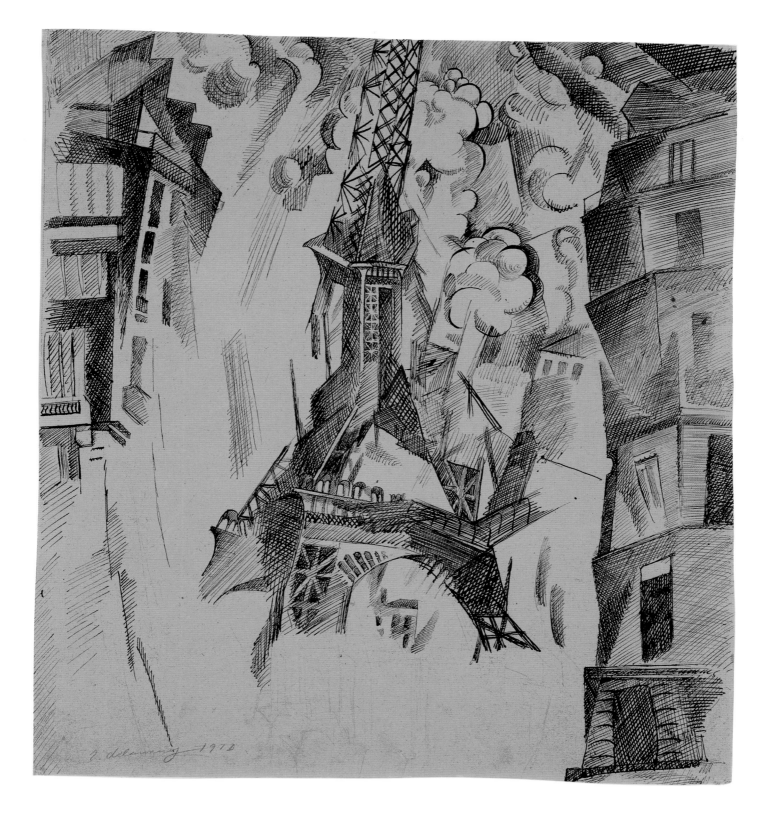

Pablo Picasso

SPANISH, 1881–1973

STANDING NUDE (MLLE LÉONIE). (1911.) Pen and ink, traces of pencil, 12½ x 7½" (31.8 x 19 cm)
Promised gift of Mrs. Bertram Smith

This untitled, undated drawing is usually known as *Mlle Léonie,* and indeed it relates to Picasso's etchings of this subject, made in the summer of 1910 at Cadaqués on the coast of Catalonia as illustrations to the Max Jacob play, *Saint Matorel,* which Kahnweiler published in February of the following year. But it must be a postscript to the Cadaqués works: the density and extent of the hatching that surrounds the linear armature are unusual for Cadaqués (which tended to produce sparer compositions), as in the inclusion of rudimentary "signs" for the subject's breasts. (Such signs only emerged when Picasso, back in Paris, sought to offset the nearly total abstraction he had reached that summer with discrete clues to the identities of distinctive features of his subjects.) The confident finish also suggests a later date. Picasso, we know from Kahnweiler, struggled painfully in the summer of 1910 and was dissatisfied with much of what he had done. It may well have been when the *Saint Matorel* volume appeared, if not indeed later, that Picasso returned to Mlle Léonie's image to produce this consummately beautiful work.

I call attention to this probable genesis of the drawing because it reminds us that Cubism was both an art of month-by-month exploration, constantly moving in its analysis of how reality could be grasped, and an art in which no single approach was ever quite lost in those that followed. It was an art of memory not only in its approach to its subjects—which it evoked by re-presenting those accumulated, remembered experiences which constituted knowledge of these subjects—but also in its approach to its own pictorial language. Each new step, especially in those amazingly fecund years, 1909 to 1912, of Analytical Cubism, remembered and condensed those which preceded it. Here, Picasso looks back to the formal severity of Cadaqués as he returns to this subject, while working in an intrinsically more lyrical vein; and he looks back earlier too, to the tangibility of Cubism's beginnings (p. 55), while now presenting the tangible not in the form of a sculptural illusion but as a generalized attribute that is somehow embedded within the wafer-thin sheet of the picture plane.

At Cadaqués, said Kahnweiler of Picasso, "He had taken the great step. Picasso had pierced the closed form." Before then, a looming sense of volume remained, however much Picasso had fragmented and angularized forms and however much prominence he had started to give to the flattened linear armature. At Cadaqués—and hence Picasso's struggles there—he finally managed to spread out frontally the bodies of objects to the flattened continuum of the surface: by abandoning the use of faceted shading around the broken contours of objects (a method we see in use in the Delaunay reproduced on the previous spread) and using instead long straight edges that disregarded contours, along with highly generalized shading that provided an illusion of depth somehow disengaged from specific forms. We see here the refinement of this method. Representation, as a function of line, and illusion, as a function of modeling, are separated from each other (and separate with them drawing's traditional descriptive components), then are reassembled to produce an image that contains them both.

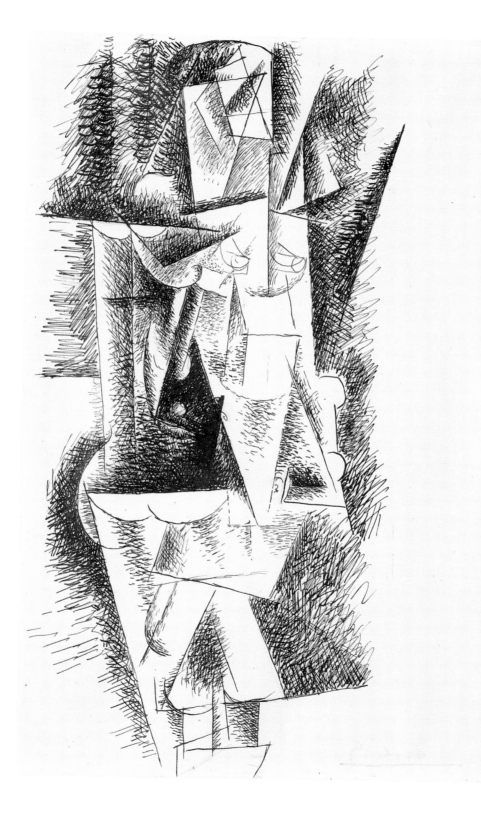

Mikhail Larionov

RUSSIAN, 1881–1964

RAYONIST COMPOSITION: HEAD. (c. 1913.) Oil on paper, 27¼ x 20½″ (69.3 x 52.1 cm)
Gift of the artist

Larionov invented the term "Rayonism" to describe works like the one shown here, defining it as being "concerned with spatial forms that can arise from the intersection of the reflected rays of different objects." This definition does help us to appreciate why this study of a head assumes the form it does: it diagramizes the imagined paths and patterns of invisible light bouncing off and colliding around an incompletely described but implicitly solid headlike form in the center. In order properly to understand, however, why the drawing uses the particular elements it does we need to look beyond the artist's own explanations. This work uses a simplified and exaggerated form of Cubist drawing. It is in the language of Cubism that its identity is best defined.

The disengagement of the two components of traditional drawing (line and shading) and therefore of their two traditionally associated functions (image-making and sculptural illusion) had produced in Cubism a contrapuntal system wherein line, virtually alone, carried the informational function of drawing and shading produced only a generalized kind of illusion, descriptive not of individual volumes but more of space itself. (We see this in the 1911 Picasso reproduced on the previous spread.) Larionov's two-part system of tensely abbreviated lines and shading, simplified either into flattened, feathery shapes or into domino spots, is built on this Cubist foundation.

The domino spots (though suggestive of some source in decorative or folk art) are, functionally, extrapolations from the atomized shading of Cubist art. Their restriction to black and white—and the restriction to these colors also of the feathered form of shading—looks back through Cubism to Cézanne, and his avoidance of middle tones in order to make drawing a matter of patterned contrasts that cause a constant shuttling of attention between surface and depth (see p. 20). And the feathered shading itself is descended from the fray-ended hatching of Cézanne's paintings, similarly allowing an easy sense of gradation, or *passage,* between figure and ground. Because each element of the drawing is shaded separately, and because the domino shading passes through the linear elements, the work is kept open, and obviously particulate, in a characteristically Cubist way.

Since the linear drawing is neither controlled by perspective nor limited to an exact contouring function (again, as in Cubist drawing), it too can carry freely throughout the sheet, confusing figure and ground and assisting the openness of the work. The extent of its freedom, however, is what principally separates this work from its Cubist models. Its dissection of the subject is broader, its unit parts are larger and more assertive, and its flexibility is certainly greater. Eschewing the tight compactness of Analytical Cubism, the drawing seems more reminiscent of the primitivized, pre-Cubist Picasso of 1907 (p. 55), to whose striated hatching its crisscross axes seem to refer. But it is more obviously a flattened, spread-out conception of drawing. Because the shading is so utterly schematic, and flat, line and shading together can function principally as elements of design. Rhythm, balance, and composition of the whole surface achieve new and extraordinary emphasis. Linear drawing is used to discover the spread and flow of the surface: it marks out surprising axes across the surface, and in revealing the format of the surface reveals itself.

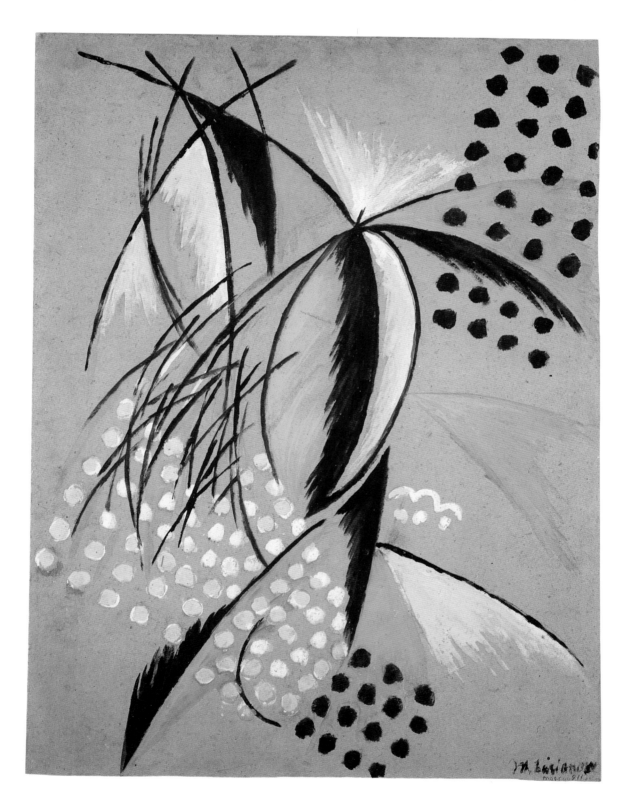

Marc Chagall

RUSSIAN, born 1887

Study for CALVARY. 1912. Gouache, watercolor, and pencil, 18⅝ x 23⅜" (47.4 x 59.2 cm)
The Joan and Lester Avnet Collection

Chagall has produced countless compositions of biblical subjects. This study for a painting of autumn 1912, also in The Museum of Modern Art, is, except for a simple pen drawing that preceded it, the first of his representations of the Calvary theme. It is less detailed and decorative than the final painting; what it surrenders in charm, however, it makes up for in the directness of its vision. The heightened, and Fauvist-influenced, color and the broadly Cubistic structure, both characteristic of Chagall's first Paris period of 1910–14, appear here in uncompromised boldness as figure and ground are held in a powerful symbiosis, wherein the vivid complementary zones of red and green seem to resonate with rhythms derived from the stylized bodies of the three principals. By no means is this simply an applied Cubism; rather, it is the discovery in Cubist design (and Fauvist color) of a primitive language of highly emotive forms appropriate to Chagall's most personal and atavistic vision and capable of carrying the most serious of meaning, often without the aid of specific representation. Even the cross itself is dissolved by the pressure of these sonorous and expressive rhythms. But as Chagall himself noted of this composition, "In the exact sense there was no cross but a blue child in the air."

Iconographically, the work is certainly unusual. The two figures beside the remnant of the cross would seem to be the traditional John and Mary. Chagall, however, has identified them as Christ's parents. Wanting "to bring them down to more intimate dimensions," he wrote to Alfred Barr in 1949, he based them on his own parents, and added, in explanation of their discrepant sizes, "My mother was about half the size of my father when they got married." The river, he said, "is the river of my native town. . . . The figure and the boat represent the element of calmness in life as a contrast to the strangeness and the tragedy." The turbaned figure to the right, identified by Chagall as Judas, carries a ladder not as an instrument of the Passion but again for the sake of "intimacy," by which Chagall presumably means, as with his representation of Christ's parents: to demystify and make obviously human. That certainly is the effect, and as a result, the uncanny apparition of a suspended and seemingly luminous "blue child in the air," which replaces the conventional Christ, is the dominant and mysterious unreality of the scene: exceptional in what we see, only the sail of the boat—on its way, we assume, to the traditional paradise beyond the water—having a comparable unearthliness in its likeness to a blue flame.

Biblical art, like any art that requires repetition of familiar values, tends easily to sentimentality, for sentimentality, by definition, appeals to what one already knows. That is to say, it depends upon the existence of common subjective values that antedate the experience of the work of art and remain unchanged by that experience. If we are affected by the experience of Chagall's new version of the Calvary, it is not, however, because he has found in the story other than familiar values; rather, it is the sense of fresh discovery in the rejuvenation of these values, which Chagall thus preserves, that gives to his work the power and importance of achieved art.

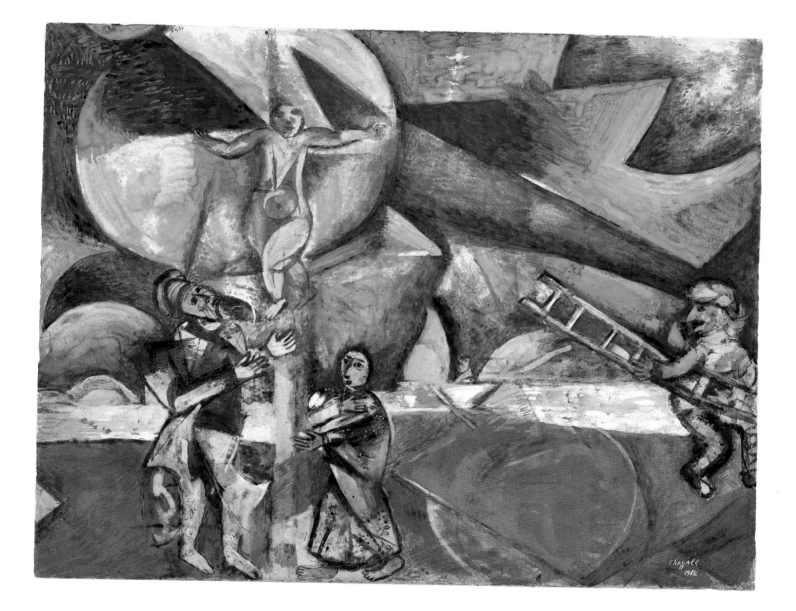

Wassily Kandinsky

RUSSIAN, 1866–1944

Study for PAINTING WITH WHITE FORM. (1913.) Watercolor and ink, 10⅞ x 15″ (27.6 x 38.1 cm)
Katherine S. Dreier Bequest

The preparatory studies that Kandinsky made in order to establish the compositions of his paintings also often served the function of progressively abstracting motifs taken originally from nature until they were, to use his own term, "dissolved" beyond easy recognition. Certain elements in this study—notably the house with yellow chimney in the upper center—would be further abstracted in the painting itself (now in the Guggenheim Museum); most, however, are already dissolved, and many, therefore, are impossible to decipher precisely. We see a landscape of rocks and foliage, with two domed towers to the right of the aforementioned house, and directly below them what is probably a white boat on its side with a black mast projecting into the center of the composition, and around it a stormy sea. It is a deluge composition, one of the eschatological subjects that Kandinsky favored in this period. That much seems certain. It has been suggested that the tall white form to the left denotes a figure with head and arms attached; but that, like other details, is so abstracted that its precise derivation remains obscure.

Such obscurity Kandinsky deliberately courted, as a way of expressing what was more important to him than the contingent appearances of things. "When a line is freed from delineating a thing," he wrote in 1912, "and functions as a thing in itself, its inner sound is not weakened by minor functions, and it receives its full inner power." By this he meant that line, independent of representation, could itself release the spiritual resonances he believed all objects possessed when the distraction of their material outward appearances had been dissolved. Kandinsky was an animist. His line is essentially a symbolizing, metaphorical line. As such, it relates to that of other Expressionist artists like Kokoschka (p. 49) or Pechstein (p. 53), but is less nervous than the former's and more fluid than the latter's, for it is by running freely about the surface, then stopping to form small organic clusters, then continuing, that it becomes metaphoric of the *anima mundi,* of the "soul" of the natural world.

Color, independent of line, supports the metaphoric function of line by virtue of its independence. It is transparent "film" color that either washes over line, further blurring its descriptiveness, or else (in Kandinsky's words) "seems to hang in the air and appears to be surrounded by a haze," thus providing a sense of intangible, ambiguous, and atmospheric space dissociated from objects of the world. The shallowness of the space, and the disengagement of firmer line drawing from looser brushwork, tells of Cubist influence; the layering of separated color units, which find their unity in the breathing whiteness of the sheet, tells of the influence of Cézanne's watercolors. But Kandinsky's work lacks that sense of a tangible, resistant flat surface so crucial to his sources. In this sense, his is a more conventionally illusionistic art. But the extra space that he retained from premodern art allowed him a special freedom, for it excepted his art from the quasi-geometrical drawing and modular compositional structures that flatness seemed to impose on Cubist art; it was this extra space that allowed line to move as freely as it did. Kandinsky's freely moving line had extraordinary importance for later abstract art. With it, the modularity of the Cubist tradition, together with that sense of urban, man-made order it carried, surrenders to an art of air and free extension.

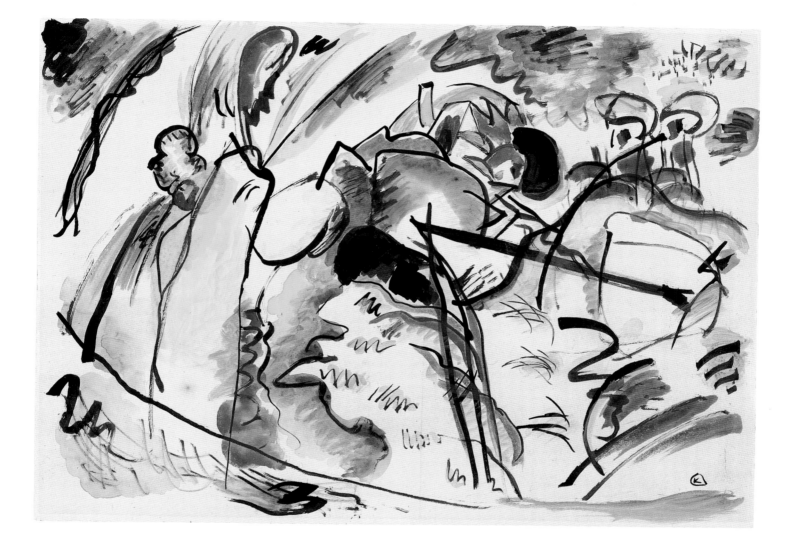

Franz Marc

GERMAN, 1880–1916

BLUE HORSE WITH RAINBOW. (1913.) Watercolor, gouache, and pencil, 6⅜ x 10⅛″ (16.2 x 25.7 cm)
John S. Newberry Collection

"Is there a more mysterious idea for an artist," Marc once wrote, "than to imagine how nature is reflected in the eyes of an animal?" For Marc himself, there was obviously not; hence the following, practical problem he raised: "How does a horse see the world...?" Some students of Marc, I regret to say, have attempted to answer this question. The artist himself realized (as his work makes clear) that questions like this, which ask about the unknowable, usually get answered by answering instead a related but finally quite different question: How does art require that such a subject be treated? And the answer to that question is: through certain conventional structures and symbols which, by referring to archetypes associable with subjects of this kind, can make this specific subject artistically comprehensible. In Marc's case, his "new" subject—nature as seen from the inside, by the animals that inhabit it—achieves comprehensible form by his using a pictorial language (Expressionist-Symbolist drawing) developed to evoke the essence rather than appearance of nature. Also by his transformation of this inherited language so that it refers back (further even than to the sources of this language) to appropriate atavistic myths of the animal world that associate animals with elemental forces of nature.

Marc's drawing style bears comparison with that of his colleague Kandinsky (p. 67), with whom he founded the Blaue Reiter (Blue Rider) group the year previous to this *Blue Horse with Rainbow*. It is a Symbolist-derived style that abstracts line to probe the growing forces of things behind their surface appearances. With Marc, however, the line is lighter and more evenly weighted, and forms more rhythmically repeated patterns that tell clearly of the influence of Jugendstil decoration. They tell also of Cubism in the interweaving of their separately shaded bands to produce a shallowly compressed space from the balancing out of advancing and receding colors. But, as often the case in Expressionist art, Cubism is not followed as an analytical method but is used, rather, as a simplifying device to reduce and distill the plenitude of nature; and here, the sliding colored bands, metaphoric of elemental forces, energize a space that for all its shallowness is almost realistic. Marc's art required this realistic reference in order to stress, by contrast, the very exceptional events it contains.

Thematically, this work presents what Northrop Frye (in his theory of literary myths) calls a "point of epiphany," where the apocalyptic and natural worlds come into alignment. The mountaintop setting is customary for images of this kind since it allows simultaneous representation of the heavenly and the earthly, thus facilitating movement between the two zones. The earthly, as shown here, has pastoral connotations, for the horse is the gentle horse of romance, and stands at the end of a rainbow (itself symbolic of spring and regeneration, as in the story of Noah) cut with green and suggestive of fertile rains. But the rainbow also merges heaven and earth. As the sky is divided, a Pentacostal descent of golden fire is implied, and the earthly is seen as charged—through the medium of the horse—with a swirling, mysterious, heavenly light.

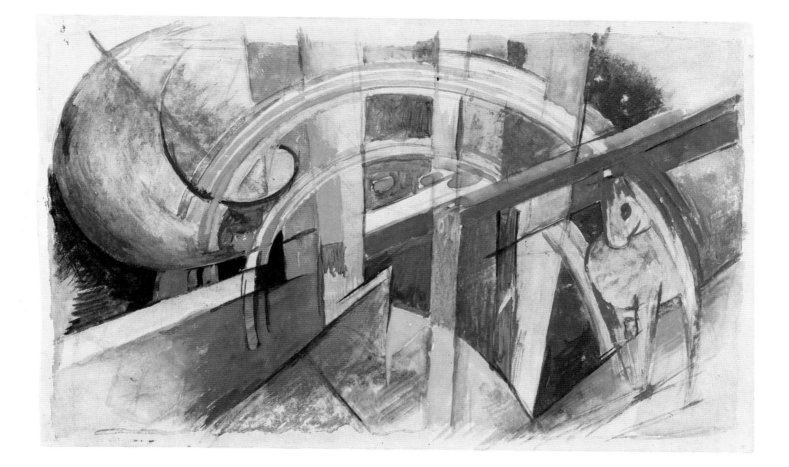

František Kupka

CZECH, 1871–1957

STUDY IN VERTICALS (THE CATHEDRAL). (1912.) Pastel on brown paper, 16 x 8⅞″ (40.6 x 22.5 cm)
The Joan and Lester Avnet Collection

Breaks with tradition, so-called, deserve this name only when looked at retrospectively, from a long distance—and even then, more often than not, they turn out to be not really breaks with tradition at all. For seen from a distance, precipitous breaks, like the precipitate judgments that argue for them, are usually smoothed by the erosion of time until they are little more than little dents or hollows in the art-historical landscape. Conventions, certainly, often get broken, the better to renew traditions. Traditions, however, more usually decay. And when, as occasionally does happen, traditions are broken by a truly innovative artist, it is because they have decayed. And in such cases, innovation is more truly renovation, for then, tradition is simultaneously broken and repaired.

These words are prompted by the abstraction of Kupka's pastel, for the "invention" of abstract art (and Kupka is certainly one of the major candidates for the honor of creating the first abstract picture) is often presented as the most important dividing line between the truly modern and its only transitionally modern and premodern past. Abstraction, unfortunately, is one of those terms—modern is another—that seem to invite such semantic quibbling as to be best not analyzed lest they lose whatever force of meaning they commonly have. Still, if we mean by abstraction a kind of art that defers neither to the appearance of the external world nor to the pictorial conventions developed for its representation, then neither Kupka's art nor that of any of his competitors for its invention—indeed, virtually no modern art that is not decoration made prior to the Second World War (and none reproduced in this book)—is fully abstract. (It has yet, in fact, to be shown that truly abstract art has really taken.) All "abstracts" in one way or another form worldly prototypes, referring the observer back to meanings, however general-ized, that are obviously external to the art itself, and adopt modified versions of the discrete easel-picture conventions of earlier representational art. Of course, all art necessarily defers in some way to the visible world, if only because the ultimate subject of all pictorial art is the visible itself. That is not in dispute. But abstraction, certainly as practiced by its pioneers, like Kupka, should not too quickly be separated from what preceded it. For they found in abstraction a way of recovering what they felt had been lost in the materialist art of realism, namely, the emotive charge of objects that depiction, as such, seemed actually to hide.

In Kupka's case, his abstraction, developed originally from Art Nouveau and Neo-Impressionist sources, does radically break its connection with the world as previously represented; only, however, to recall its earlier representations: in this instance, it specifically recalls the abstraction of Gothic art through an idealizing, Symbolist filter. This pastel is almost certainly based on an interior view of Chartres Cathedral, which Kupka is known to have visited frequently at this time. His interests in color theory attracted him to the subject of stained glass. As simplified into narrow, straining bands of translucent blue, and contrasted with more opaque forms derived from masonry, the Chartres windows transform into a somehow sonorous as well as luminous space that willingly surrenders appearance for the emotional chords it rings pictorially. Abstraction, here, far from being something devisively modern, reimagines in modern form an old and familiar experience, retrieves it from mere familiarity, and renews it.

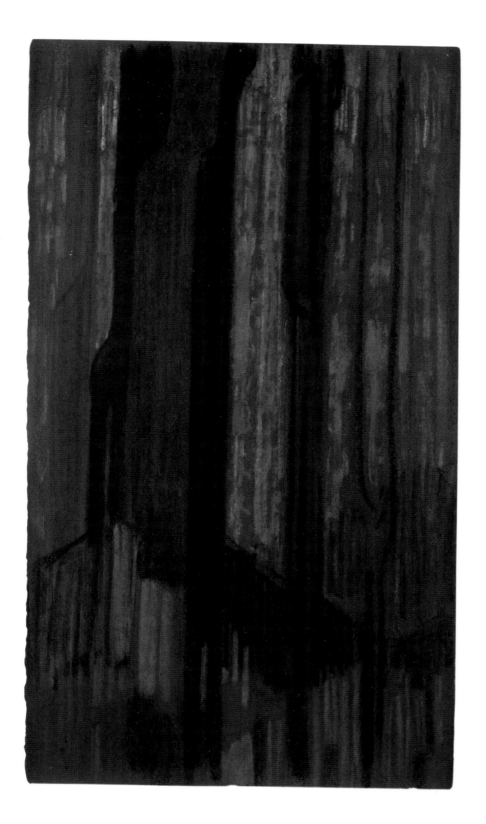

Paul Klee

SWISS-GERMAN, 1879–1940

LAUGHING GOTHIC. 1915. Watercolor over traces of pencil, 10¼ x 5⅜″ (26 x 13.6 cm)
Purchase

Watercolor, by virtue of its transparency, which allows the white sheet to breathe through the applied color, readily provides a sense of internal light and space that joins whatever is represented to a seamless continuum somehow distanced from the tactile world. In watercolor, to a greater extent than in any other pictorial medium, objects more easily connect than separate, and more often seem to surrender their substance to the flattening spread of the surface that lightens and aerates them. Emphasis on the visual in modern art has tended to accentuate these innate characteristics of the watercolor medium. It has also brought watercolor itself into new prominence. Since the revival of the medium in England in the second half of the eighteenth century, watercolor had increasing influence on the techniques of oil painting. Since Cézanne, however, its influence, especially on the great modern colorists, has been extraordinary, and the best color painting of this century has been consistently closer to the modalities of watercolor than painting in any previous century in the West. But no one in this century more than Klee made of watercolor itself a medium of major expression. He found a luminous poetic world, freed from the constraints of ordinary logic, in the limpid, ethereal effects it naturally provides.

Klee was crucially affected by experience of Cubism. *Laughing Gothic* shows him at his most Cubist moment: its composition generally derives from Delaunay's *Saint-Séverin* series of paintings, begun in 1909, and its interlocking zones of glowing color reflect Klee's admiration of the same artist's *Fenêtres* series of 1912. But even at this moment, Klee uses his inherited vocabulary in a way that, while building on Cubism, also denies and escapes it. What he especially denies is the sculptural in Cubism, which he escapes in the absolute priority afforded to color as creative of a purely optical space: a space created not from an armature of lights and darks but from the interaction of different hues, and from disembodied hues, moreover, that expand the picture plane in a way that opposes the compressing effect of Cubist design.

The delicately adjusted dilutions of flat unshaded colors combine to create the illusion of a profound internal space, but one that seems to have been back-projected, as it were, onto the screen of the surface. The flatness of this work is indeed that of a luminous screen rather than of a tactile skin, and for all the Cubist filling and packing that occurs, the surface seems less covered than infused. Watercolor itself uniquely offered the possibility of such an effect, but it was the utter precision of Klee's art, as well as its intensity, that realized it. Exactness manifests itself in how the separate planes are modulated in depth without shading; in how they vary, but not egregiously, in size, shape, and color, to bend and warp the pictorial space while preserving its modular cohesion; in how the color itself is balanced from warms to cools, and aerated without being atmospheric, so that it snaps tight to the surface even as it opens depth. It is through adjustments of this kind that the watercolor achieves its astonishing fullness and opulence without ever seeming claustrophobic, for through such adjustments the lambent, somehow unscathed, quality of the surface is continually insisted on, and preserved.

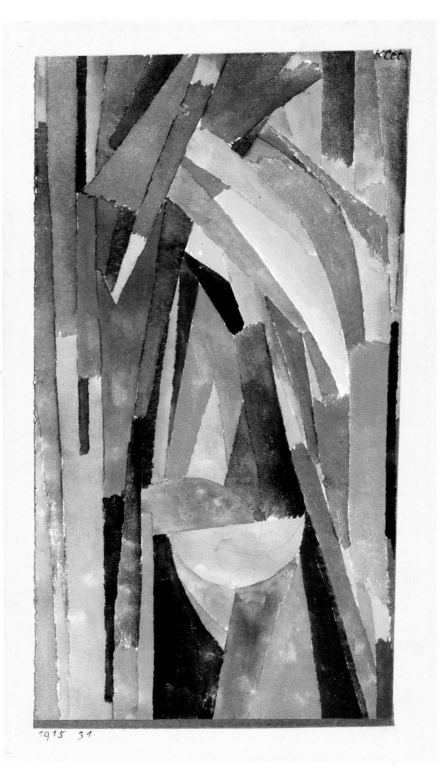

Odilon Redon

FRENCH, 1840–1916

VASE OF FLOWERS. (1914.) Pastel, 28¾ x 21⅛″ (73 x 53.7 cm)
Gift of William S. Paley

"I believe that suggestive art owes much to the stimulus which the material itself exerts on the artist. A truly sensitive artist does not receive the same inspiration from different materials since these impress him differently." This is Redon speaking. If the nature of his imagination, and of his subjects, seems at times to link him to an earlier epoch than the modern, then the explicitness with which he acknowledges that the medium of an art is itself inspirational marks him certainly as an artist of our own time. His words help us to understand the changed character of the colored pastel reproduced on the opposite page when compared with his somber, introspective charcoal drawing of some thirty years earlier (p. 27).

Since the time of his early charcoal drawings, Redon had found inspiration in dreaming before nature and, as he put it, "docilely submitting to the arrival of the 'unconscious'." That was not altered. What the use of color did alter was the forms in which the unconscious arrived. His submission to the arrival of the unconscious meant also submitting to the properties of a specific medium and the way that it itself allowed images to form. Hence, in some of his pastels he would start by scrawling colors on a sheet to help release inspiration and from these random marks begin to create images. We need, in fact, to distinguish two phases of inspiration: the "docilely" passive phase and the active phase into which it elides. For Redon (as for any "truly sensitive artist"), the prefatory glow transformed into gradually dawning sense only as it was refracted through a particular medium, in which refraction its meaning was focused and thereby revealed. And if this metaphor does not quite manage to retrieve the word "medium" from the communications industry, let us recall its biological meaning: a substance within which something is grown; a "culture," no less. The extent to which Redon's images did not entirely preexist their pictorial manifestation but were shaped in the material he used is accentuated by the changes that occurred from charcoal to pastels. He began to use pastels in the early 1890s after working for twenty years primarily in black and white. "Colors contain a joy that relaxes me," he said; "besides, they sway me toward something different and new." In fact, toward a new joyousness. No longer did his dreams produce monsters.

The "unconscious" fantasy of Redon's art had always been based on study of nature, only after which, he once said, was he "overcome by the irresistible urge to create something imaginary." Toward the end of his life, the "real" and the "imaginary" were not thus easily separated. In 1910—at the age of seventy—he inherited a country house outside Paris where his wife began to cultivate flowers and arrange them for him in vases. In his studies of these subjects, the real itself takes on an imaginary character, inhabiting a curious halfway zone between the blinking light of the external world and the musty indoors of Redon's imagination. Here, flowers float in strangely disembodied and exotic harmonies of brilliant, jewellike color so utterly intense as to seem artificial. The powdered pollen of the pastel realizes their fragile delicacy but is also the medium of their separation from the natural world. They glow in the unreal, internal light that it provides, reminding us that however realistic Redon's art became it was but the realism of a painted dream.

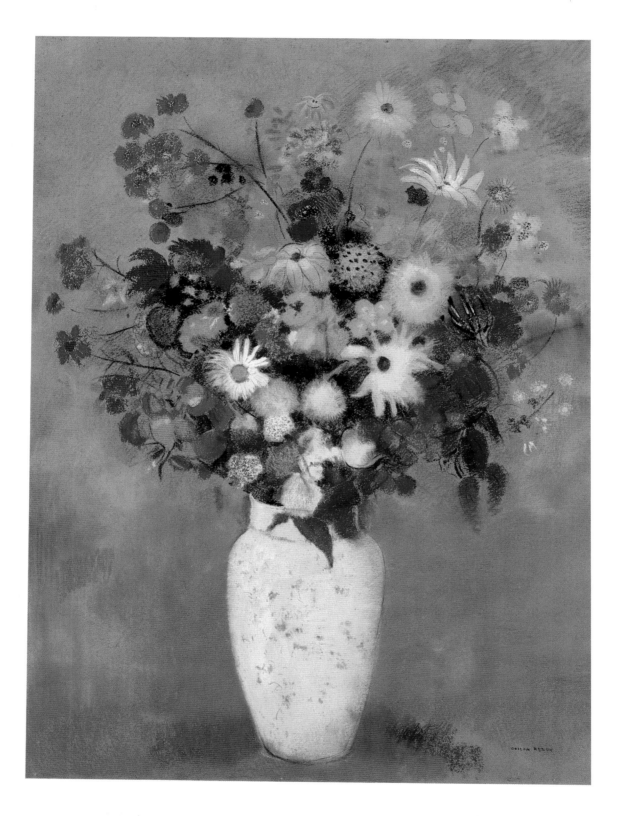

Pablo Picasso

SPANISH, 1881–1973

GUITAR. (1913.) Cut and pasted paper, charcoal, wax crayon, and ink over canvas, 26⅛ x 19½″ (66.4 x 49.6 cm)
Nelson A. Rockefeller Bequest

All of the images reproduced in this book so far are untraditional without being antitraditional. They posit a serious and involved relationship to the past, albeit one that required criticism and radical reimagining of past forms. They acknowledge, however obliquely, a sense of historically transmitted authority, and seek to affirm, however drastic their alteration of inherited tradition, narrative continuity with the earlier art that formed their models of excellence and authenticity. Collage did not immediately bring with it implications of discontinuity between old and new and of the rebuilding of the new from the apparently no longer usable past. And it proved capable of retaining an entirely traditional kind of formal, architectonic gravity, indeed splendor—as is evident from the *papier collé* shown here. Still, more than anything that preceded it in modernism, it marked a new beginning in this century's art.

Collage developed quite logically—or so it seems in retrospect—from the flatness and frontality of immediately preceding Cubism (p. 61) and from the use there of individual "sign" fragments that hold the eye to the surface and provide more realistic reference to the subject than the abstracted and spatially illusionistic forms surrounding them. But flattening the surface with truly "real" elements that dispelled virtually all trace of the illusionistic, and actually constructing works of art from the physical manipulation of these elements, changed modern art in 1912 more radically than did Cubism itself. In the work seen here, the guitar is dismantled and spread out across the sheet as it is reconstructed from the separate, overlapping planes that indicate (from left to right) the dark and light parts of its curvilinear front, its angularized back, and finally its shadow. Above and (illogically) below these elements run vertical planes that stand for the neck of the instrument and its shadow. Still life itself is an artificially constructed subject of art. Here, the constructed still life is not reproduced but made. As the guitar wittily divides into a "feminine" body with a "masculine" shade, it also bonds in an additive accumulation of tangible, material parts; and the drawn lines that surround and overlap it are as concrete as the parts themselves.

It is now a commonplace that art is something that is made, with its own distinct order that emerges from the character and disposition of its materials. This modern conception owes more to the invention of collage than to anything else. It is also a commonplace that art is a harmonious construction of parts; this idea, which collage inherits, is as old as the theoretical discussion of art itself. But not until collage did the pictorial arts (shortly to be followed by sculpture) explicitly realize this. In doing so, collage created a newly additive, juxtapositional mode that replaced the narrative continuity of earlier art—and ultimately, the narratively conceived tradition that accompanied it. In isolating and expressing the principles both of discontinuity and of construction, collage is the quintessentially modern expression of modernism's loss of faith in historically transmitted authority, and its building of its own unique and optimistic tradition: of ideally self-contained and self-sufficient fabricated objects; freely independent objects, more in the world than of it.

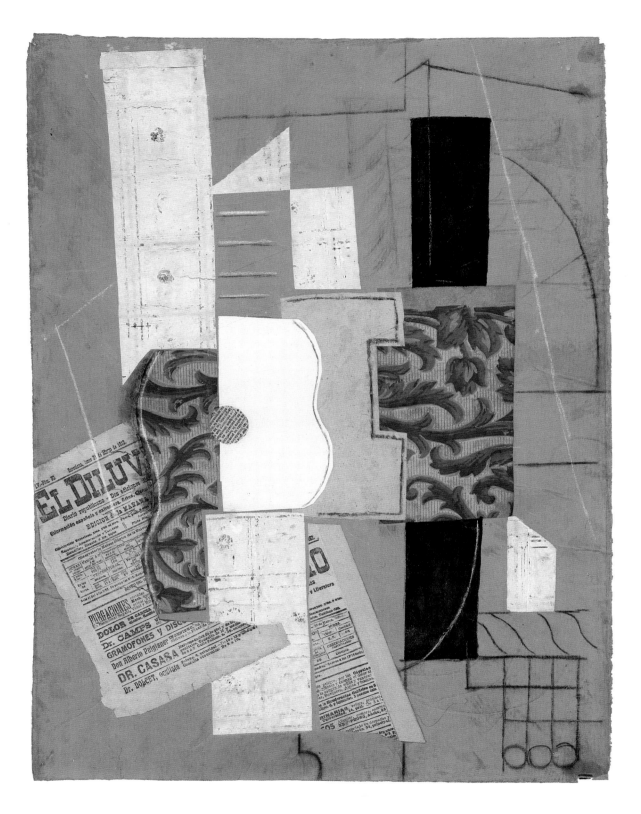

Georges Braque

FRENCH, 1882–1963

CLARINET. (1913.) Cut and pasted paper, charcoal, chalk, and oil on canvas, 37½ x 47⅜″ (95.2 x 120.3 cm)
Nelson A. Rockefeller Bequest

The dividing line between collage and *papier collé* is not easily drawn. But collage, strictly speaking, introduces "foreign" elements into what essentially remain paintings or drawings because these elements are used literally; that is to say, as obviously extraneous forms. *Papier collé* is not only more coherent technically—involving introduction only of paper elements on (usually) a paper support—it also tends to use these elements more for their pictorial qualities: instead of seeming "foreign" to the work of art, they actually create its structure. Braque made the first *papier collé* in September 1912, four months after Picasso's first collage. *Papier collé* is a development of collage and a version of the collage technique. But it is as much a medium of its own as the assemblage sculpture that also emerged from the same source. By the time that this Braque *papier collé* was made, the artist obviously felt that his new medium was sufficiently established as even to challenge painting; hence its exceptional size and rare use of a canvas support for the affixed paper and charcoal-drawn forms.

It is one of the most ambitious and authoritative of Braque's *papiers collés*: calm, sober, yet exhilarating in its openness, and beautifully controlled in its tense balance of surface expansiveness and finely graded space. The four overlapping papers to the right provide a sensation of recession; yet the final black paper seems also to advance: because it is denser than the others and because it appears to be standing on the front of the table drawn below it. Space, therefore, rather than actually receding, is thrown forward of the surface to create the effect of a shallowly projecting relief. But the smaller black paper, abutting rather than passing under the long *faux bois* paper strip, draws back that strip to the surface even as its larger companion seems to pry it away; and it lifts, like a force pressing on a beam, the opposite side of the composition, equalizing weight. And through the center of this balance the drawing of the clarinet dips over and under the pasted forms. It strangely is broken by the very *faux bois* strip that suggests its material; and though drawn over the piece of newspaper seems actually beneath it, overlaid by the clipped-out "L'Echo" that specifies the musical theme of the work.

Drawing is crucial to *papiers collés,* especially Braque's; and not only charcoal drawing. That gives us the identity of objects in its tangible, wirelike lines, and lifts illusionistically the edges of pasted and outlined forms in its muted shading to discover space behind them. But independently of that, drawing is carried in the edges of the cut paper: a kind of contour drawing without drawn lines that is coextensive, therefore, with the surfaces of the cut paper; and hence with the color they carry into Cubist art. Objects and their spaces and colors and their surfaces are specified by two different kinds of drawing. But even more basic than either of these, drawing axially marks the spread of the surface in the thrust of the pasted elements themselves. Whereas the order of Picasso's *papiers collés* tends to be classically gridlike (p. 77), implying a conceptual framework remembered from earlier art, Braque's spokelike organization of overlapping materials seems more completely a product of the physicality of the new medium. It takes its centralization of elements from earlier Cubism, but frees them more from the rectilinear support by harnessing to them a gestural quality traditional to drawing. The physically bonded, interwoven materials seem to have generated an internal structure on, and of, their own.

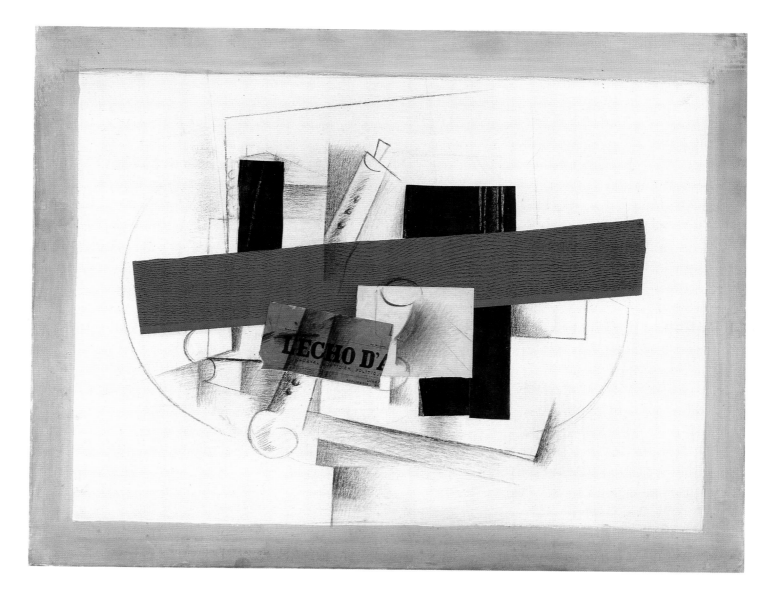

Juan Gris

SPANISH, 1887–1927

BREAKFAST. (1914.) Cut and pasted paper, crayon, and oil over canvas, 31⅞ x 23½" (80.9 x 59.7 cm)
Acquired through the Lillie P. Bliss Bequest

Compositional placement receives new attention in collage and *papier collé*. If art is physically additive in its method, and uses flatly pasted elements, then the adjustment of elements across the flat, rectilinear surface necessarily becomes of primary concern. After the invention of collage, this normative feature of all pictorial art—which collage isolated—played an extraordinarily important role in subsequent modernism. As the illustrations in this book make clear, artists began to conceive of their pictorial components as tangible elements, to be freely arranged, to far greater extent than did those whose styles were formed earlier. The entire pictorial surface became equally available and equally significant to the artist. No longer tied to illusionistic space, art could—potentially at least—arrange its elements at will.

The majestic *papier collé* shown here is less free in its exploitation of the new medium than either the Braque or Picasso reproduced on the preceding pages; for it is clear that the planar materials, rather than generating the structure of the work, fit into a linear design that divides, a priori, the entire surface. Gris's conservatism, however, rebounds into something extremely innovative. Preoccupation with the surface as a whole proved perfectly suited to the spreading flatness of the collage method, and linearity—if the areas it bounded were kept sufficiently large—a useful way of tightening without confining its compositions. In Gris's hands, *papier collé* composes the whole surface, not just the elements within it. Whereas Braque's centralized planes (p. 79) mark the axes of the surface, Gris's far broader ones spread axially to its very edges, and draw in these edges as parts of the composition. Gris's use of the medium, moreover, is far more complex than either Braque's or Picasso's. It combines the pictorial properties of materials (which Braque especially realized) with emphasis on their literal qualities (which Picasso tended to stress) to produce a pictorially representational kind of *papier collé* that was entirely his own.

Whereas Picasso's and Braque's precollage Cubism suggested the presentation of objects from variable and mobile viewpoints, Gris's Cubist method involved examination, from separate and single viewpoints, of the dissected parts of objects; then reconstruction of these objects from their component parts. It was ideal for transposition to collage. Some of the elements we see here have been precisely cut to correspond to the contours of those parts of the breakfast setting they represent: among them, the table legs and the wittily depicted package at the back of the table. Most, however, are abstractly designed. With the superimposed drawing that Gris used to such advantage (to soften the geometry, specify the forms, and to provide, at times, an astonishing illusion of projecting relief), they describe the materials and components of the subject, intersecting as seen from different views. Modeled or flat, implicitly receding or projecting, each element is given its own specific character. Together, they offer an extremely complex experience of conflicting volumes and spaces held in tension by the straining geometry of the composition, and by the flatness that it, and the pasted paper, imposes. On the newspaper fragment in the foreground, Gris's own name holds the eye to the surface, reminding us that the flatness of the work is indeed its final signature.

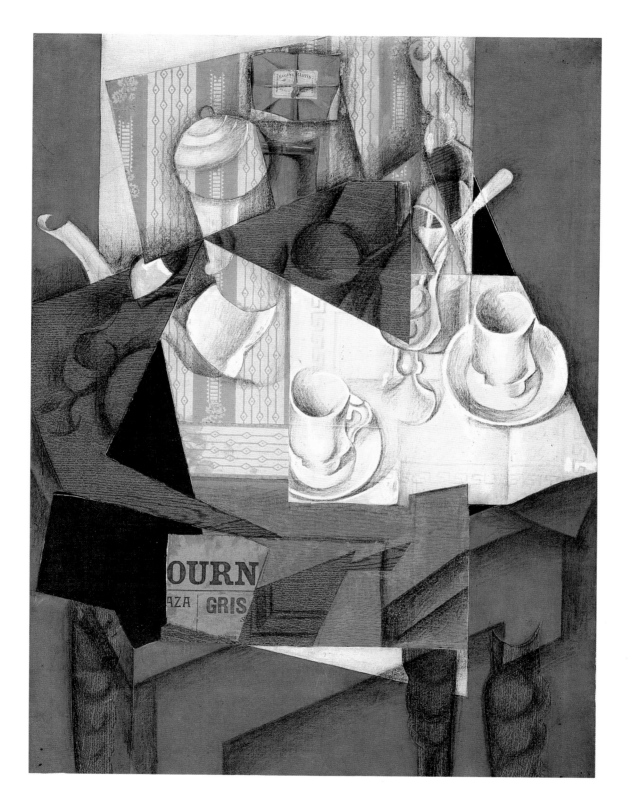

Alexander Archipenko

AMERICAN, 1887–1964

FIGURE IN MOVEMENT. 1913. Cut and pasted paper, crayon, and pencil, 18¾ x 12⅜″ (47.6 x 31.4 cm)
Gift of the Perls Galleries

Two opposing directions are to be seen in the use of *papier collé*: dispersion, until the pasted papers occupy and compose the entire pictorial surface, drawing in its edges as part of the design; and concentration, where the applied elements comprise virtually an independent object within the surface, albeit an open and expansive one, with little or no support from the surrounding edges. Gris's work (p. 81) exemplifies the former approach and Braque's (p. 79) the latter, while Picasso's (p. 77) falls somewhere between them. Although it was not Braque, of the "concentrated" *papier collé,* but Picasso who made sculpture using the collage method, it is obvious that the concentrated direction leans more closely to sculpture and the dispersive direction to painting. Indeed, with the spread of Cubism, it was artists who began as painters— most notably the Dadaist Kurt Schwitters (p. 137)—who found new ways of developing the dispersive *papier collé,* while sculptors tended to use the concentrated form.

In 1912, Archipenko began making what he called "sculpto-paintings," relief-sculptures on rectilinear grounds, in which (in his own words) he "used the principle of collage but attached patterns of flat materials in different diagonal positions in relation to the background and interrelated them with the round elevations of bent sheets of metal." *Papier collé* was the ideal medium for planning these works, for they comprised, in effect, a continuous picture plane onto which were fixed fragmented, bent, and rounded elements cut, as it were, from another picture plane. The planar surface, normative to pictorial art, is the source of the elements which, applied to a planar surface, modify its planarity by virtue of the spatial distortions which have been imposed upon them. The *papier collé* reproduced here provides this effect illusionistically. The collaged elements, shaded to suggest tubular or bent sheets of metal, recapitulate a picture plane that has been dismembered and distorted, then recomposed in the form of a human figure, identified as female by the superimposed drawn breasts. The drawing that surrounds and joins these elements functions like strings holding together a loosely articulated puppet; it helps to specify the identity and wholeness of the image. But it also extends into the surrounding space the directional, thrusting movements and implied volumes of the elements themselves; and occasionally opposes them, further enriching the spatial complexity of the work.

If the representational quality of Archipenko's work makes it seem more traditional in effect than the painters' *papiers collés* reproduced earlier, then his separation of the collaged elements one from the next (the linkage drawing notwithstanding) more completely manifests the open and the structurally syntactical possibilities of the medium. While it is, primarily, the imagist quality of the work that associates the separate collage elements, their spatial disengagement means that the image they produce is wholly relational in its composition. The relationship between elements—that is to say, syntax—is certainly as important as the elements themselves. Indeed, relationships are stressed to such an extent that even the image seems in danger of being subsumed in them. Being readily identifiable, it reasserts its wholeness, but as a compounded, constructed image that abstracts the articulations and movements of the human body to reveal not the appearance of the body but the body as actually lived.

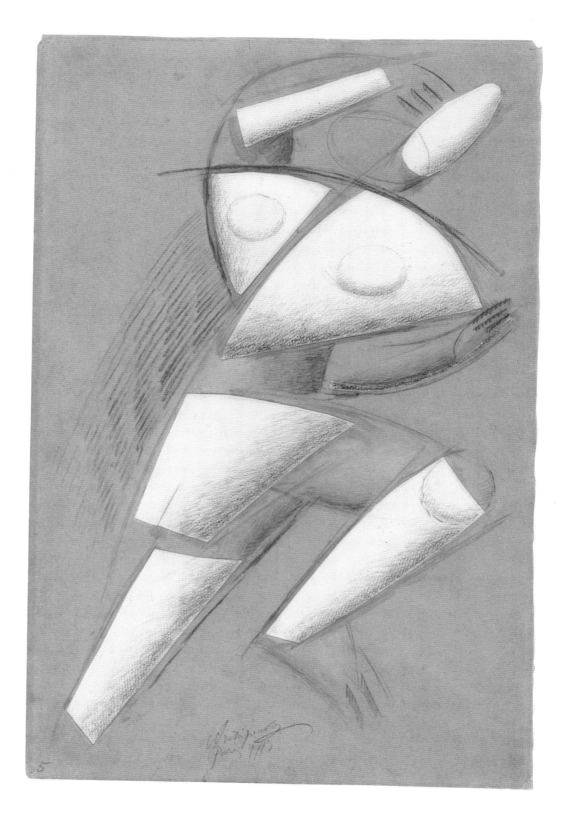

Vladimir Tatlin

RUSSIAN, 1885–1953

STUDY FOR A COUNTER-RELIEF (1914.) Gouache and charcoal, 19⅝ x 13⅝″ (50 x 34.6 cm)
Gift of The Lauder Foundation

Tatlin's term "counter-relief" expresses his opposition to premodern relief sculpture and his inversion of its spatial effect. His work principally opposed these two cardinal norms of the traditional relief: first, that the composition advance fairly evenly forward to establish an imaginary frontal plane, parallel to the surface of the support and touched by several points of the highest relief; and second, that the rear, ground plane present itself as implicitly transparent, the relief elements being so modeled as to provide illusionistically—with the help of their cast shadows—sensory information about the reverse sides of the objects represented, thus seeming to open the rear plane onto an extension of the viewer's space. The desired effect—as summarized in Adolf von Hildebrand's influential 1907 treatise, *The Problem of Form in Sculpture*—was as if the composition existed between two flat sheets of glass.

This drawing—a study for a sculpture of which no record now exists—posits a very different conception of the relief form. Its flat, convex, and linear forms overlie a manifestly opaque plane that functions, in effect, like a sculptural base. The forms themselves are drawn in such a way as to suggest their interlocking and overlapping, and thereby their spatial separation, shadows being used to pry them visually apart as separate, seemingly tangible things. But there is never a sense that Tatlin is trying to provide information about the unseen sides of these forms. Surface alone is manifested to us. Since objects in general can only be known visually from apprehension of their surfaces, what Tatlin is doing is working solely with what can actually be known through sight. The physical object imagined in this drawing is composed of surfaces (even the wirelike lines seem flat); they advance frontally, more or less parallel to the ground plane, carrying memories of its flatness within them even as they bow and bend away. They advance, however, not evenly but like strata, thus creating not one imaginary frontal plane but as many as the number of their stratifications. Of the two parallel transparent sheets that bounded the traditional relief, one is rendered opaque and the other is shattered. The sculpture presented in Tatlin's drawing, rather than opening backward into depth, seems projected forward into the viewer's space.

The year prior to making this drawing, Tatlin had visited Paris, specifically to see Picasso. His conception of relief sculpture derived very directly from Cubist assemblage and collage. (The uptilting plane at the bottom of this drawing recalls that in Picasso's first sheet-metal *Guitar.*) But Tatlin transformed the still-life basis of Cubist assemblage into a fully abstract art, and one that placed special emphasis on (usually industrial) materials as generating their own intrinsic repertory of forms. Hence, the forward plane represented here seems to indicate some thinner, lighter (and possibly transparent) material as compared to the gray (presumably metal) planes behind it, and the coloration of the gray planes seems to suggest, if not different kinds of metal—say, steel, zinc, and aluminum, all of which Tatlin used—then different sections and weights of metal. The very tangible lines that slice between them indicate cables in tension, with which Tatlin supported some of his reliefs. For after first composing them on rectilinear grounds, he found that the plane of the wall itself was more fitting a backdrop for his "real materials in real space" than the delimited picture plane, from which they sought to escape.

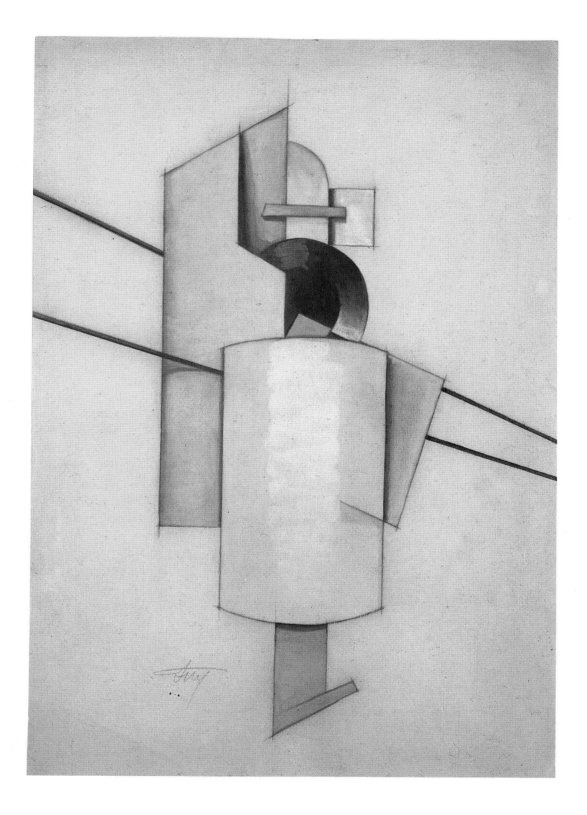

Jacques Lipchitz

AMERICAN, 1891–1973

SEATED NUDE. (1915.) Crayon, charcoal, pencil, watercolor, brush and ink, 19⅝ x 12⅞″ (49.9 x 32.8 cm)
The Joan and Lester Avnet Collection

It is often observed that drawings by sculptors tend to present more tangible realities than drawings by painters usually do; that rather than use the sheet as a two-dimensional pictorial surface, on which to investigate those illusions and ambiguities peculiar to a visual art, they tend to conceive of it as an implicitly spatial field within which to imagine potential configurations of tactile, three-dimensional forms, which are often projects for sculptures themselves.

Imagination of what sculpture will look like is of course one of the most basic, and common, functions of sculptors' drawings, which are indeed usually more factual and literal in conception than painters', even at times to the extent of seeming virtually illustrational. But still, the aforementioned distinction presumes, and derives from, a notion of sculpture as primarily a tactile art. Modern sculpture, however, tends more often to be visual before it is tactile, and often expels tactility along with the monolithic form that traditionally carried it. Sculpture that emerged from Cubism, as Lipchitz's did, is not only conceived visually—to be seen rather than touched—but often is conceived pictorially: composed from surfaces (which derive from the applied surfaces of collage) that combine to offer fixed views, pictures in effect, which the eye reads in two dimensions as well as in three. Drawings for sculptures of this kind necessarily investigate issues as fully pictorial as those addressed by painters.

This Lipchitz drawing is a study for a 1915 wooden sculpture, now destroyed, that was constructed from narrow, flat boards, one of which (indicated here in orange) terminated in a large, half-spherical volume. Like the sculpture, it pictures a Synthetic Cubist image of juxtaposed and jigsawed planes arranged principally at right angles to the viewer: here, parallel to the surface of the sheet, whose continuity they recapitulate and affirm. As in Synthetic Cubist paintings, these planes synthesize parts of the figural subject, and the subject is reconstructed, as it were, from these separately abstracted parts. To judge from the extant photograph of the sculpture, it was not painted, as implied here. The color-coded surfaces of the drawing serve the same function as they do in Synthetic Cubist paintings (and the stippled areas especially recall such paintings): to spatially distinguish the flat planes and suggest their overlapping. But they also emphasize the part-to-part, constructional nature of the image. The sculpture itself was actually demountable, made of separate and separable components, like a prefabricated toy. Its components were neither as paper-thin nor as intricately cut as the drawing suggests. Its wooden material demanded simplification from what we see here. But what we see here composes the sculpture, which is as pictorial as this drawing is.

Only the very schematic shading that surrounds the image marks this as a sculptor's drawing. For its function is purely nominal: to lift illusionistically from the sheet the grouping of flattened planes and thereby define, by isolation, the image as potentially sculptural. It was not needed, we notice, around the upper part of the image, for there the planes themselves unfold an illusion of three-dimensional space. The result, as a drawing, is curious and highly compelling: an image partly on top of and partly parallel to the flat sheet, at which point the sheet surrenders its flatness to that of the image, concavely retreating to accommodate it. Such blatant submission of surface to image tells us that this is indeed a sculptor's work.

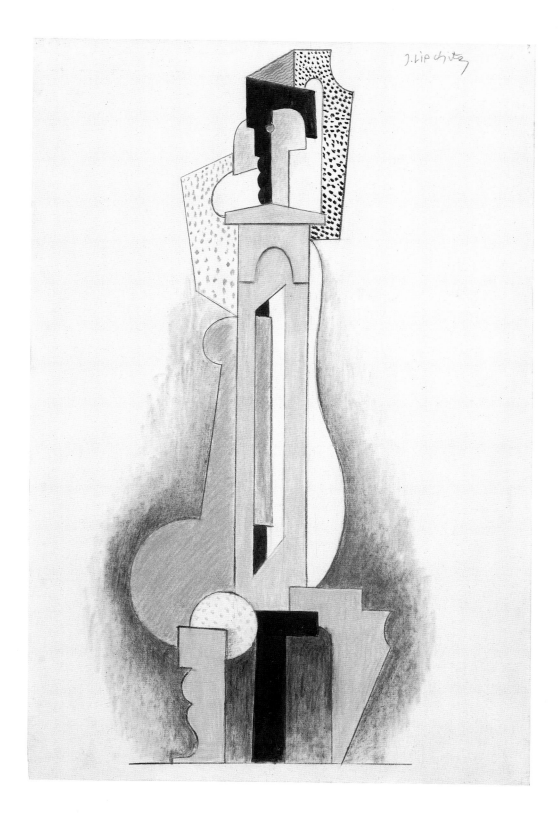

Constantin Brancusi

RUMANIAN, 1876–1957

Study for THE FIRST STEP. (1913.) Crayon, 32⅜ x 15″ (82.1 x 38 cm)
Benjamin Scharps and David Scharps Fund

The First Step was Brancusi's first wooden sculpture. He subsequently destroyed it, retaining only the head. Judging from the extant photograph of the complete work, we might suppose that he did so because it was too derivative of African carving, or possibly because this first attempt to deal with other than unitary form lacked the clarity of articulation that informs this preparatory study. The success of this calmly monumental drawing is importantly due to its balance between being a "given" figural image and one that reads as a self-sufficient, aesthetically independent image, whose organization derives from the objective existence of the forms that comprise it.

After Cubism, especially after the invention of collage, the most advanced modern art increasingly aspires to be a physically self-sufficient art, with its own intrinsic order, issuing from objective consideration of those properties normative to its own particular medium. Such an aspiration is certainly to be noticed in earlier modern art—indeed, in the objectivity of earlier naturalism—but it was not really until collage that, in pictorial art, objective consideration of the work of art's representational function finally gave way to preoccupation with the objective order of the work of art itself. Sculpture and literature were slower in developing this position than painting was, partly because objective naturalism in those fields was applied to intrinsically dramatic subjects, which thereby prolonged, even into early modernism, the subjectivity of Romanticism, while painting tended to be "cooler" in subject choice as well as in style. Sculpture achieved a self-sufficiency equivalent to that of painting by borrowing from painting: most decisively from Cubist collage. But Brancusi was the first sculptor to achieve such an ideal within language intrinsic to sculpture itself, and he did so almost simultaneously with the invention of collage. The shift to aesthetic self-sufficiency in this period is so crucial an episode in the history of modern art that it becomes permissible to talk of an earlier, transitional paleo-modernism (to borrow a term from Frank Kermode) finally being transformed into the modern itself. In these terms, Brancusi is the first independent modern sculptor.

"Truth to materials" is to the aesthetic objectivity of modern art what "truth to nature" was to the objective naturalism from which it derived. This, like the preceding summary, is necessarily a simplification of a large and complex subject, but it serves to explain why Brancusi only exceptionally made drawings for his sculpture; most were made after the finished work. The idea that each material has its own intrinsic qualities, which must be respected and retained in the work of art, carries ethical connotations that associate it with the idealism of independent modernism. Theoretically, it is easily faulted, for no material can be made to do what is intrinsically impossible to it; practically, however, it brought into sculpture, with Brancusi, a new directness and objectivity in handling materials. For Brancusi, the structural properties and the shape, in its raw state, of each material he used tended to produce a particular kind of sculptural object. Invention, therefore, took place in sculpture itself, and drawing took place only from what was before his eyes. This drawing was made, it seems, from a photograph of an infant taking its first step. It anticipates the character of wood—the extension of its grain; its naturally rounded sections; its natural forking—and posits an articulated set of volumes that derive from imagination of what carpentered kind of object it uniquely could create.

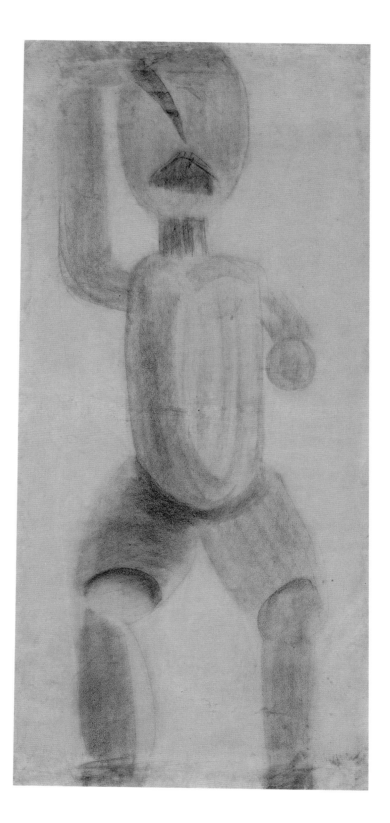

Amedeo Modigliani

ITALIAN, 1884–1920

CARYATID. (1914.) Gouache, brush and ink, 22¾ x 18½″ (57.8 x 47 cm)
Harriet H. Jonas Bequest

His blushing, blank-eyed nudes have made Modigliani a very popular artist; and critically, because of his popularity, an often underestimated one. He occupies, however, an interesting and almost unique place in early modern art in Paris, for he managed a special fusion of the decorative and sculptural tendencies that had separately emerged from Post-Impressionism, thus creating—with the help of "primitive" and archaic art—one of the few authentic alternatives to Matissean image-making on the one hand and Cubist image-decomposition on the other. Arriving in Paris in 1906, he took as his starting point the archaic classicism of Picasso's painting of that year. It was not, however, until 1909 that he found a way of making it his own, and that was achieved through the mediation of Brancusi's sculpture. He had begun by thinking of himself as a sculptor rather than as a painter, and worked under Brancusi from 1909 through 1914.

During these years, Modigliani made possibly as many as seventy-five drawings and gouaches of caryatids—standing or kneeling female figures with raised arms, who in Greek architecture (and in nineteenth-century Greek-revival architecture, which returned them to popularity) served to support an entablature, and in Modigliani's drawings, more often than not, simply support the top edges of these works, pressing them out and up in a way that seems to drain the figures of the effects of gravity. It is generally supposed, but without clear evidence, that they served as preliminary studies for stone sculptures. However, only one such caryatid sculpture has survived. (It is now in The Museum of Modern Art.) The remainder of Modigliani's extant sculptures are heads.

While Modigliani avoided the abstraction of Brancusi, he did absorb aspects of Brancusi's style, especially for direct carving in stone, and discovered in the simplifications it seemed to enforce the system of rhyming ovoid forms that would henceforth characterize much of his work. He also found through Brancusi a way of absorbing the earlier art he admired. The stylization of the head in this drawing looks back through Brancusi heads like the *Sleeping Muse* of 1909–11 to the delicate and linear Baule style of African Ivory Coast sculpture, as well as to pre-Cubist works by Picasso (p. 55). Brancusi, moreover, was a very graphic sculptor, given to clearly defined and taut, crisp forms. His own drawings (p. 89) accentuate graphic directness in the use of firm silhouettes with only generalized infilling. Modigliani adopts this method in his drawings too, but flattens the form more completely to the sheet by eschewing internal articulations in order to emphasize the sequence of heavily marked curves that comprise the contour. Whereas Brancusi gives us a constructional, part-to-part accumulation of forms, in Modigliani it is the contour that is thus constructed. The result, necessarily, is a far more pictorial than sculptural work, for it is space (a serpentine, flowing internal space, which reminds us of Modigliani's allegiance to Mannerist art) and area (which decoratively divides the surface) that hold our attention before form—and form, as it emerges, emerges pictorially, inseparable from the surface it spreads to occupy. Before Brancusi, carving had first been revived by painters, notably Gauguin and Derain. Modigliani's drawings, and later his paintings, return the sculpturally graphic to the pictorially decorative, while retaining a feeling for bulk that tells of his sculptor's training.

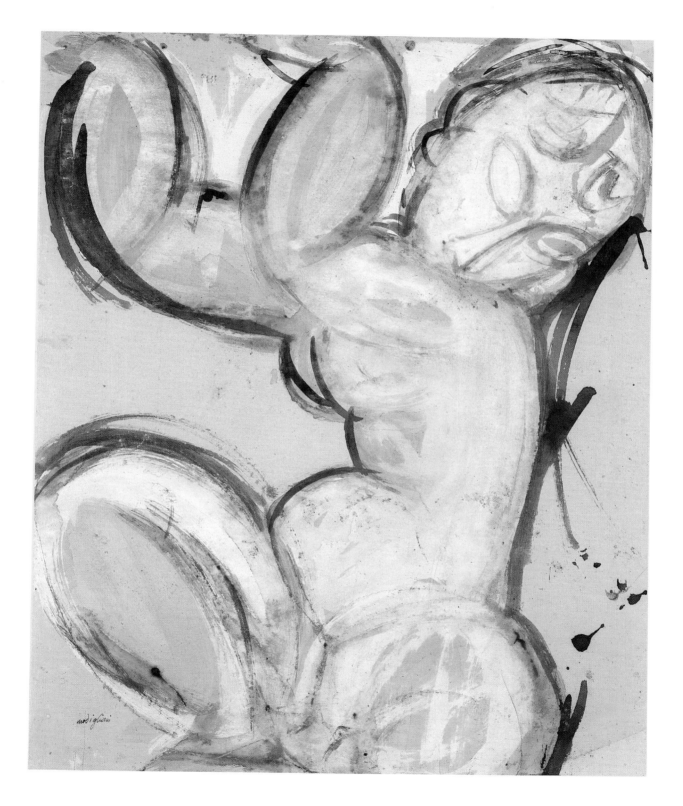

Umberto Boccioni
ITALIAN, 1882–1916

MUSCULAR DYNAMISM. (1913.) Pastel and charcoal, 34 x 23¼″ (86.3 x 59 cm)
Purchase

The French philosopher Maurice Merleau-Ponty once rhetorically asked: Why is it that photographs of figures in movement, though obviously accurate and true to what they show, seem strangely unreal, whereas paintings of movement that show quite impossible postures (like Géricault's paintings of horses) do actually convey what movement is like? He took his answer from Rodin, who said: "It is the artist who is truthful, while the photograph is mendacious; for, in reality, time never stops cold." And Merleau-Ponty added: "The photograph keeps open the instants which the onrush of time closes up forthwith; it destroys the overtaking, the overlapping, the 'metamorphosis' (Rodin) of time…Painting searches not for the outside of movement but for its secret ciphers, of which there are some still more subtle than those of which Rodin spoke. All flesh, and even that of the world, radiates beyond itself."

Boccioni's drawing is related to his famous 1913 sculpture, *Unique Forms of Continuity in Space,* and presents a running figure, his back twisted around to the viewer as he speeds from right to left across the sheet. Flesh, and muscle, indeed seems to radiate beyond the nominal limits of the body—almost to peel from the body—as the artist reveals a continuum of action, a unity of movement to which is surrendered the unity of the body itself. Using terminology derived from Henri Bergson (a philosopher widely important for early twentieth-century artists), Boccioni wrote of wanting to capture both the "absolute" and the "relative" movement of his subject. By this he meant both its constant, internal dynamism and its constantly changing relationship to its environment. Crucial to both, he claimed, and their common denominator, was the interpenetration of form. The "unique forms of continuity in space" were forms that melt and blend with one another. Creation of such forms was basic to Boccioni's Futurism, for they seemed to express not only the vitality of motion, but also the dynamism of modern life.

Boccioni's indebtedness to Bergson reveals, in turn, a more basic debt: to that Symbolist preoccupation with a vital, organic order underlying the surface appearances of things. Like other artists whose subject was the fluxionary modern experience—like Delaunay, for example—Boccioni updates Symbolism through Cubism, transposing its dynamism from nature to the machine: in this case, by discovery in nature—in the human body—of a dynamism analogous to that of the modern machine. Like Delaunay (p. 59), he takes from Cubism the simultaneous interpenetration of volumes (by means of discontinuous contours and separately shaded planes) that fractures objects, melding them with their surroundings. But whereas Delaunay gives us, specifically, a splintered modern city—frozen, it seems, eternally in flux—Boccioni metaphorically provides a streamlined image of mechanized power in human form. From the smudging softness of the charcoal and pastel medium he creates a swirling atmospheric slipstream of exhilarating movement; but within it, an unstoppable, weighty, armor-plated mass of loosely connected volumes. The tense linear rhythms that define these volumes disengage from them, however, abstracting from the body its "secret ciphers" not only of movement but also of brute force.

Gino Severini

ITALIAN, 1883–1966

ARMORED TRAIN IN ACTION. 1915. Charcoal, 22½ x 18¾″ (56.9 x 47.5 cm)
Benjamin Scharps and David Scharps Fund

In 1914, Futurist glorification of modern technological force found its ultimate subject: the so-called Great War. When Italy joined the conflict in 1915, most of the Futurists volunteered for active service, having spent the previous year campaigning for their country's intervention, during which time the tendency to abstraction within their work was checked by specific reference to contemporary events. Severini's poor health prevented his participation in the war. But the bombardments of Paris, where he was living, were constant reminders of it. He was "obsessed" by the war, he wrote later to the Museum; collected photographs of it; and from such photographs produced this work. It is a study for one of the most famous of Futurist war paintings (and a promised gift to the Museum), *The Armored Train* of 1915.

The First World War, more than any previous war, was a war in nature, destroyer of nature, and therefore (writes Paul Fussell) the ultimate antipastoral. Cubist stylization, which asserted the geometrically man-made in opposition to the organic, was the Futurists' way of describing it. The organic, in this drawing, is divided and hurled back by the force of the mechanical as it speeds destructively through the landscape. Before Cubism, the pastoral had dominated idealist modern art, culminating in the Arcadian imagery of decorative Fauvism (p. 41), which posited a nostalgic, backward-looking utopia of pure instinct. What replaces it, in Futurism, is also utopian: as utopian as the war meant to end all wars the Futurists celebrated. And also instinctive. For Futurism, in effect, replaced the Arcadian, backward-looking utopia of early modernism with a millennialist, forward-looking one, but retained in this new form the vitality and the irrationality of the old. The harmony of the old is expelled—only, however, to exaggerate the instinctive. Here, it is identified with martial force.

Even in 1909, the Foundation Manifesto of Futurism had proclaimed, "We wish to glorify War—the only health giver of the world…" Futurism was born on a battlefield of iconoclasm, where the past was the enemy and passivity was the ally of the past. If the confusion this produced between the passive and the pacific now seems politically naive, we must nevertheless remember that hygienic purging of the old order was, for the Futurists, as urgent an imperative, in culturally backward Italy, as was codification of an already established modern order for their colleagues in France. It produced not only the first truly schismatic modern movement, but also the first modern movement willfully to oppose the developing purity of French modernism, while building stylistically upon it, in order to idealize (not merely report on) what seemed most disturbingly new. In this drawing, however, reportage has not yet quite given way to idealization. Softer in form (because of its charcoal medium), less clearly defined than the final painting, it seems to counter its enthusiasm for machine warfare with the kind of grim and grainy reality characteristic of many First World War photographs. Its impersonalization is more poignant than heroic, its formalization ambiguous, not yet polished into machine beauty, but still tarnished by the imperfections of the real.

Arthur G. Dove

AMERICAN, 1880–1946

NATURE SYMBOLIZED. (c. 1911–12.) Charcoal, 21¼ x 17⅞″ (54 x 45.4 cm)
Gift of The Edward John Noble Foundation

Dove's drawing, very modern for its date, has also a look to it of the decorative *moderne*. The work is composed of overlapping planes that stand like theater flats against the blocked-off backdrop, its shallow convexities seemingly upholstered into the image of a rising sun. Stylistically, it joins the emphatic contouring and flat patterning of Gauguin or Matisse to the geometric simplifications of early Cubism, and adds to that a hint of Futurism in the abrupt energy of its line. Fusion of these disparate sources produces a highly charged vocabulary of modern elemental forms. The space they inhabit, however, though certainly shallow (even by modern standards), is almost premodern. It is the squeezed-in space of the theater. Nature is "symbolized" not only by being abstracted; also by being dramatized, thus to convey its latent dynamism and inner, organic life.

Prior to its acquisition by the Museum, this drawing had twice been exhibited, in recent years, in an upside-down position as compared to its reproduction here, and with dates significantly later than now proposed. Its revised presentation was suggested by its similarity to a 1911–12 pastel known as *Nature Symbolized No. 1,* which shows a composition of roofs and factory chimneys interspaced with more organic forms. This too would seem to address, though more abstractly, that familiar—and particularly American—modern theme that Leo Marx has aptly defined: the machine in the garden.

Only rarely in Dove's work do we find even a hint of the industrial. Except in a few works of the period of this drawing, his is an affirmatively pastoral iconography that rejoices in its freedom from man's works. But when he did bring country and city together, it was not (surprising though it may seem) in the usual American oxymoron. Contrast, certainly, but then analogy is the informing structure of this drawing. Man's works, when treated, are celebrated as parts of nature itself. The industrial is rooted in, and rises triumphantly from, the natural in a confident phallic image of regenerative growth. Contrast is assured by the two forms of line drawing that Dove himself defined as operative in his work: "character lines," which mark the dark perimeters of objects, showing their meeting and intersection with their neighbors, and "force lines," which express their vital inner structure. Both are apparent here, the foreground cluster of abstracted roofs, chimney, and (possibly) trees being delineated by the former, and the generalized scalloped backdrop being divided by the latter to create a sense of radiant energy metaphoric of organic growth or of the spreading light of the sun that generates it. But what drawing thus separates, spatial compression joins. The backdrop pushes palpably forward, forcing analogous reading of its raylike divisions and the triangular roofs beneath them. And the light that seeps out behind the architectural masses—a beautifully transitional dark light of dawning day—infiltrates the whole composition with an almost pantheistic resonance: it glows with immanence through the velvety softness of its tones.

Lyonel Feininger

AMERICAN, 1871–1956

The Village of Legefeld, I. 1916. Pen and ink, charcoal, 9½ x 12½" (24 x 31.6 cm)
The Joan and Lester Avnet Collection

Cubism had a profound influence on modern German art (and Feininger must be considered a German artist, for his style was formed in that country and most of his work was done there). Its influence, however, was more often channeled (and thus distorted) than exactly followed; and it was the "harder," dynamic and iconographically modern, technological version of Cubism, such as Delaunay's and the Futurists', rather than Picasso's or Braque's, that especially found favor among German artists. What this produced at times was a merely cubified art: what Gertrude Stein once scathingly called "the painting of houses out of plumb." In the strictest sense, no German art is truly Cubist. The importance of Cubism to Germany is that it served to focus and cohere the Expressionist movement in the visual arts—and to draw it closer to literary Expressionism—in a way that Fauvism, the principal preceding foreign influence, had never quite managed to do. Stylistically, the "harder" side of Cubism offered a way of renewing the nervous, brittle linearity of the Gothic tradition. Iconographically, its urban subjects fitted well with the metropolitan literary interests of Expressionism. Cubism was able to forge a link between the tense and vital modern city and the spirituality of the Gothic past. Between 1910 and 1912 (the period when Feininger's mature style emerged), Cubism consolidated Expressionism in its typically angular, distorted, and dynamic pictorial form.

Feininger's drawing of Legefeld is one of a series of studies he made in small towns and villages around Weimar, the intellectual center of old Germany. In these works the forms of modern and medieval architecture are dematerialized into transparent, intersecting planes that interpenetrate with their surroundings to create a splintery, crystalline space. Technically, the drawing refers to the methods of engraving; like much Expressionist art, it adopts from printmaking its resistant, naturally angular line. It does so with obvious reference to Delaunay (p. 59), from whom Feininger developed the presentation of buildings from multiple viewpoints and with illogically shifting sources of illumination. What separates this drawing, however, even from the most aggressively urban Cubist art is its moody emotionality, its almost claustrophobic density, and the prism- or glass-like accumulation of facets that covers the surface (and the light trapped seemingly behind it) like a brittle and buckling shell. Like many Expressionist artists and writers, Feininger seems to stand back, outside the urban scene he is portraying, in order to view it as a metaphor of active forces contained within the rigid surface. Many such portrayals—including earlier ones by Feininger—seek especially to evoke a sense of contrast between the frozen hardness of the surface and the internal energy that threatens to break out. In this phase of Feininger's work, however, surface and internal energy seem frozen together in permanent stasis, "Whereas before," he wrote to Kubin in 1915, "I aimed at movement and unrest, I have now felt the eternal calm of objects and even the air surrounding them, and have attempted to express that." The change in his art coincided with the First World War, and implied a quest for some luminous image that would provide a point of order among chaos. The glass imagery—typical of the period—reinforces this implication. It carries cathedrallike connotations, as do the aspirative angular forms, through which burns the, therefore, implicitly spiritual light that infuses the whole scene.

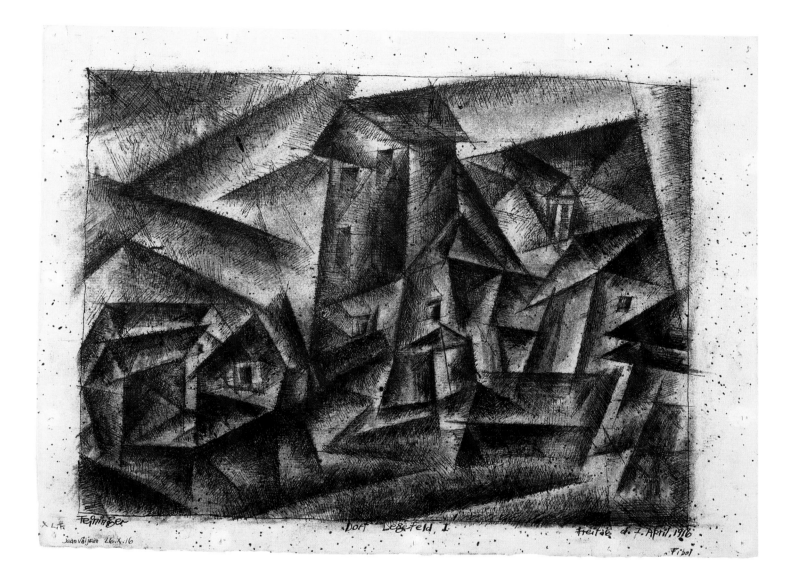

X L.F. Feininger Dorf Legefeld I. Freitag d. 1. April. 1916

Jean Valjean 26.X.16 Fibel

Lawrence Atkinson

BRITISH, 1873–1931

COMPOSITION. (c. 1914.) Pencil and pastel, 31¾ x 21¾" (80.3 x 55.1 cm)
The Joan and Lester Avnet Collection

Lawrence Atkinson officially joined the English Vorticist group in 1914, a year after it had emerged under Percy Wyndham Lewis's leadership. Within another year, the group was dispersed by the First World War: like Futurism, an ironic casualty of the mechanical action its artists celebrated. Futurism and Vorticism are often associated, and indeed shared many of the same aspirations. But the Vorticists were antagonistic to Futurism, finding its rebellion too heatedly romantic. They posited instead a hard, clear, and "classic" geometric art, tending often to total abstraction. Their art was concerned, like Futurism, with the modern mechanical whirlpool of noise and violence, but it was detached from it: by virtue of occupying the still and silent "vortex" at its center.

Atkinson's drawing is nominally abstract, but might best be described as an almost realistic rendering of abstract forms. For while the forms themselves appear abstract, the space they inhabit, though shallow and illogical, continues to allude to the space of the external world. The coherence of the drawing, moreover, owes as much to this allusion as it does to its abstract compositional geometry. Indeed, the two go together in presenting some steely hillside city of the future that spatially belongs in the world but formally is detached from it. "The Vorticist," wrote Wyndham Lewis, "is at his maximum point of energy when stillest." This drawing is virtually a diagram of what he had in mind: something that tells of the vital modern city, but coolly and impersonally, "a sort of death and silence in the middle of life." After which phrase, we cannot but be reminded that the "vortex" idea of Vorticism was suggested to Lewis by Ezra Pound, and ultimately derives from the "gyre" of the Symbolist W. B. Yeats. Though avowedly hostile to Romanticism, the Vorticists are its heirs. Theirs is a modernized Symbolist art, which discovers in the machine the same still and impersonal, but vital, beauty that had obsessed the Symbolists themselves.

That sense of distance from the violence of the city it observes links Vorticism more closely to urban Expressionism than to Futurism. There is, finally, more that links Atkinson's work with Feininger's (p. 99) than to speeding Futurist images like Severini's (p. 95). What separates Vorticism, however, from both Futurism and Expressionism (indeed from any previous attempt to picture the modern city) is its Symbolist-derived impersonality—which led it to appropriate mechanical and architectural drawing techniques as ready-made methods of describing the precision and exactness of the machine. T. E. Hulme, the critic associated with Vorticism, advocated a new art founded "not so much in simple geometric forms found in archaic art, but in the more complicated ones associated in our minds with the idea of machinery." To render such complicated forms, Atkinson uses a coldly mechanical style of drawing: of carefully graded modeling, smoothly regular shading, and crisp, evenly hard lines, snapped flat to the surface. His restrained color is exceptional in Vorticism, and was apparently intended to expel any connotation of sensuousness. It certainly seems to allude to the colors of building materials, thus to reinforce interpretation of this image as a mass of architecture looming against a sullen sky.

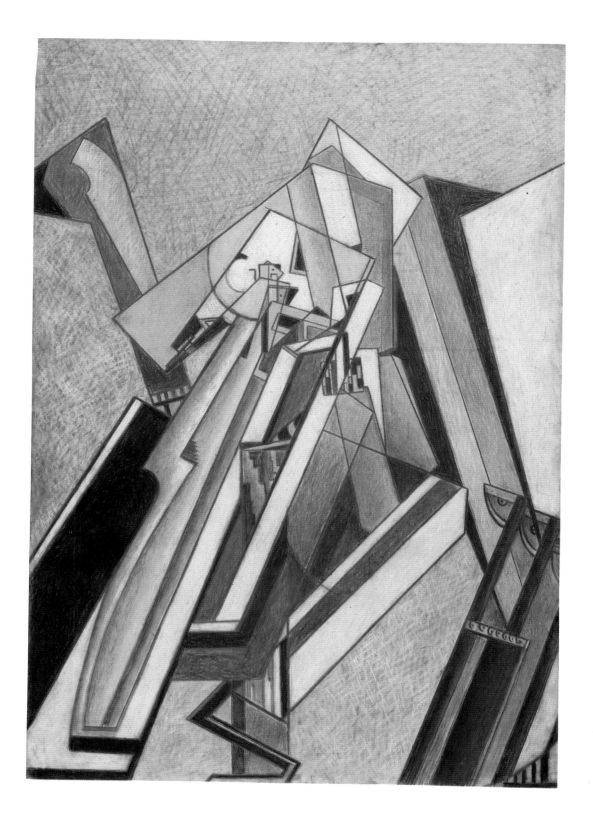

Piet Mondrian

DUTCH, 1872–1944

PIER AND OCEAN (SEA IN STARLIGHT). 1914. Charcoal and white watercolor, 34⅝ x 44″ (87.9 x 111.2 cm)
Mrs. Simon Guggenheim Fund

The year 1914 was one of crucial transition in Mondrian's work. The so-called Pier and Ocean series, begun in Paris in 1913 and concluded in the Netherlands in 1915, was the medium of this transition. During this stage, Mondrian emerged from Cubist influence to become a truly major and individual modern artist. Drawing was centrally important to him at this period. In the years 1913–16, the ratio of drawings to paintings is higher than in any other period before a similar florescence around 1940 initiated his late style. In the case of the Pier and Ocean series, more than an entire year's graphic work yielded only a single painting (*Composition 10*, 1915, in the Kröller-Müller Museum, Otterlo). Since Mondrian empirically adjusted the components of his paintings as he worked, preparatory drawings were rarely needed. Each painting was an individual step in the evolution of his art. In periods of transition, however, drawings seemed essential: not only small preparatory sketches such as began the Pier and Ocean series, but bold and ambitious works like this, which brought it to a climax. These took on the functions of paintings even as they established the basic vocabulary of his mature art.

Having worked through Cubism, as it were, since 1912, Mondrian had arrived by 1914 at a highly individual version of that style. Its two-part structure of geometric line drawing and generalized shading had been polarized to produce an art in which drawing was simplified into a (usually black) vertical-horizontal grid and shading was flattened to the surface to form areas of color (usually gray-ocher or blue), which evenly filled each pocket of the grid. In the Pier and Ocean series, color is eschewed and the Cubist grid is opened to form a cluster of "plus-and-minus" signs contained within a Cubist oval. Drawing alone—an abbreviated sign system—carries the entire informational burden of the work of art even as it forms its very structure.

From 1913 onward (when drawing became central to Mondrian and this series was begun), his art seems to be entirely nonfigurative. Until 1917, however (when this series was over and drawing diminished in importance for him), it was abstracted from specific sources in nature; and the drawing it contains—though symbolic rather than descriptive—alludes to these sources. (In this case, Mondrian recalls one of the fencelike groin piers—abstracted, bottom center—protruding into the ocean near the village of Domberg on the Zeeland island of Walcheren.) Its reduction to the vertical and horizontal generalizes its reference, however, so that it alludes also to what Mondrian saw as a cosmic dualism between the masculine and spiritual (vertical) and the feminine and material (horizontal), and to the resolution of this dualism within the work of art. Two symbolic systems thereby coexist. The Pier and Ocean series was the last that Mondrian made in which signs have this dual function. Henceforward, he abandoned subject distinctions (and thereby localized reference) in favor of purely nonobjective compositions. "Observing sea, sky, and stars," he wrote of this series, "I sought to indicate their plastic function through a multiplicity of crossing verticals and horizontals. I was impressed by the greatness of nature, and I tried to express expansion, repose, unity." Concentrating solely on drawing allowed him to find in nature a system of cruciform signs that tell, almost Impressionistically, of flickering light and movement on water, but also of a spiritual structure within nature itself.

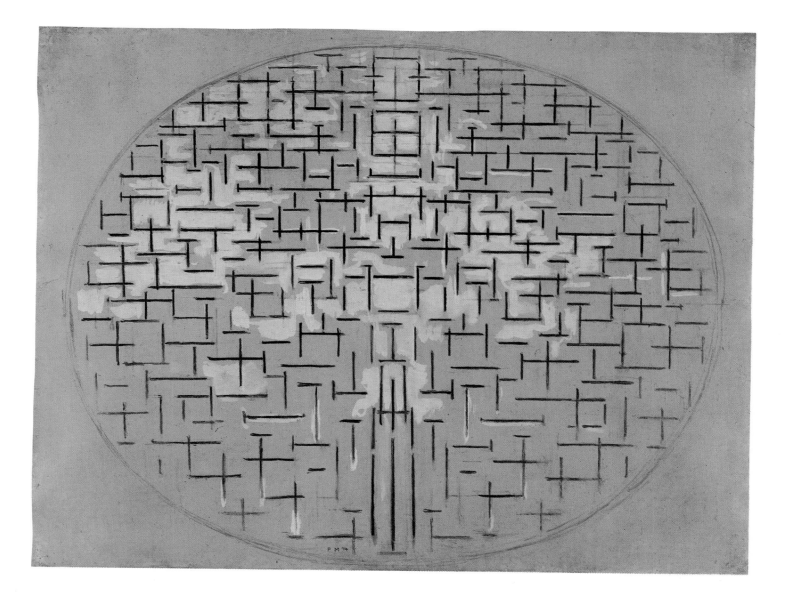

Theo van Doesburg

DUTCH, 1883–1931

COMPOSITION (THE COW). 1916. Tempera, oil, charcoal, 15⅝ x 22¼" (39.7 x 57.7 cm)
Purchase

In 1925, van Doesburg's book, *Grundbegriffe der neuen gestaltenden Kunst* (The Principles of Neo-Plastic Art), was published in Munich under the Bauhaus imprint. It explained and justified his preoccupation with a purely abstract art—but one, like Mondrian's (p. 103), connotative of the structure of nature—that had led him to found (with Mondrian and others) the Dutch de Stijl group in 1917, the year his book was originally composed. Accompanying its second chapter was a page of four illustrations, collectively titled "An Object Aesthetically Transfigured." The four illustrations were respectively labeled: "Photograph," "Form preserved but relationships accentuated," "Form abolished," and "Image." The photograph was of a cow; the following illustration was of the tempera we see here; then came a further abstracted study, unrecognizable as based on a cow; and finally (and even more refined), the painting of this subject, which is also in the Museum's collection (as is a sequence of eight related pencil drawings).

The second chapter of van Doesburg's book, on "The Aesthetic Experience," dealt among other things with the familiar modern idea (deriving ultimately from Lessing) that "the most powerful expressional form of any art is achieved by using only the means proper to each." There is no such thing as inchoate experience, he says in effect; rather, experience of any object is determined by personal and professional biases, so that the "cow" seen by the farmer will be a different "cow" from that seen by the veterinarian, the butcher, or the artist. Within the arts, moreover, experience of an object will be affected by the particular medium the artist uses. And the artist should respect the qualities of his medium, for "if the bounds of the expressional means proper to an art are overstepped the form of the art will be impure and not genuine." However, "if the formulation of the aesthetic experience of reality is kept within the bounds of the expressional means proper to each art, each branch of art is pure and genuine in itself."

Like the idea of "truth to materials" (see p. 88), to which it is related, this belief that each of the arts is at its most successful when manifesting its own irreducible norms and excluding those that belong also to other arts, is a central tenet of that aspect of modernism most concerned with aesthetic self-sufficiency. Often, as here, associated with abstraction and carrying idealist connotations, it usually posits the development of modern art as one of gradual purification during which things extrinsic to each art are discarded, leaving only the essential. Van Doesburg's explanation of his Cow series presents it as a recapitulation in local terms of this historical development—which leads, irrevocably it seems, to the creation of de Stijl. "The pure expressional means of painting," he writes, "are color (positive) and noncolor (negative). The painter expresses his aesthetic experience through relationships between colored and uncolored planes." And his aim is "the balancing of positive and negative to achieve exact harmonious unity." What in fact is being proposed is an art that discovers in its own purification not only the basics of art but also the same cosmic duality that concerned Mondrian. Here, art is purified not in order to separate it unto itself, but to allow it to tell more exactly of the harmonious unity of dualities in the natural world. The material, natural world was an external manifestation of the spiritual and transcendental world, and therefore was full of symbols— symbols of ideal forms—that had to be deciphered, even in cows, and aesthetically revealed.

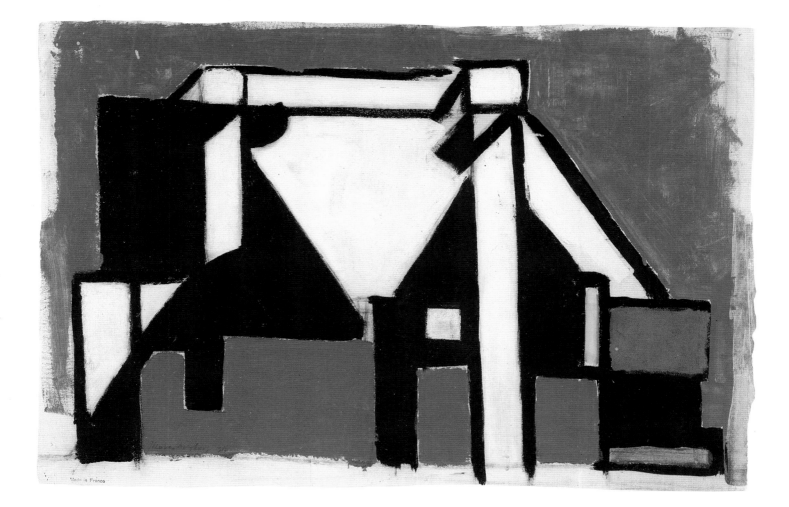

Kasimir Malevich

RUSSIAN, 1878–1935

SUPREMATIST ELEMENTS: SQUARES. (1915.)
Pencil, 19¾ x 14¼″ (50.2 x 35.8 cm)

There is a notion of the modern in art as something cold and calculated—even vaguely scientific—a matter more of theory than of inspiration. It usually is derived from noticing the growth in importance, in the art of this century, of highly reductive, geometric compositions, works like the Malevich reproduced on the opposite page. It is indeed true that the modern tends more often to be "cold" than "hot"—at least, it tends that way at its most successful—for that was how it reacted against late Romanticism, by placing new emphasis on sobriety and control. (And we see this even in the most fiery temperamental of great modern art.) It is also true that some geometric art is indeed very highly calculated (the van Doesburg reproduced on p. 105 is a case in point), and that some of its practitioners have made use of mathematical formulas to plot their compositions. And modern art has certainly had more than its share of theorizing. (Malevich's is often confusing and contradictory, as well as obscure.) But neither coldness nor calculation precludes feeling; and theories, finally, are irrelevant when faced with the work itself. In fact, experience of Malevich's work makes clear what his writings confirm: that he initiated reductive art from an obsession not with geometric calculation but with feeling, indeed with spirituality. These two densely hatched squares, drenched with internal energy, as if some larger fields of force had been condensed and concentrated within their boundaries, are far from expressing anything chillingly cerebral; they seem obviously designed to intensify and to focus feeling, not to escape from it—unless its realization in artistic form can be considered an escape.

Malevich described the black quadrilateral, which he established as the first and basic component of his Suprematist method sometime between 1913 and 1915, as "the naked icon of my time…a royal infant." Traditional pictorial art was seen to have ended in the decomposition of material objects achieved by the Cubists. Suprematism—which meant "the supremacy of pure feeling"—was not an "abstract" art that simplified the observed appearance of worldly things, but a "nonobjective" one that escaped from individual objects in order to manifest a more generalized order of natural forces that were husbanded within its elemental forms. Therefore Malevich's famous definition of a black square on white: "The square equals feeling, the white background equals nothingness." The white, that is to say, is conceived as a field from which energy has been drained in order to saturate the force-filled square. To this basic explanation of his procedures Malevich added numerous and metaphysical justifications for them. They are not essential to the pleasure communicated by his dense modern icons. Indeed, his art reminds us constantly of two normative characteristics of all art, but to which modernism as a whole draws special attention: first, the extent to which art can do without explicit meaning without losing anything artistically essential; and second, that intensity, not multiplicity, of meaning is what finally counts.

Jean (Hans) Arp

FRENCH, 1887–1966

COLLAGE ARRANGED ACCORDING TO THE LAWS OF CHANCE. (1916–17.) Torn and pasted paper,
19⅛ x 13⅝″ (48.5 x 34.6 cm). Purchase

Dada is principally known as an antiart movement. Arp's serenely beautiful collage is neverthe-less a characteristic Dada work, made in Zurich, the first Dada center, in 1916–17. For while Dadaist propaganda did indeed talk of the end of art, such talk only came to dominate Dada when it reached Berlin (see p. 128), and even then it meant, by implication, the end of art as previously known. Dada artists, at least, understood that while the refusal of old structures could indeed seem, to propagandists, a daringly iconoclastic idea, to artists it was a familiar one, always a necessary part of the search for new structures. Dada as a whole rejected old structures more loudly and vehemently than had any previous modern movement. Such rejection characterized many of the movements that appeared around the same time—among them, Futurism, Suprematism, and de Stijl. This marks a distinct change in the history of modern art, for not only had earlier modernism been more respectful of the past, but it too was now often rejected along with the past itself. But even in this divisive climate, Dada stands out. Past art, including past modern art, belonged to a corrupt, materialist society which had produced the First World War: all that had to be destroyed in order to make a fresh start. Hence the importance of collage to Dada, for as noted elsewhere (p. 76), the very technique of collage implied destruction of the narrative continuity of earlier art and construction of the new from the fragments that remained.

But Cubist collage itself was useless to the Dadaists. Its secure rectilinear order told of a structured, man-made world they knew had been destroyed. Arp's Dada collages replace that order with arrangements made "according to the laws of chance"—a generic title for many of these works. His collages with this title immediately followed some severely geometric collages (which he had made in collaboration with Sophie Taeuber), where a paper-cutting machine was used to eliminate the accidental and thus find, in the purest of abstraction (never, of course, reached in Cubism), a contemplative order that escaped contemporary suggestion for some-thing timeless and elementary. "I further developed the collages," he wrote, "by arranging the pieces automatically, without will." To do so was not to admit accidentality into his works but further to assert their essential order, for chance—not merely accident—was viewed by Arp as a means of access, through the unconscious, to the basic ordering processes of the natural world. Hence, he declared that "these works, like nature, were ordered 'according to the law of chance.'" It is clear, however, even from this probably most loosely composed of these works, that conscious arrangement did play a crucially important role. As with Arp's contemporaneous drawings (p. 113), "chance" was a liberating idea, a method of beginning a work of art that evaded traditional composition, but not an avoidance of composition itself.

This particular collage is unusual in using torn paper, a method that Arp fully developed only in the 1930s. Hans Richter, Arp's colleague, claims that the "law of chance" was discovered when Arp tore up a failed drawing and was struck by the pattern it made on the floor. This very carefully torn collage does have a sense of natural, inevitable order, as if it came into being instantaneously, happening of itself.

Georgia O'Keeffe

AMERICAN, born 1887

EVENING STAR, III. (1917.) Watercolor, 9 x 11⅞″ (22.7 x 30.2 cm)
Mr. and Mrs. Donald Straus Fund

The extent to which pioneering twentieth-century art, regardless of stylistic affiliation, draws on, and develops, Symbolist idioms is far greater than often is acknowledged. We know, of course, how influential Symbolism was at the very beginning of the century, before Cubism; but later even, preoccupation with the creation of pure images, conceived as expressive of universal order, tells of the persistence of transcendental Symbolism in artists as stylistically different as Mondrian and van Doesburg, Arp and O'Keeffe. There is a reasonable case to be made that while those artists who accepted the Cubist dissolution of images did escape the Symbolist succession — for clearly defined imagery does seem to be central to its concerns — those who resisted such dissolution, or who recovered pure image-making after it had taken place, were those who preserved the succession, and disseminated it through later modern art. Such a formulation neglects to account for those artists on the fringes of Cubism, the Futurists for example, who preserved vitalist, Symbolist beliefs while manifesting them in Cubist-derived forms. But Cubism, by pictorially expressing a sense of disjunction between reality and its representation, is generally alien to the Symbolist aesthetic, which opposes (as merely allegorical) all such dualities of imagery and meaning. What is essential to Symbolism, and what links O'Keeffe to the aforementioned artists, is a mode in which (in Croce's words) "the idea is no longer thinkable by itself, separate from the symbolizing representation, nor is the latter representable by itself effectively without the idea symbolized." This is to talk of an art of ideas and meanings but ones unthinkable away from the method of their representation.

O'Keeffe's link to Symbolism is to be traced through her teacher, Arthur Dow, who had been with Gauguin at Pont-Aven. Her *Evening Star, III*, draws ultimately upon the approach to watercolor exhibited in Gauguin's works of that period (p. 25). If art is to be concerned with what lies hidden beneath common experience, then a special order of its own must be created to evoke it: an order derived from nature but apart from it; a harmonious order that will express the inherent compatibility and essential unity of elements within the natural world; and a synthetic order, whose components will provide a physiognomy of nature but at the same time will tell more of the processes that inform nature than of nature's face. Hence, a necessarily abstract art that discovers in the medium of watercolor analogies for the order, harmony, and processes of the natural world. It was O'Keeffe's greatest contribution to early modernism to find in watercolor (and transpose, then, to oil painting) a way of reimagining, purely abstractly, what Gauguin adumbrated for modern art and Fauves like Matisse and Derain more fully realized: a pastoral mode of peace and vitality together; serene and sensuously instinctive at the same time. Like her predecessors, O'Keeffe uses homogeneously colored forms, whose organic contours are coextensive therefore with their color. Unlike them, however, because she is free from specific representation, she can assert the fluidity of watercolor to such an extent as to present forms that seem to have grown organically of their own accord, flowing like rivers across the white sheet, the ground of their existence. Saturated by their colored wetness, the ground breathes through them its own openness and expansiveness, which is as "symbolic" of the version of nature presented here as are the forms themselves.

Jean (Hans) Arp

FRENCH, 1887–1966

AUTOMATIC DRAWING. 1916. Brush and ink over traces of pencil on gray paper, 16¾ x 21¼" (42.6 x 54 cm)
Given anonymously

Arp's title for this work is slightly misleading. He did begin by making spontaneous and unpremeditated pencil outlines, finding that "accidental" or "automatic" procedures of this kind helped to liberate him from received and rational ideas about shape and composition. But once he turned to brush and black ink to fill in these outlines, shape and composition were very carefully adjusted indeed. Arp was a pioneer of automatic drawing. His version of it, however, is much less "automatic"—because less rapid—in effect than those of later practitioners like Miró (p. 171) or Pollock (p. 191). The velocity of his shaped lines is slowed by the larger shapes that buffer them; by the very precision of their contours, which suggest fixed, not mobile things; and by the flattened, fat, wormlike connotations. Because of their relative uniformity of texture, both shapes and shaped lines seem to have been flatly expanded to reach their precise contours organically, as if of their own accord. Growing rather than moving is what the drawing suggests. It tells of a benign biomorphic world, abstracted from memories of some primitive and harmonious form of nature.

Arp's formal vocabulary looks back to the simplified organic line in Art Nouveau and Symbolist art. He therefore belongs with those other early modernists—among them Matisse and Miró and Kandinsky and Klee—who also rejected the geometric vocabulary of Cubism in search of something that would connote the instinctive and organic rather than the man-made and mechanical world, and for whom the cursive Symbolist line was expressive of an underlying natural order behind surface appearances. Versions of this line appear in much Expressionist art; Arp's derives specifically from Kandinsky (p. 67), whose work he admired, but it rejects the sense of illusionistic space that still remains in Kandinsky. The mutation of line into shape that sits flatly on the surface flattens the surface as a whole. Space is implied in the bending of the organic shapes, but it is a kind of space that seems entirely detached from that of the external world. In space as well as in form, Arp's drawing style separates itself from ordinary, practical appearances to evoke a primitive realm apart. It "takes us back," Max Ernst once remarked, "to a lost paradise."

This drawing was made in Zurich in 1916. That year, Arp was one of the founders of Zurich Dada, and his was its only new pictorial style. Its primitivism is of a piece with the Dadaists' so-called "antiart" ideas (so often misunderstood), for basic to the whole primitivist tradition (since at least Rousseau and the eighteenth century) was the belief that what was wrong with modern civilization was its artificiality: that "art" had corrupted "nature"; that man's works had corrupted man's own nature and destroyed his original organic equilibrium. Emblematic of this corruption and destruction, for the Dadaists, was the Great War. "If the opposite of war is peace," writes Paul Fussell, "the opposite of experiencing moments of war is proposing moments of pastoral." This is exactly what Arp proposed in Zurich during the war: a peaceable kingdom of the spontaneous and instinctive, populated by forms that escape contemporary suggestion to return through art what man's arts had earlier destroyed.

Giorgio de Chirico
ITALIAN, 1888–1978

THE MATHEMATICIANS. 1917. Pencil, 12⅝ x 8⅝″ (32.1 x 21.8 cm)
Gift of Mrs. Stanley B. Resor

An old pictorial convention, whereby the identities of saints or martyrs were specified by depiction of their attributes beside them, undergoes a curious twist in this de Chirico drawing. These two mathematicians are constructed from their attributes—geometer's triangles, mostly—as well as from pieces of furniture and propped-up planks of wood. It is not a new idea. Arcimboldo and Bracelli, among others, had done something similar in the sixteenth and seventeenth centuries. But it assumes a new form, and a new significance, in a work drawn only a few years after the invention of collage. These two figures—one forming a desk at which the other is seated—are imagined sculptural assemblages that stress the discontinuous, juxtapositional potential of the collage method, and contrast it with the older form of the monolith placed conveniently beside them. Distinctively modern *capricci* or *bizzarrie,* their constructed, carpentered forms seem disturbingly alien, as set down in the silent, deserted, classical piazza. They recall Lautréamont's famous evocation of contextual displacement, "the chance encounter of a sewing machine and an umbrella on a dissecting table." Except that nothing is left to chance in this meticulously plotted subversion of the mathematical using mathematical means.

Perspective, which traditionally gave a measurable order and therefore a sense of stability to the invented, pictorial world, does exactly the opposite in de Chirico's work. Multiple and conflicting vanishing points create spatial confusion and disorder, and far from opening space, close it claustrophobically, flattening it to the eye. Modeling, which traditionally gave solidity to things, is so schematic as to render them almost weightless: paper-thin and flimsy. Cast shadows, far from reinforcing the presence of objects, either fade into gray wisps, causing us to doubt these objects' existence, or achieve such tangibility of their own as virtually to become objects in themselves. And, of course, no two shadows ever quite fall in exactly the same direction. Despite all appearances to the contrary, this cannot really be a sun-drenched piazza. The lighting is false, controlled offstage, and it too flattens the classical setting, which reads, finally, as a theatrical setting. Constructed simply from facades, it nostalgically evokes the classical only to subvert its rational order. Though calm, clear, and very precise, it seems threatening, hallucinatory even. Though drawn in the language of Renaissance illusionism, it opposes illusionism in its modern, patchwork-flat surface of contrasting lights and darks. The planarity of this surface, to which everything finally defers, is as indebted to Cubism and to Cubist collage as the mathematicians that spread out, dismembered, across it.

De Chirico's use of traditional techniques for modern purposes carries with it a sense of form being deployed at arm's length, as it were—from an almost ironical distance: very different from that sense of direct formal engagement that characterizes the most innovative of early modern art. This is not new to de Chirico. But it starts to become more noticeable in the period of his emergence to maturity. Once modernism, it seems, had reached with collage the possibility of aesthetic self-sufficiency (see p. 76), there developed—in Futurism, then Dada, as well as in de Chirico's art—a whole doubting, alternative modern tradition that stepped backward from the purely formal, and that opposed the aesthetically self-sufficient as being escapist, too much disengaged from the uncertainties of modern life.

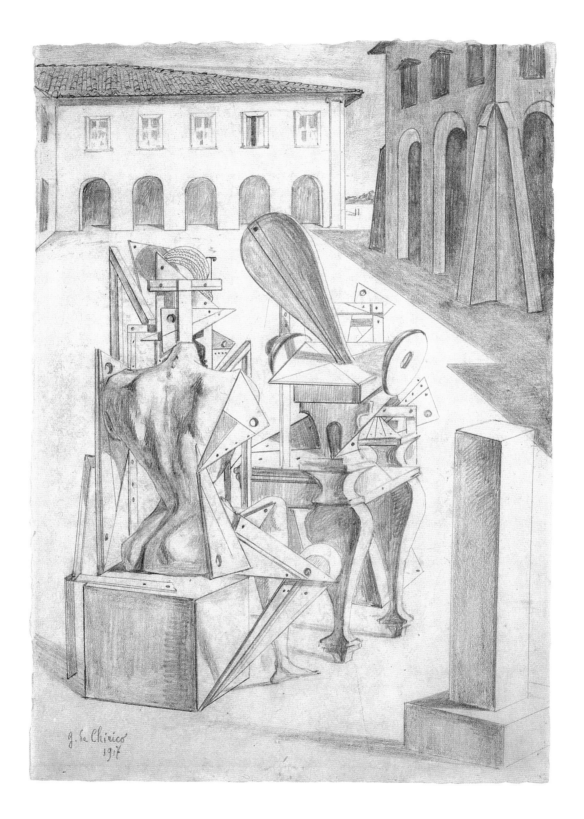

g. de Chirico
1917

Francis Picabia

FRENCH, 1879–1953

DADA MOVEMENT. 1919. Pen and ink, 20⅛ x 14¼″ (51.1 x 36.2 cm)
Purchase

If Dada, as claimed by the Dadaists, was a noisy alarm that woke up modern art from merely aesthetic slumber, then this Picabia drawing shows us how the alarm was sounded. It is the wiring diagram of a Dada alarm clock (made in Switzerland in 1919) which historically plots the flow of the current of modern art, from Ingres to *391,* Picabia's own Dada magazine. For the nonmechanically minded, some words of explanation as to how this machine works:

To the left we see a battery in cross section, with the electrical current moving in waves between the positive and negative poles, properly represented: the former in black, the latter in white (and with the ladderlike pattern that conventionally associates the negative with neutral or ground). French modernism is attracted to the stable, negative pole (and therefore to tradition), and rises historically until it reaches (with the help of Walter Arensberg, patron to French artists in New York) the rectangular transformer that bears the Dada name. Around the top of the active, positive (and therefore antitraditional) pole is an international cluster of innovative early twentieth-century artists, headed (of course) by Picabia himself. This positive pole directly connects with the Dada clock. The negative pole of French modernism, however, has to pass through the Dada transformer before it can be wired up to that inner circle. (Even then the wiring job looks amateur and not entirely convincing, but apparently it works.) When thus connected, the circuit is completed; the clock can start ticking, and the bell that was made in Paris and New York can begin to sound.

The drawing was made for the "Anthologie Dada" issue (May 1919) of the Zurich magazine *Dada,* edited by Tristan Tzara, where it was reproduced on pink paper by the printer Julius Heuberger, who was sent to prison for his anarchist activities during the preparation of the magazine. On its inside cover was reproduced a Picabia drawing called *Réveil matin,* made by dismembering an alarm clock and printing its parts in ink. After previously having mainly used automobiles as the source of his machine images, Picabia shifted (appropriately) to clocks when he moved to Switzerland; hence the form of this drawing too. Its subject is by no means unique. Indeed, charts like this became a favorite Dada pastime just after the war, and served three main functions: to assert the superiority of Dada among contemporary movements; to clarify the progenitors and sympathizers of Dada; and to establish hierarchies within Dada itself, as quarrels about priority and importance developed once the movement became established. The first such chart, Picabia's *Construction moléculaire,* was published in the first Zurich issue (February 1919) of *391.* It listed only New York and Paris Dadaists. This one, published three months later, affirms Picabia's alliance with the Zurich Dadaists, listing as it does Dadaists from all three centers within the clock face.

Obviously, then, this is an interpretation as well as a document of history, drawing as it does a highly selective diagram of the history of modern art: a history, in fact, not of modernism itself but rather of what the critic Frank Kermode calls neomodernism, the antitraditional and antiformalist branch of modernism, intimated by Futurism, that Dada properly began. The history recounted in this drawing justifies the kind of modernism that it itself pioneered.

Man Ray

AMERICAN, 1890–1976

ADMIRATION OF THE ORCHESTRELLE FOR THE CINEMATOGRAPH. 1919. Gouache, wash, ink, airbrushed, 26 x 21½″ (66 x 54.6 cm). Gift of A. Conger Goodyear

When the Futurists extolled the dynamism of the machine, machines had not yet become common in daily life. As the First World War ended, however, a new age of ubiquitous technology truly began. Man Ray trained as a draftsman specializing in engineering and machinery and was therefore ideally qualified to picture the appearance of this new subject in terms specific to itself; in terms, at least, of its popular appeal. For while Vorticists like Lawrence Atkinson (p. 101) had already coopted the techniques of mechanical drawing to give to abstract subjects a cool, machinelike look, Man Ray used techniques developed for advertising technological products to give to the invented machine we see here the glamour that attached to machines themselves. This drawing was prepared by stencils and templates, over which an airbrush was used. Then carefully ruled lines, meticulous lettering, and areas of painstakingly filled-in gouache complemented what, in effect, is a presentation drawing for a manufactured object—but one whose function is irrational and obscure.

Whereas the dynamism of the machine is the principal subject of pre–First World War technologically obsessed modernism, the function and then the appearance of the machine become more important as artistic subjects from around the time of the war. This is partly to be attributed to the increasing familiarity of machines and to disenchantment with technological force produced by the war. While further from an actual machine than the Severini shown on page 95, Man Ray's drawing looks more closely at the workings of machinery than that does; and it does so ironically. It also, however, makes the structure of the machine its own structure. Before this could happen there was required not merely a new attitude to and knowledge of technology; also, a new perception of the function of subject matter in modern works of art.

Once the subject and the object of modern art converged, as they did in collage—where representation of a still life was replaced, in effect, by making a still life—the work of art became an object more in the world than of it. A curious impasse was thus produced, for further to increase art's objecthood could only, it seemed, lead to works of art that were simultaneously subjects and objects—like "real" objects in the world. To follow this path would be to surrender most of the traditional reasons for making art at all. Hence Picasso's return to representation after the First World War. Marcel Duchamp, however, did carry the objecthood of modern art to its logical conclusion. His "readymades" are common manufactured objects, detached from their contexts, that function as art objects themselves, with subject and object as one. Manufactured objects were ideal for this purpose because they, like art objects, were artificially contrived. The machine, and things made by machines, thereby became paradigmatic of what art itself was in the world. In Man Ray's drawing, not subject and object but subject and structure are one. This also derives from Duchamp: from the so-called Large Glass that followed his first readymades, from which Man Ray also takes his sexual interpretation of the machine. The female "Orchestrelle" leans over invitingly to the beaming Cinematograph. "Abandon of the Safety Valve" trails through the air like one of those advertising slogans still to be seen pulled by turning aircraft, but a novelty then. And in a strip up the side of the drawing, even, passion begins rising, then reaches a climax and crosses the edge of the sheet.

25
25
25
25
25
25
16
9
5
3
1

ABANDON OF THE SAFETY VALVE

Admiration of the Orchestrelle for the Cinematograph

man Ray 1919

Pablo Picasso

SPANISH, 1881–1973

SLEEPING PEASANTS. 1919. Tempera, watercolor, and pencil, 12¼ x 19¼″ (31.1 x 48.9 cm)
Abby Aldrich Rockefeller Fund

In 1915, the sequential development of Picasso's art was suddenly ended. He turned to realistic imagery, and henceforward a remarkable diversity of styles (some of them concurrent) characterized his art. Picasso's stylistic diversity—previously unknown to the history of art—is something as peculiarly modern as the most advanced of his individual pictures, speaking as it does of a stylistic self-consciousness so developed that the artist can choose a pictorial style in the same way as he previously chose, say, a color from his palette. Picasso's volte-face in 1915 was not, then, a retreat from the modern, or not entirely that. But it was a reaction against the modern "impersonality" and abstractness, to which Cubism had tended, and a return, in a new form, to the more broadly traditional imagery of his pre-Cubist art.

The tempera-on-cardboard medium of this *Sleeping Peasants* recalls a fresco technique, and reveals the influence of the Pompeian frescoes that Picasso had seen in Italy two years previously. It is one of the earliest of the colossal Neo-Classic compositions that dominated his art from 1919 to 1923 and that join elements borrowed from Renaissance and Mannerist painting, from Ingres, from the late style of Renoir, and from classical art to create, however, an entirely original blend of these sources that seems neither eclectic nor historicist. Rather, it seamlessly fuses its borrowings within a pictorial conception that, while obviously more conservative than Cubism, would have been inconceivable without its example.

The conservatism and classicism of this work are to be associated with that nostalgia for the French tradition which developed in Parisian art circles around 1920 and provided an idealistically forgetful antidote for the horrifically modern war that had just ended. For some artists, this involved classicization of the modern itself, as if a technological war could only be justified in images of an idealized technological peace. Picasso (among others), however, turned from the contemporary to a kind of pastoral that had been common in French art before the war. His classicism is rural, not urban; amoral and instinctual, not civic and didactic. Here it is decidedly rustic, telling not so much of the *doux pays* of the prewar pastoral as of something rougher, more earthy, and finally more primal in nature, avoiding as it does the lightness and elegance usually associated with the pastoral mode.

As William Rubin has noted, the bulk of the figures makes them seem very much of the earth, and together with the implied heat of the sun provides a sense of weighty exhaustion to the forms of their bodies, whose postures suggest prior lovemaking. The hatching that follows the forms, analogizing as it does the treatment of the hay on which the figures rest, also blends them with nature. While the treatment of the exposed upper parts of the woman's body is highly reminiscent of Ingres's *Bain turc,* it is less obviously erotic, and curiously detaches itself from the surrounding, crisper drapery in a somewhat disturbing image of dismembered roseate flesh. It seems even to hint at the elegiac connotations that traditionally attach to representations of pastoral bliss. And of course, it is the special pathos of the pastoral that what we see presented is more euphorically at peace in nature than the viewer can ever expect to be. What we see here, though nominally of the present, has (like the Golden Age itself, which its coloration evokes) gone by. Like the classicism used for its evocation, it is remembered with regret.

Juan Gris

SPANISH, 1877–1927

MAX JACOB. 1919. Pencil, 14⅜ x 10½″ (36.5 x 26.7 cm)
Gift of James Thrall Soby

The Ingres-like realist style that Picasso used in the years 1915–23—a version of which can be seen in the tempera composition on the previous page—undoubtedly affected Gris's occasional works in a similar but more severe vein. This magnificent portrait of the then forty-three-year-old poet Max Jacob, a close friend of the artist since they met in 1906, is certainly one of the greatest drawings of its type. Few were produced, for Gris generally remained true to the highly abstracted Synthetic Cubist style that he developed from his earlier collages (p. 81).

"I try to make concrete what is abstract," Gris wrote in 1921. "I proceed from the general to the particular, by which I mean that I start with an abstraction in order to arrive at a true fact. Mine is an art of synthesis and deduction..." He is referring to his Synthetic Cubist paintings. In this case, he obviously had to begin with the particular: with the posed sitter. Even here, however, it is clear that observed and recorded data fill out and concretize a strictly ordered geometry that to some extent at least is a priori, conforming as it does to the kind of geometry we find in Gris's more abstract work. And certainly, synthesis and deduction operate here in the flattened simplifications, spatial intervals, and carefully plotted formal analogies that cohere this extremely methodical work.

Precision, clarity, exactness of representation are implied by the absolute sureness of Gris's line. It contours, with hardly a touch of shading, the mass of the figure to produce a far more robust effect than characteristic of the Picasso line drawings from which the style derives. Its purity and firmness are classical—which supports its comparison to Ingres's line. But it eschews the fine fragility we often find in Picasso's Ingres-like line drawings. There is an obdurate quality to Gris's work that withdraws it from elegance even as it seems to approach it, as at first sight it does here. Moreover, while the contours do indeed flow fluently, and twist around the sheet, and subtly vary according to the pressure of the line, they also suddenly stop, or fade, at times, and illogically stay on the surface when we expect them to turn in depth. At this point we begin to notice the exquisite rhyming within the drawing, and the formal analogies that interfuse it, ironically, with a certain droll humor, which humanizes the coldly severe pose. They also contradict the first-glance purely mimetic conception of the drawing, emphasizing its artifice and its abstraction.

Most obvious, perhaps, is Gris's precise alignment of the right-angled molding in the background to the center of the sitter's eyes, then, as it drops exactly vertically, to the vest button that locates a second right angle within the form of the figure. The witty comparison of molding and vest pocket supports the contradiction to three-dimensionality implied by this fusion of figure and ground within the geometry of an exact square. Two additional rhymes reinforce this geometry, while modifying its strictness with a touch almost of whimsy: the punning of eyes and tie and of clasped hands and wrinkled sleeve. Both serve to hold attention to the spread of the surface. The latter expands the implied base of the square so that it curves away to the edges of the sheet to provide a kind of decorative base, above which rise the graver elements of the work.

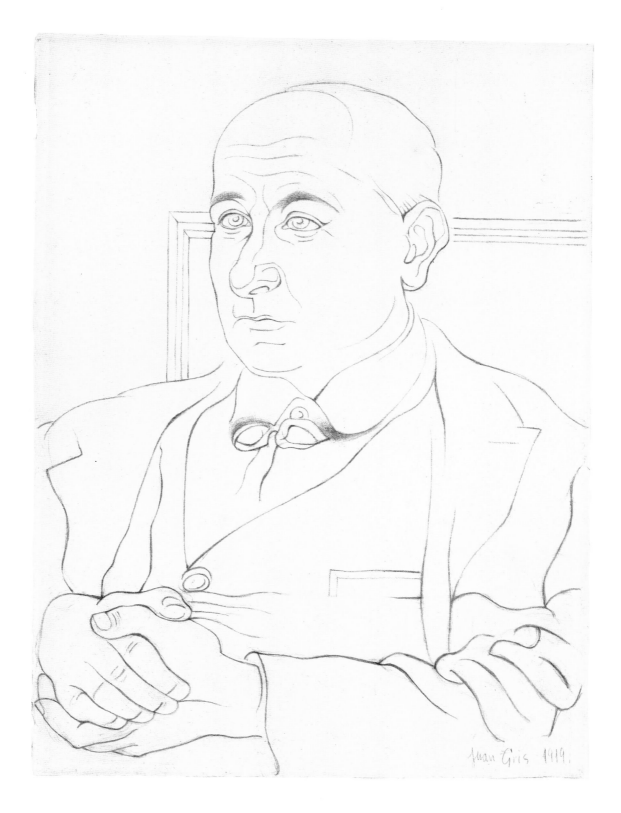

Max Beckmann

GERMAN, 1884–1950

THE PRODIGAL SON. (1918.) Gouache and watercolor with pencil underdrawing on parchment,
14½ x 11¾" (36.1 x 29.9 cm). Purchase

This Beckmann gouache is one of four in the Museum collection from his Prodigal Son series, and is drawn on the back of an illuminated Bible page, on which is inscribed the opening words of the parable (Luke 15: 11–32) that the series illustrates. Exactly which incident from the parable is depicted here is uncertain: possibly, the son's realization that he has squandered his inheritance. Beckmann has improvised on the basis of a very concisely told story; appreciation of the force of his work does not require knowledge of its textual source.

The style of the gouache, however, carries certain religious connotations, for Beckmann's work after the First World War was strongly influenced by fifteenth-century woodcuts, which imbued it with something of the spirit of Gothic ecclesiastical art. We sense this here in the tightly compressed space: not imagined and then filled, but actually created by composition of the figures themselves. Their grotesque distortions, especially their enlarged heads and hands, recall the cruder forms of Gothic art. But the claustrophobic space they create—highly appropriate to the uneasy, and often incipiently violent, mood of Beckmann's art—is certainly as important an adaptation from the Gothic: the stretching, bending, unpleasantly overgrown forms gain in intensity by virtue of their compression within so cramped a format. Crucial to both spatial and anatomical distortion, however, and the principal expressive agent of Beckmann's graphic art, is the emotionally charged (and again, Gothic-derived) contour.

Like many other Expressionist artists, Beckmann found particular affinity with the nervous, angular Gothic line, and with the resistant toughness it acquired when used in early woodblock printmaking. Gothic drawing is conceptual, not perceptual; symbolic, not mimetic; hieratic, not illusionistic: for these reasons alone it was compatible with the aims of Expressionist art. But additionally, its technical form was that of synthetic enclosure drawing: expressively simplified lines synthesize in their own weightedness and tangibility a sense of substance, seemingly drained into them from the flattened, emptied forms that they bound and define. Modern versions of this synthetic line—drawn from a variety of sources, not only from the Gothic—have been used since the beginning of this century—indeed, since Gauguin's adoption of it in works such as that reproduced on page 25. But Expressionism made it especially its own, more fully exploiting its sense of condensed palpability than did any artists in France. This Beckmann gouache uses it in a surprising and novel way. The lines seem inscribed. Though positive, articulating elements of the composition that clench, in their twisting movements, the expressive weight of the forms they describe, they read also as negative, subtracted elements that cut and divide the surface into the tightly packed and lightly modeled oak-colored enclosures. Beckmann's modeling of the enclosed forms gives substance to these forms. They are flattened, however, by the very insistency of their enclosure, and the drawing that encloses them partakes of their tangibility as well as setting it in relief. It is a highly original use of the synthetic line, and one that is reminiscent more of a wood carving than of a woodcut. The gouache gives the appearance of its having been chiseled out of some blond wood. It recalls the misericord carvings of medieval cathedrals: not only in subject; also in form.

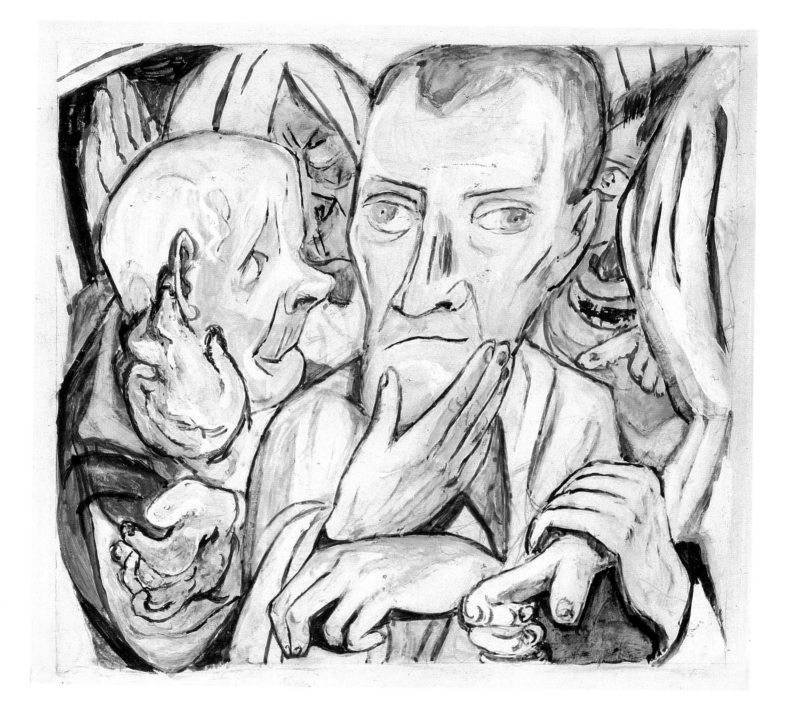

Otto Dix

GERMAN, 1891–1969

SELF-PORTRAIT. 1922. Watercolor and pencil, 19⅜ x 15½" (49.2 x 39.3 cm)
Gift of Richard L. Feigen

The phrase "Neue Sachlichkeit" (new objectivity or new matter-of-factness) was used in Germany to describe the reaction against Expressionism that developed in the early 1920s and was consolidated by 1924, the year after the stabilization of the German mark. Inflation and Expressionism gave way to regulation and sobriety, it seemed, producing the opposed phenomena of International Style architecture and realist art. Both were considered *sachlich*—disinterested, really: the first in its functionalism, the second in its view of the world. Neither description, in fact, holds true. The new architecture was no less utopian than the Expressionist architecture it replaced, only more capable of being built. The new realism—of Dix, Grosz, Beckmann, and their colleagues—looked reportorially real when compared with their earlier work, but it extended Expressionism in a soberer, disillusioned form. In some cases it developed from Dada, not immediately from Expressionism (as can be seen by comparing the two Grosz drawings on pages 129 and 157), transposing into realism its mordant view of the world. In either case, however, its cynicism, like all cynicism, was a kind of disappointed idealism, and as such the doubting counterpart of the new architectural hope. It too preserved the aspirations of Expressionism while attempting to bring them in contact with the actuality of the social world.

Although an early example, the unflinching forthrightness of Dix's self-portrait is typical of the new realism, as is the stern, sardonic image it projects. By no means, however, is it objective in its realism. Seen beside Expressionist art, it is indeed clear, precise, documentary even; but documentary in the sense of being the product of an art whose purpose it is to make something *seem* real.

Writing about German filmmakers of the period 1920 through 1924, Siegfried Kracauer observed, "They preferred the command of an artificial universe to dependence upon a haphazard outside world." This of the period when, in painting and drawing, the new realism appeared. Dix drew his self-portrait in the same year that Fritz Lang's famous *Dr. Mabuse, the Gambler* was released. Less purely fantastic than that seminal Expressionist film, *The Cabinet of Dr. Caligari* (1920), from which it generally derived, it juxtaposed the realist and the Expressionist (Kracauer notes) by staging its contemporary action in settings of pronounced artificiality. The form, then, of Dix's drawing is by no means unusual. Its own dramatization of the nominally real by placing it within a luridly unreal context is characteristic of the way in which Expressionism was changed in the 1920s. Whereas the 1918 Beckmann (p. 125) is removed from the world as we know it, flattened distortedly to the sheet, Dix's drawing, though equally artificial in its staging, seeks to persuade us that what we see is associable with the external world. The almost satanic fire that unifies the mood of the drawing as stormy and disturbed also models the figure, giving it the illusion of tangibility. As in films like *Dr. Mabuse,* reality is opposed by a competing version of it, whose verisimilitude and contemporaneity seem to be convincing but are in fact illuminated by the theatrically fantastic. No art, of course, tells unbiasedly of the world. Neue Sachlichkeit art is no exception, even when cooler than it is here. It uses the authority of realism to give to reality a dramatized existence, confusable with the observed world, but far more vivid, and contrived. Life itself, it seems, in Germany was most believable when it took on theatrical form.

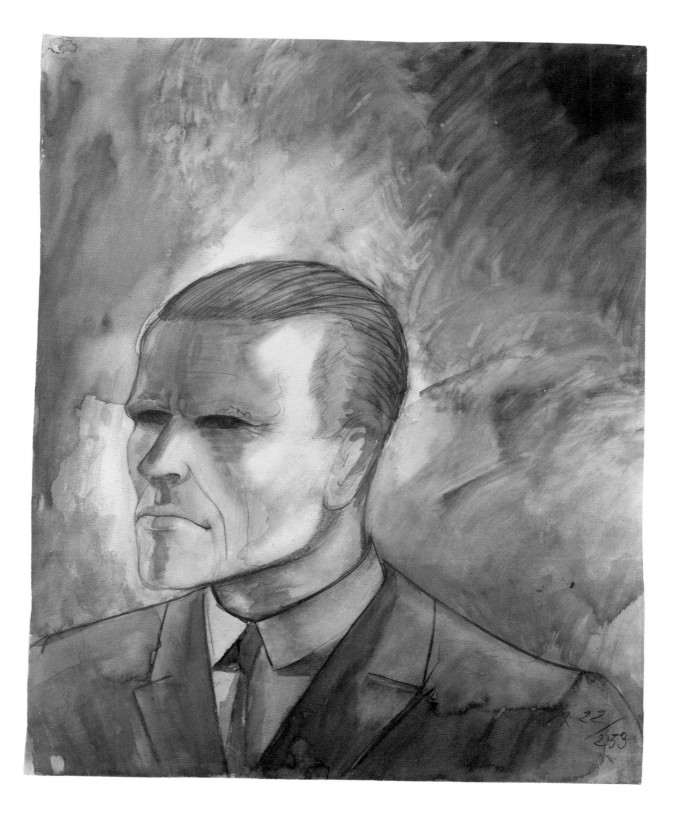

George Grosz

GERMAN-AMERICAN, 1893–1959

THE ENGINEER HEARTFIELD. (1920.) Watercolor, pasted postcard, and halftone, 16½ x 12″ (41.9 x 30.5 cm)
Gift of A. Conger Goodyear

The sly, pugnacious character with the machine heart does not much resemble the artist's friend and Dada coconspirator Helmut Herzfelde, alias John Heartfield. Toughness and belligerence have been added. If the result evokes a convict, imprisoned in his cell, with a broken water-jug beside him, then that, surely, was how Grosz conceived the antiauthoritarian Berlin Dadaist.

The blue smock suggests prison garb; also, however, the outfit of a mechanic. Heartfield was known as "Monteur-Dada," for his concentration on photomontage—which term (wrote Raoul Hausmann) "translates our aversion at playing artists…thinking of ourselves as engineers, we intended to assemble, construct [*montieren*] our works." Berlin was the most aggressive of Dada centers. In Berlin, wrote its leader, Richard Huelsenbeck, "Dada…loses its metaphysics and reveals its understanding of itself as an expression of this age which is primarily characterized by machinery and the growth of civilization. It desires to be no more than an expression of the times." When Dada began in Zurich, it opposed machinery and civilization, as associable with the First World War and the materialism that had produced it, and proposed instead—most notably in Arp's work—an instinctive and primitive escape from its times. Outside that neutral oasis, however, such an approach seemed far too passive. In hungry, war-weary Berlin, it seemed simply "metaphysical," and there Dada engaged with its times. Hence the importance of photomontage, and of the caricature-based documentary realism that frames it here. Dada was to replace art by documentation, and thus provide a more authentic record of the world than a picture of a narrative could. (Which is why "art" was to be opposed; it "lied.")

But, of course, there is no such thing as inchoate experience; neither can anything that is crafted be simply "an expression of the times." It was all a Dadaist fiction: a way of giving factual shape to the alogical world of instinct that lay at the heart of the Dada imagination. Dada in Berlin, no less than in Zurich, opposed the technological with the instinctive. But whereas Arp presented a world that was purely instinctive, virtually every other important Dadaist—including those in Berlin—sought rather to reveal the instinctive within the modern. Common to Dadaists as different as Man Ray, Max Ernst, Kurt Schwitters, and Grosz, is a duality of affiliation—commitment to an instinctive ideal and responsibility to their own time—which manifests itself in the use of modern subjects or materials to tell of a spontaneous kind of existence that opposes the world of technology yet does not seek to escape it. In Berlin, it produced photomontage and documentary realism. For what was required were forms that could give to something unseeable the appearance of something real that had actually been documented, thus to subvert mechanically the modern machinist world and discover within it a primitive internal world as "real" as the world outside. And when, as here, the space of this world needs to be shown, the irrational perspective of de Chirico (p. 115) is used to define it. But whereas the effect of de Chirico's art is of traditional techniques used for modern purposes, that of Grosz's is exactly the opposite. Modern techniques are employed for traditional purposes, namely didactic and ideological ones. Modernism is used but not engaged. "Doubt became our life," wrote Huelsenbeck of Dada in Berlin. "Doubt and outrage." It was a kind of doubt so fundamental as to suspect even the language in which it was spoken.

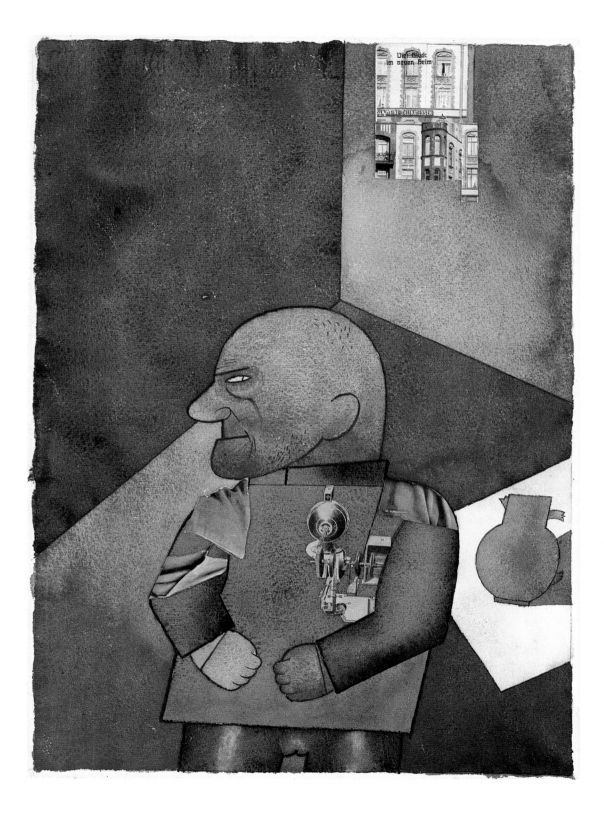

Max Ernst

GERMAN, 1891–1976

THE HAT MAKES THE MAN. (1920.) Cut and pasted paper, pencil, ink, and watercolor, 14 x 18″ (35.6 x 45.7 cm)
Purchase

When asked by the Museum whether this work had any specific source or significance, Ernst replied: "Brauhaus Winter, 1920." He was referring to the notorious Dada Vorfrühling exhibition in Cologne, which took place in a glass-roofed courtyard at the back of the Brauhaus (Brasserie) Winter; it could only be reached by going through the men's lavatory. Visitors were challenged to destroy whatever they did not like. They perhaps did in the sculptural counterpart of this drawing, made of piled-up hat molds, that Ernst produced for the exhibition.

"One rainy day in 1919," Ernst wrote, "my excited gaze was provoked by the pages of a printed catalog. The advertisements illustrated objects relating to anthropological, microscopical, psychological, mineralogical, and paleontological research. Here I discovered the elements of a figuration so remote that its very absurdity provoked in me a sudden intensification of my faculties of sight..." All that was necessary, he realized, was subtly to modify and rearrange these images. "These changes, no more than docile reproductions of *what was visible within me,* recorded a faithful and fixed image of my hallucination. They transformed the banal pages of advertisement into dramas that revealed my most secret desires."

Like Man Ray's use of machine images as a way of musing on the loss of instinctive sexuality (p. 119), or Grosz's giving his friend a machine heart (p. 129), Ernst's use of mechanical illustrations to tell of autobiographical fantasies and hallucinations reveals that characteristic Dada duality in which modern and instinctive worlds collide. Inscribed on this image of anthropomorphic eroticism is the legend: "Seed-covered stacked-up man, seedless water-former, ('edelformer'), well-fitting nervous system also tightly fitted nerves! (The hat makes the man, style is the tailor.)" Curiously enough, a number of the Dadaists were interested in fashion. Schwitters made a number of collages on the subject. Hausmann wrote a paper on German trouser design. Ernst, that most iconographically inventive—and literary—of the Dadaists, erects from the subject of hats a phallic fantastic construction in combined human and plant-life form. He had been a student of psychology before the First World War, and had indeed read Freud. But if we see in his work the obsessive self-regard of a Freudian age, we also, I think, see that when he inspected his fantasies, he found them drolly humorous. At least, that is the impression provided by this massive set of perambulating phalli, satirically sexual mutations of de Chirico's cold mannequins (p. 115), transparently blundering about their little stage.

Ernst's interpretation of collage has little in common either with Cubist collage or with the work of his colleagues, Schwitters and Arp. Collage for him is not a method of formal construction; rather, it is a method to subvert (albeit by formal means) the kind of formal construction emphasized by earlier modern art, which has minimized descriptive or image content in favor of the communication of content in a less particularized way. Ernst resurrected the traditional *imagier* over the modernist *peintre,* thus returning to art its premodern capability of serving a particular, didactic purpose and expressing a distinct and specified ideology. Ernst's Dadaism is indeed ideological and purposive in a way that earlier modernism is not. But unlike premodernist art, it is ideological without a specific ideology and purposive without a purpose at all. Its narrative iconographies tell a story that is always obscure.

bedecktormiger stapel-
mensch nachtsamiger wasserformer
(vedelformera) kleidsame nervatur

auch
! umpressnerven !
(c'est le chapeau qui fait l'homme)
(le style c'est le tailleur)

max ernst

Alexander Vesnin

RUSSIAN, 1882–1950

PROJECT FOR A MONUMENT TO THE THIRD INTERNATIONAL. 1921. Gouache, 20¾ x 27¾″ (53 x 70.5 cm)
Acquired through the Mrs. Harry Lynde Bradley and the Katherine S. Dreier Bequests

The structure that is depicted in this drawing was momentarily built. It formed the centerpiece of the decorations of Moscow's Red Square on the occasion of the 1921 Congress of the Third International or Comintern, an organization dedicated to the spread of Communism across the world. "Long Live the Third Comintern" reads the legend scattered over the forms at the top; and below that, "Proletariat of All Nations Unite." Composed of ramps and podiums for orators (one of whom is depicted), and aggressively angular planes, all held down by guylines, it evokes a vessel under sail. Highly appropriate, of course, to its subject, the structure metaphorically suggests some kind of pirate ship, launched on a journey to capture the workers of the world.

Alexander Vesnin—artist, architect, and stage designer—was the youngest of three brothers, all trained architect-engineers, who often worked together on Soviet design projects during the 1920s and early 1930s; most importantly, perhaps, on a 1923 project (never realized) for the Moscow Palace of Labor, the basic concept of which was derived from the structure we see here. This structure, in its turn, was based on an unrealized project for a huge pageant, to have been directed by Meyerhold, called "Struggle and Victory of the Soviets," which was to have taken place in Moscow's Khodinsky field also during the period of the Comintern Congress. In that design, dirigibles were to have supported the structure from above. A sense of forms as if suspended carries over into the design of this monument and contributes to the aspirative lightness of the structure, opposing the bulk and weight of its imagined materials.

The year this drawing was made, Vesnin contributed to the historic "5 x 5 = 25" exhibition, which announced the death of easel painting and its replacement by objects of utility. The term "Constructivism" is now used to indicate either all art that is physically constructed from tangible (usually geometric) elements or art of this kind that developed in Russia after the example of Tatlin's reliefs and subsequently spread to the West. Originally, however, it denoted the application of this artistic principle to the creation of useful constructed things. Vesnin worked in Tatlin's studio from 1912 to 1914. While the angularity of his drawing is reminiscent of Cubo-Futurist art, its planes and lines recall Tatlin (p. 85), and represent what, in effect, is a free-standing architectural relief. Art moves, in Constructivism, out of the gallery and into daily life.

Many of the artistic movements that emerged during or just after the First World War talked of the end of conventional art as associable with an old, destroyed order, and—reacting against the implied autonomy of earlier modern art—proposed the creation of new forms that would dissolve boundaries between the individual arts, and between them and daily life. Except in the first of these movements, Dada, this meant that architecture became the focus of the alliance of the arts. This is what associates the de Stijl group in Holland, the Bauhaus in Germany, the Constructivists in Russia, even the Purist circle in France (and justifies association of their different kinds of art with the term "Constructivism"): a belief that art, ideally at least, can construct a new world, or if not that, can form a blueprint for one. In Russia, the success of the Revolution fueled this belief, to produce a euphoric, utopian public art form that swept avant-garde artists from their painting and sculpture studios—only to find, when the excitement subsided, that they were not allowed to return.

Paul Klee

SWISS-GERMAN, 1879–1940

TWITTERING MACHINE. 1922. Watercolor, pen and ink on oil transfer drawing, 25¼ x 19″ (63.8 x 48.1 cm)
Purchase

Klee's art began with an investigation of line, and however much he enriched his formal vocabulary it was to line that he continually returned. In line drawing, as in no other pictorial method, Klee saw a way of expressing in the microcosmic form of his art the movement and growth that he saw in all creation. "An active line on a walk, moving freely" symbolized the fact that "through the universe, movement is the rule." And yet, as often as we find organic subjects in Klee's art, we also see images of the mechanically constructed world. The *Twittering Machine* is an image of movement, but movement controlled by man, imposed on nature and opposing it.

It was in the period 1912–14, when Klee was assimilating the language of Cubism, that he began to make drawings of wirelike lines that evoke constructions and machines. At the end of that period, he discovered in transparent color a way of infusing his work with a poetic, seemingly back-projected light that opened deep space, but an optical space that preserved the identity of the flat surface (see p. 72). Such a space we see here, and see that it is ideally suited to the kind of line Klee uses. Closer to the modalities of writing than to those of pictorial illusionism, his drawing is inscribed as if on a prepared tablet. Line and surface are plastically independent; so, therefore, are form and color, subject and space. As happens in other post-Cubist art—in Mondrian's, for example (p. 103)—line drawing is disengaged from other pictorial components so as to constitute a separate sign-system that carries the entire informational burden of the work of art. A Cubist grid still informs the organization of Klee's drawing. But his drawing opposes the man-made rational order connoted by Cubist art. When it addresses the mechanical world, it strains against it, expressive of constraint.

Klee's line is yet another version of the synthetic, Symbolist line—which clenches in its own compressed density the substance of the forms it defines—so central to early modern and especially to Expressionist art. But it is an extremely radical version, so thinned as to be deprived of most of its natural weight. Like extruded wire, it stretches the bulk of matter into a flexible filament that rarely contours or encloses but forms pictographic trajectories that seem to be shallowly embedded in the surface, as if in wax. Line, in fact, was transferred to this drawing from a preliminary sketch by means of a kind of handmade carbon paper (which also provided the "accidental" dark smudges). This transfer technique distances Klee's touch and (as Bernice Rose has observed) thereby cools it, rendering it more diagrammatic than descriptive. The specifically diagrammatic form of this work associates it with Picabia's machine drawing (p. 117). But Klee's work, though seemingly as playful, is finally far less indulgent in its attitude to the machine. His Symbolist, organic (not mechanical) line deconstructs it toward the primitive. Pernicious technology is returned to its roots in ignorant magic and thereby exposed. A *Concert on the Twig* (the title of Klee's preliminary sketch) is transposed into an image of nature's bondage, where crazed and dying birds, pierced by arrows and fastened to a hand crank (suggestive of a music box), form a sort of lure for other birds, over a concealed pit. It is a machine (one commentator has noted) in the Latin sense of a trap *(machina)*. The acid blue-violet and darkly smudged ground atmospherically spreads its own sense of menace, as well as suggesting the reverberations of an unpleasantly harsh and high-pitched sound.

1922/151 Die Zwitscher-Maschine

Kurt Schwitters

GERMAN, 1877–1948

SANTA CLAUS. 1922. Collage of pasted paper and cloth, 11¼ x 8¼″ (28.4 x 20.8 cm)
Purchase

Schwitters coined the word *Entformung* to describe what happened to the "foreign" materials in his collages. The neologism resists exact translation, but can be taken to mean "metamorphosis" or "dissociation," the prefix to *-formung* ("formation") indicating establishment of or entry into a new state or abandonment of an old one. It meant turning old materials into new art: making new art from the remains of a former culture, as he once put it. But also, it seems, something nearly opposite: the creation of a traditionally classic art from the remains of a contemporary culture. Fragments taken from the streets and gutters tell by synecdoche of the modern, urban world from which they derive, but of a discarded, used-up world. They tell of it, therefore, in the past tense, and far from celebrating the modern experience constitute its elegy. Included, however, in the work of art, they are dissociated from their former contexts and in that aesthetic transubstantiation are purged of what Schwitters would call their *Eigengift,* their inherent vice or personality poison. The image is that of cleansing. (Schwitters would indeed often carefully wash his materials; hence the faded, muted colors of works like this.) Things taken from the world are purified as they constitute works of art, and art itself is an antidote to the world outside.

This is an understanding of art as something that soothed and ameliorated the noisy modern experience which Berlin Dadaists like Grosz (p. 129) embraced. Indeed, it was an escape from that experience. Art was the creation of timeless order out of temporal chaos, and the creation of a private retreat from the remains of the outside world. This is closer in spirit to the original primitivism of Zurich Dada than to anything in Berlin, recalling as it does the purity and instinctive order that preoccupied Arp (p. 109). The difference, however, is that whereas Arp used forms that themselves escaped the modern experience, Schwitters did not. We therefore see in his work not only the picture of a purified order but a picture of its creation. For a sense almost of rivalry, and then of resolution, between the external world and its aesthetic purification is a necessary part of the experience of his work. If Dada was indeed turmoil and tempest, Schwitters was not, like Arp, a Gonzalo who denies civilization, but a Prospero who repudiates it in order to find a new and reformed balance between the civilized and natural man.

The duality of impure materials and purified order, while separating Schwitters from Arp, associates him in certain respects with the majority of Dadaists, even those in Berlin, who, as noted elsewhere (p. 128), also sought to reveal something primordial within the modern. In Schwitters' case, however, it is a duality that returns to the very beginnings of collage, which even in Cubism affirmed a distinction between the pure world of art and the impure world of external reality from which its materials derived. Schwitters was the first, and only, modern artist to make of Cubist-derived collage the very basis of his whole art. His *papiers collés* especially carry to a logical conclusion what I have called the "dispersive" aspect of the medium (p. 82), where pasting of papers composes the entire pictorial surface and forms the entire structure of the work of art. Elements of the world are thus rebuilt into a new kind of worldly object, different in order from anything we know in the world. For Schwitters to create objects like this required that he bring together, for the first time, the idea of "liberated" materials and that of purely abstract design—the two central innovations of twentieth-century art.

Relchardt-Schwertschlag

Der Weihnachtsmann

K. Schwitters. 22,

El Lissitzky

RUSSIAN, 1890–1941

PROUN GK. (c. 1922.) Gouache, brush and ink, pencil,
26 x 19¾" (66 x 50.2 cm)

A "new man" creating a new art for a new world without frontiers was the image that Lissitzky projected as he traveled around Europe in the 1920s, welcomed by the international Constructivist avant-garde as an ambassador-at-large for the new Soviet culture. The image he projected was that to which Constructivist artists of the 1920s aspired. Theirs was not a Constructivist art in the original Russian sense (see p. 132), for by 1922 (the date of this drawing) the whole range of abstract and constructional styles that had developed during and just after the First World War had escaped their national boundaries to create a newly ecumenical alliance, though one whose factions retained their original names. Common to them all—from de Stijl to Lissitzky's own "Proun"—was a notion of art as composed of "elements," viewed as expressive of both modern and universal order from which, in theory, any fabricated object could be made. Lissitzky was an extraordinarily versatile artist, who worked in nearly a dozen fields from painting and printmaking to architectural design. "Proun" was an acronym for "Project for the Affirmation of the New (in Art)," and he described its intention as to create an "interchange station" between painting and architecture. The travel metaphor is appropriate to Lissitzky. Modernity and movement together were central to his art (as indeed they were to his period).

Proun compositions were modern because they embodied the economy of means, clarity of form, and precision of relationships characteristic of the machine. "Machine fetishism" was opposed, but the order of technology was admired: indeed (*pace* the Dadaists), its economical processes were analogous to those of nature itself. Anything that specfically connoted nature, however, was avoided, including sensuous color. The restrained color scheme of Lissitzky's work analogized industrial materials: copper, iron, aluminum, and so on. (Color was a "barometer of materials," he nicely put it, in a true Constructivist spirit.) The presentation, then, is coolly modern. But as one studies a work like this, it becomes evident that its calmness conceals a wealth of spatial ambiguity that forces an extremely active relationship to it on the part of the viewer. The forms are descended from Malevich's; they similarly inhabit a weightless and scale-defying void, and the laws that control them are entirely their own. As in Tatlin's drawing of reliefs (p. 85), projection is implied in advance of the picture plane—only, however, to be denied. Traditional perspective and spatial coherence are opposed to create a far more complex, and tenser, space than in earlier Constructivism; also a more dynamic one, with its contrasts, diagonals, asymmetry, and twisting movement. Moreover, experience of these properties is purely mental. We do not react, I think, kinesthetically or empathetically to the shifting of the forms. They travel within the mind.

Lissitzky is often described as a "bridge" between Tatlin's Constructivism and Malevich's Suprematism. It is an attractive metaphor, punning as it does on his own Proun railroad-station idea—and Lissitzky was indeed a synthesist. But he was very much more. Not only was he a great avant-gardist—in Harold Rosenberg's definition, one who has an *idea* of the present, as a means of transition to the future—but also an original artist, whose insight into his time was embedded in his practice of his art, which thereby escapes contemporary suggestion for an entirely classical stasis, even as it tells us how he thought the contemporary should be changed.

Wassily Kandinsky
RUSSIAN, 1866–1944

BLACK RELATIONSHIP. 1924. Watercolor, pen and ink, 14½ x 14¼″ (36.8 x 36.2 cm)
Acquired through the Lillie P. Bliss Bequest

When Kandinsky joined the Bauhaus in 1922, he came from Russia, where he had been living since 1914. He returned to Germany a changed artist. Responding to Malevich's use of simplified geometric elements (p. 107) and to Lissitzky's dynamic opposition of bars and planes (p. 139), his work had cooled and hardened. Comparing this watercolor of 1924 with that reproduced on page 67, from a decade earlier we see that improvisational drawing has given way to the use of straightedge and compass. Freely moving, organic lines have been stretched taut to become directional, pointing lines. Transparent film color assumes an even and contained form, to provide the effect of cut-out pieces of stained glass; and neutrally applied surface color now dominates. A sense of deep illusionistic space remains, despite—and at the same time because of—the larger flat areas of untouched paper. Thin, frontal, and silhouetted forms float on the clear window-pane plane of the picture surface, shallowly overlapping in front of a deeply recessive, albeit indeterminate void.

As modern works of art approached the condition of autonomous objects, the great florescence of truly radical art that this produced (in the period around the First World War) was soon followed by a faltering of momentum, for to follow this path through was simply to create (or find) "real" objects, as Duchamp and the practical-minded Constructivists did. While it was precisely this crisis within modernism that allowed artists (usually outside France) to transpose its lessons to environmental design, it created acute problems for art-object makers themselves. One solution was to retreat from abstraction into illusionism as happened within the School of Paris. Kandinsky's art, however, was abstract *and* illusionistic. And as he moved into pure abstraction (losing thereby the coherence earlier provided by generalized naturalistic allusion), he began to produce what are, in effect, flat designed objects but ones whose designing does little to call attention to their flatness. The paper-thin forms that Kandinsky seems to paste onto the surface are certainly themselves flat. But their designing does not serve the flatness of the surface. They function as repoussoir forms, pushing back into deep space the blankness that surrounds them. Depicted and literal flatness, that is to say, tend to become isolated one from the other. Although Kandinsky's organization of the depicted flat elements does refer to the axes and enclosing shape of the literally flat support, it does not cohere but decorates it—constituting a kind of pattern-making that takes place on top of a neutrally "given" ground—with the result that the object quality of the work of art overwhelms its pictorial quality. At least, it does so in almost direct proportion to the size of the work itself.

Reproductions never properly convey the scale of works of art. As shown here, this watercolor is approximately half in each dimension its actual size. It is indeed a small work. Because of this, imagery and support are seen as one, and the ground, though deeply spatial, is tangibly whole before our eyes. Paradoxical though it may seem, it is by becoming more graspable as an object that it escapes being merely an object, and functions instead as a richly pictorial work of art. From the date of this work, Kandinsky began to refer to his watercolors not as preliminary or supplementary to his paintings, but as independent works of art. Since his turn to pure abstraction, these most modest of his independent works are generally his finest.

Charles Demuth

AMERICAN, 1883–1935

STAIRS, PROVINCETOWN. 1920. Gouache and pencil on cardboard, 23½ x 19½" (59.7 x 49.5 cm)
Gift of Abby Aldrich Rockefeller

Provincetown in the summer, though indeed hot, can hardly have provided inspiration for color quite as intense as we see here. Nor can the clapboard architecture of New England entirely justify either the austerity or the complexity of Demuth's geometry, which opposes his color's richness. Obviously, we are shown the back, exterior stairway of a Provincetown house, with a facade of boards, door, windows, and window blinds behind it. But parts of the boarding have been shifted into a vertical direction; others tilt to align themselves to the stairs; the door and windows intersect with their adjacent architecture (whose overlapping forms flatten like a house of cards); and the stair itself defies climbing. Unimaginably light, it resembles a color-scale chart, methodically plotting the tonal steps in reds and yellows from warm to cool, then diluted to saturated as it rises. At the same time, however, everything we see does seem to be based on observed fact. The shapes of things are reported. Details are noticed. The invention is in their adjustment. Demuth's so-called Cubist-Realism clings more literally to appearances than anything in Cubism (or Futurism), from which it derived. Attempts have been made to show that such literalism is a distinctively American characteristic. If it is, it appears here not quite as New World directness but more in the spirit of Colonial elegance and puritan simplicity. Demuth's art is as fragile and fastidious as he himself apparently was. Watercolor—either purely transparent or in the form of gouache—was its perfect medium.

This work climaxes Demuth's series of hard, geometric watercolor studies of landscape and architectural subjects, begun in 1916, which gave way around 1920 to urban, industrial subjects, most in tempera or oil. Its austerity, and absence of landscape reference, anticipates the forthcoming paintings, but it preserves the crisp and crystalline delicacy associable with Demuth's preceding art. Technically, it is a watercolor drawing since it was made in two distinct stages: first, pencil and straightedge drew out the complex structure with mathematical precision; then, gouache, thinned as necessary and occasionally blotted to produce tonal variations, was carefully filled in. The composition is characteristically Cubist—densest at the center and fading to the edges—and is uncannily reminiscent in its total shape of a Cubist guitar image as it appears in Picasso's collages (p. 77). Not to be found in Cubism, however, and very unlike the Futurist "lines of force" from which they derive, are the "ray-lines" that beam from the upper left corner and from the center of the composition, often altering the shade of the elements they pass through. Shining through the work like tiny spotlights, they serve both to extend the directional lines of depicted objects and to interfuse the whole subject with an extremely reticent kind of "dynamic" light. Everything, indeed, is reserved; even the splendid color, tightly fitted into its proper compartments, whose geometry it softens and stills. It is a picture of sensuality contained. Demuth's art has been described as classic; it is, more accurately, ironic. An intrinsically dramatic subject of shifting, twisting planes is austerely brought to rest with a dandyish coolness, and far from evoking the out-of-doors, its color exudes the hothouse atmosphere of an aesthete. Demuth, we remember, was a friend of that most famous of modernized dandies, Marcel Duchamp. He shares Duchamp's aloofness; also his dry humor. The stair that dominates this picture parodies his friend's most notorious work.

John Marin

AMERICAN, 1870–1953

LOWER MANHATTAN (COMPOSING DERIVED FROM TOP OF WOOLWORTH). 1922. Watercolor and charcoal, with paper cutout attached with thread, 21⅝ x 26⅞″ (54.9 x 68.3 cm). Acquired through the Lillie P. Bliss Bequest

The Woolworth Building was the tallest structure in New York when it opened in 1913. For Marin, it and the other Manhattan skyscrapers were what the Eiffel Tower was for Delaunay (p. 59), and indeed his representation of it generally derives from Delaunay's splintery forms. But the slashes of abstract line that Marin put into watercolors like this overlie a Fauvist looseness and bravado quite alien to Cubist art, and a sensation of atmospheric color that is really more Impressionist than anything else. Marin's is an ecumenical modernism; also, a robust one. There is a generosity to his art. It welcomes and absorbs its immigrant sources and fashions from them an eclectic but entirely unique state of ruggedness. This may not be quite the tough indigenous product proclaimed by the Marin myth, but it does indeed seem indisputably American: not only in its ruggedness but also in what that tends to conceal—a fine and extremely Romantic lyricism and an obvious love of fact.

The sewn-on sunburst which focuses this composition was inspired by a gold-leaf motif on the now-demolished World Building, clearly visible from the top of the Woolworth tower. Even when he appears to be at his most purely inventive, Marin is observing. The observed world is submitted, of course, to an interpretation dependent upon his borrowed styles, but the directness of Marin's engagement with it is what manages to transcend them. To the previously mentioned sources should be added that of Futurism; also an American one: Winslow Homer's watercolors, which brought a form of Impressionism to a medium appropriate to it (and again to an American sense of fact), and which Marin's modernized Impressionist watercolors rival in their simplification and in their lightness. But as is the case with Marin's other sources, these too are absorbed: by the urgency, no less, with which Marin recorded what he understood to be his own truth.

In this period, at least, it was a passionate sense of the city as an organism bursting with its own internal force. The New York City watercolors of 1922 are perhaps the strongest urban pictures of his career, and perfectly express in their fused and exploded forms the excitement of "great forces at work"—of "a sort of mad wonder dancing to away up there aloft," as he put it. At the same time, however, if we stress the velocity and exuberance of Marin's vision, and leave it at that, we distort—and minimize—his achievement. A work such as this, though indeed expressive of all that Marin says, is also still and suspended, and symmetrically bonded to realize these qualities for itself. And what provides this bonding—the abstract surface armature and (more crucial to Marin's best work) the organization of boldly contrasted zones—composes a surface that is open, aerated, and extremely light in feeling; one that exhales, through its transparency, a highly restrained, indeed reticent, color. The ubiquitous lyricism of the Stieglitz circle—which we find in Dove (p. 97) and O'Keeffe (p. 111) and Demuth (p. 143)—we find also in Marin's work, its clamor and its glamour notwithstanding. It inherits, in its own way, that same kind of cool-in-hot, post-Symbolist aesthetic that appears so often in early modern art. Its application to the city is not unusual; what is, is its vividness. More than any of his American colleagues (and most of the Europeans whose art came from a similar direction), he took his art outdoors, brushing off all that seemed musty and make-believe.

Charles Sheeler

AMERICAN, 1883–1965

SELF-PORTRAIT. 1923. Conté crayon, gouache, and pencil, 19¾ x 25¾" (50.1 x 65.2 cm)
Gift of Abby Aldrich Rockefeller

We can, if we look carefully, see Sheeler's self-portrait (minus his head) reflected in the window. But the title of his drawing is obviously ironic. In that innocent age of telephone technology when personification (now either inadmissible or Disney-contrived) was simply unconscious, it was indeed possible to present, unchanged, this egregious instrument as a ready-made manikin with mouthpiece head and ear hanging from its arm. The title alone would make the point.

If this, however, were the only point of Sheeler's drawing, we would already be turning the page. What else there is includes two other puns of a rather different kind: Sheeler's careful carpentering of the frame of the window so that it fits exactly the framing edges of the drawing, to provide a nice, snug symbiosis of subject and support; and (more subtly) the hanging white cord that invites imaginative pulling and therefore concealment of the window (and Sheeler's reflected, but not his metaphorical, self-portrait) by the white window blind. In the age of humanoid telephones, drawings—if important enough—still used to be exhibited with blinds like this, to be pulled down to keep the light from images when we had finished looking at them.

I stress these puns rather than the carefully paced and grainy beauty of this composition because they draw attention to the sense of immanence that it possesses. This scene is stopped in time, frozen to the architecture of the sheet, but contains within itself latent and concealed possibilities of time restarting. Like any important drawing, it tells us something normative to drawing itself: specifically, how the act of drawing a scene such as this is crucially a matter of somehow suspending it from the movement of time...

Drawing from an immobile object would seem to be a simpler proposition than drawing from outside nature in this one crucial respect: nature has a tendency to move, however imperceptibly, while immobile objects, by definition, stand still. And yet, to any very careful observer, immobile objects too do move; if not in space, with the movement of that observer's head or even eye, in time; and for such an observer, the act of recording the object in drawing comes down, in effect, to trying to record the present while it is taking place before it can slip into the past and be lost forever. By this I mean: experience of observation (not even of drawing) will show that fixed concentration on an object may appear to suspend time and hold it in the eternal present, but with the slightest lapse backward it jumps (in reverse, like a clock that poises for a minute at each minute mark before it lurches forward) and a new (and later) observation has to begin...which means: unless the memory of that first, concentrated observation can be preserved, a new sensation before the object (if not, a new object itself).

Some artists (notably the Cubists) have accepted and enjoyed this temporality of appearances, building it into the very structure of their works. Others (like Matisse) have wanted to cancel it out. Sheeler, strangely, does both. That telephone, for example, is frozen in time, but its temporal suspension is neither that of a Degas (p. 17), say, where an action is suspended to evoke a single, transitory moment, nor of a Seurat (p. 19), where a pose is held seemingly forever. It is closer to the Seurat, except that the subject itself metaphorically implies the possibility of change, of the sudden awakening of time's progress in a blind that can be pulled down, a reflection that can move, and a telephone that can ring.

Oskar Schlemmer

GERMAN, 1888–1943

Study for THE TRIADIC BALLET. (c. 1921–23.) Gouache, brush and ink, incised enamel, and pasted photographs, 22⅜ x 14⅝″ (57.5 x 37.1 cm). Gift of Lily Auchincloss

This technically complex work—a seamless blend of gouache, brush and ink, incised enamel, and pasted photographs—imagines the ending of Schlemmer's *The Triadic Ballet*, conceived in 1912, performed in fragments in 1915, and fully realized in its first complete performance at the Landestheater, Stuttgart, in 1922. The three parts of the ballet contained twelve different dance scenes, executed by three dancers in turn—two male and one female—in a total of eighteen costumes, which hid their bodies under padded cloth and papier-mâché forms with colored and metallic surfaces. This design shows the conclusion of the third ("Black") series of dances, with "The Wire Figure" (rear) and "The Gold Sphere" (center), who performed in the eleventh dance, and "The Abstract/The Metaphysical" (front), whose twelfth dance ended the ballet. The first ("Yellow") series of dances was of a burlesque character, danced against lemon-yellow sets; the second ("Rose") series, ceremonious, on a pink stage; and the third, a mysterious fantasy, danced on the stage we see portrayed here. Developing from the humorous to the serious, the ballet was enacted, in effect, by human marionettes moving in precisely choreographed, stylized patterns. It was the first, and most important, of Schlemmer's "mechanical" ballets organized under the auspices of the Bauhaus, and the source for those that followed.

Undue emphasis has often been given to the machinist, robotlike aspects of Schlemmer's work. His ideal was indeed a purely—even mathematically—ordered, exactly controlled, and depersonalized art form. But never a dehumanized one. We see represented here not man as machine, but man as *Kunstfigur*, whose body takes its very form from those movements and gestures that extend the body into space. Spinning, stretching, compressing, and so on, are abstracted in the bodily costumes, which, by functionally condensing the laws of human movement, smooth down the individuals to their universal archetypes. This is by no means a soulless, robotic art; rather, a coordinated form of what dance had also meant to the Symbolist generation at the turn of the century. The discussion of Derain's *Bacchic Dance* on page 40 listed those reasons why the Symbolists saw dance as paradigmatic of what all art should aspire to. Nearly all of them apply also to Schlemmer's conception of art. In the movement-expressive costumes of *The Triadic Ballet*, he realized a most basic Symbolist aspiration, for truly we cannot know the dancer from the dance. They fuse in the disciplined, dignified figures pictured here.

The drawing itself should make clear just how far Schlemmer is from being a protagonist of mere mechanization, and just how idealist his art is. The high, utterly Romantic, vantage point that dramatizes the rushing, vertiginous space of the stage, which tilts perilously down in the foreground; the frozen isolation of the figures in the cool, crisp, grisaille light; the curious and unsettling mixture of notational techniques: these details recall even the metaphysical style of de Chirico (p. 115), and similarly impart a tense unreality to the scene. But Schlemmer ennobles the fantasy in the hieratic postures of the trinity of dancers. Between them, the club of the foreground figure floats in the form of a big, shiny exclamation point. The emphasis it adds seems to animate the whole composition.

Alexandra Exter

RUSSIAN, 1882–1949

Costume design for THE GUARDIAN OF ENERGY. 1924. Pen and ink, gouache, and pencil, 21¼ x 14¼" (51.1 x 36 cm)
The J. M. Kaplan Fund, Inc.

The Guardian of Energy was a kind of chief of police on Mars, as shown in Yakov Protazonov's 1924 film, *Aelita*. Based on a play by Alexei Tolstoy, the film tells of a Martian workers' revolution as witnessed by a Soviet engineer, scenes of whose Moscow world are satirically interspersed with the imagined utopian one. (He falls in love with Aelita, the Martian queen.) It was produced by the new Moscow film studio, Mezhrabpom-Russ, formed after the introduction of Lenin's New Economic Policy, which served to soften East-West relations and brought back to the Soviet cinema filmmakers like Protazonov, who had been working in exile since the October Revolution. It was therefore a very internationally conceived production, and Exter had the ideal qualifications to design it. Not only was she highly respected for her work in the theater (she was Tairov's principal designer) and a foremost member of the Constructivist avant-garde (its machinist interests being appropriate to, and reflected in the choice of, this particular subject); additionally, she was perhaps the most internationally experienced of Soviet artists, having regularly traveled to France and Italy, where she knew the Cubists and Futurists.

Exter's designs clearly reflect knowledge of her friend Léger's classicized machine pictures of the early 1920s, and similarly present a formalized encomium on mechanical beauty. They also, however, resemble Tatlin's counter-reliefs (p. 85) cast in human form; especially this one, which is composed of a comparable set of flat and convex metallic planes arranged geometrically at right angles to the viewer. Necessarily more effective on paper (or in stills) than moving on the screen, it imagines a modernized warrior, whose spurs are levers, whose armor is boiler plate, connected by huge flanges and with a large screw-joint at the shoulder, whose gauntlets are wiremesh, and whose helmet (of the same material) exhibits an arrow-shaped needle from a dynamometer, presumably to keep track of the energy level of his brain. Like most futuristic costumes, it has a very conventional basis—here, the sinister Black Knight of medieval romance—but it is all the more telling for precisely that reason; for it thereby recalls, as it must, the associations that attach to the conventional source and project them into the new context. And the new context, though nominally of the future, clearly belongs to 1924. T. S. Eliot once observed that historical fiction tells us far more about the time of its creation than of the time it attempts to recall. The same is obviously true of science fiction. Even the face in this drawing bears this out. There seems to have developed in the 1920s a convention as to the desirable appearance of machine heroes: a keen eye; clear-cut features, with a stern little crease or two; a rigidly horizontal line of a mouth above a stubbornly projecting lower lip-cum-chin; preferably bald; and always to be seen in profile. (The Grosz on p. 129 shows exactly these features too.)

Aelita turned out to have been a dream. The engineer awoke, and threw into the fire the plans for his Martian journey, calling for a return to serious work. Allegories often take the form of journeys—which are similitudes of metaphorical "journeys": through life usually; here, to revolution—during which the hero meets a sequence of figures, each of which is a trope, signifying a particular burden to be overcome. The hero usually wins; but not here. The dictatorship of the Guardian of Energy is reestablished in 1924—the year that Lenin died and Stalinist repression began. As utopia became dystopia, Exter herself, in 1924, moved to the West.

Fernand Léger

FRENCH, 1881–1955

Study for THE CREATION OF THE WORLD. 1922. Pencil, 8¼ x 10⅝″ (21 x 27 cm)
Gift of John Pratt

The very unusual Léger drawing reproduced on the opposite page is a set design for the one-act ballet *La Création du Monde,* first produced by Rolf de Maré's Ballet Suédois at the Théâtre des Champs-Elysées in Paris on October 25, 1923. Based on a text by Blaise Cendrars, with music by Darius Milhaud, choreography by Jean Borlin, and set and costumes by Léger, the ballet was one of those great, fugitive collaborations among the Parisian avant-garde that characterized the heady, optimistic days of early modernism. As the curtain rose, the stage was seen to be filled with huge, silhouetted figures almost twenty-seven feet high before triangularized mountains with clouds in the night sky above them. This is what the drawing shows. Slowly the clouds began to part—to the rhythms of Milhaud's music—and as the stage lightened the giant figures slid out to the wings to reveal the life-sized ones that were to perform the ballet itself. What we see here, therefore, is a design for a *tableau vivant,* conceived on a monumental scale: the plan of a self-sufficient moving picture that was itself, alone, an integral element of the performance, rather than a stage design in the conventional meaning of that phrase.

As the inscription on this drawing indicates, *La Création du Monde* was a "ballet nègre." "I created an African drama," Léger recalled. "I took as my point of departure some African statues from the great period. The original dances served as guides. Under the aegis of three Negro gods eight meters tall, we witness the birth of men, of plants, and of animals." Fascination with the primitive, so-called, is of course much older than modern art, although its impact on the visual arts is to be particularly associated with the early modern period. The classic Lovejoy-Boas explanation of this phenomenon is "the discontent of the civilized with civilization." Léger, so often the celebrant of the civilized modern, not surprisingly makes few explicitly "primitive" references in his art. Their appearance here may seem especially surprising since this was the period of his great classical figure compositions. His attraction to this subject, however, is to be explained not only by the popularity of black performers in the 1920s, which made this ballet a very topical production, but also by the depersonalized character of his style, whose stripped-down forms were reductively primitive. It was an exceptional challenge to make these forms receptive to African imagery—and one not accepted again—but an art that could find ready analogy between Neo-Classical nudes and machine parts was certainly capable of it. And if the result seems as modern and mechanical as it does primitive (the robot association of these figures is inescapable), then that was only to be expected from someone as immersed in the machine world as Léger was. A month or so after *La Création du Monde* opened, he went with some friends to one of the dance halls he liked to visit and found one of the female dancers especially fascinating. "Look at that woman," he finally whispered. "She's beautiful. Like a gas meter!" The African drama portrayed here is also a modern drama, as much a vision of the technological future as of the primitive past.

Joan Miró

SPANISH, born 1893

THE FAMILY. 1924. Charcoal, chalk, conté crayon, scored, on sandpaper, 29¼ x 41″ (74.1 x 104.1 cm)
Gift of Mr. and Mrs. Jan Mitchell

Around the time that he made this drawing, Miró began to talk about wanting to "dépasser la plastique cubiste pour atteindre la poésie." The year 1924 saw the publication of the First Surrealist Manifesto, expressing "belief in the superior reality of certain forms of association heretofore neglected..." That same year, Miró was introduced by his Surrealist friends to the work of both Arp (p. 113) and Klee (p. 135), and found in their improvisatory, organic forms of drawing confirmation of what he was seeking in his own art: a new freedom of invention (made possible by the use of newly inventive subjects, and manifested in their drawing) that would loosen and expand Cubist design while retaining its formal stability. *The Family* is drawn on the faint vestiges of a Cubist grid. These just-visible ruled lines served the traditional purpose of allowing Miró to scale up to this work the preliminary sketches that established the parts of its composition. But they also provided a firm structural scaffolding of verticals, horizontals, and diagonals to which the work is aligned. Around this grid, however, wanders a meandering line that strings together Miró's fantastic images to form a draftsmanly equivalent of verbal free-association. The line, moreover, describes objects in a diagrammatic, not illusionistic way. It is a kind of drawing (like Klee's) that the French call *écriture;* akin to writing, it tells of the world not by mimesis but by signification. For Miró, it was the way to go beyond the *plastique cubiste.* It made art into a kind of pictorial poem *(peinture-poésie)* that opposed the purist abstraction (or *peinture pure)* to which Cubism was tending. Miró's aim was to attain "poetry."

The Family is not a study for a painting, but an independent and elaborate large drawn picture, preceded by preliminary studies and painstakingly reworked (as is evidenced by its pentimenti) to establish and abstract its iconography. This is extremely complex, but its main features are these. The members of the family (which is a bourgeois one, Miró says) consist (from left to right) of a father, mother, and a little boy. The father, with moustachioed hair and displaced eyes, is smoking a pipe, holds a newspaper in his hand, and has scattered beside him a discarded shoe and sock and a pair of dice. His whiskery black ball of a head is rhymed with the larger, sunlike head of the mother, and his exposed innards with her breasts and amatory flaming heart, beside which rises a larger flame, intersected by a pin in the form of an arrow. The mother analogizes Mother Nature, growing from tree-root genitals that center her stick-figure legs. The child is rather like a toy on a stand. His head echoes the soccer ball in the foreground. To the right we see his hobbyhorse, a conical piece of furniture, a wasp; and peering in on this domestic scene, a disembodied eye at the window. All this fills out the frontal space of the drawing, adumbrating a kind of "alloverness" not to be found in Cubist art. Since collage, Cubism had been an art of placement, of balancing elements across the entire pictorial surface (see p. 80); but loosening of Cubist design and freedom from Cubist drawing were required before the entire surface could be equally addressed. Miró's art is an art of draftsmanship, of inspired, inventive drawing. He discovers through drawing the generating forces and axes of the surface, which find their expression by means of the shapes and images the drawing assumes. Imagery, by revealing the format of the drawing, reveals itself. And all is joined in an almost conversational flow of movement that runs along these three figures' common, continuous, curvilinear arm.

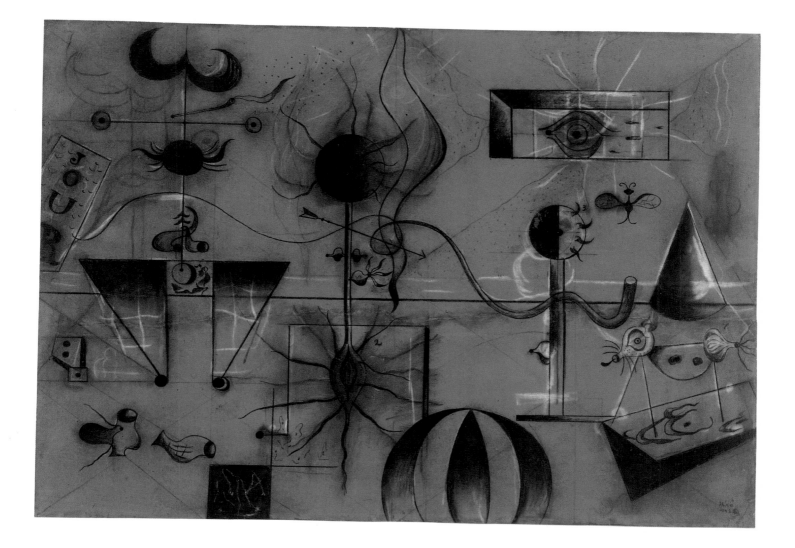

George Grosz
GERMAN-AMERICAN, 1893–1959

CIRCE. 1927. Watercolor, pen and ink, and pencil, 26 x 19¼″ (66 x 48.6 cm)
Gift of Mr. and Mrs. Walter Bareiss and an anonymous donor (by exchange)

George Grosz is frequently described as a satirical artist. And yet, the harshly invective caricatures of c. 1919–23 for which he is best known more properly belong only on the boundaries of satire. For true satire requires not only a misanthropic temperament, a decided object of attack, and a clear-cut notion of what constitutes morality (all of these things Grosz had in plenty); also, enough of a sense of irony to inject into the attack at least a touch of wit or humor, albeit of a fantastic or grotesque kind. Without that, we move into sheer denunciation, which is what Grosz was producing, by and large, at the beginning of the 1920s, with a vitriolic hatred of his bourgeois surroundings that was so intense as to disallow satire, which, in Northrop Frye's words, "breaks down when its content is too oppressively real."

After 1923, however, and the stabilization of Weimar Germany, Grosz's work began to change. Much that he subsequently produced became almost documentary, neither invective nor satire. With *Circe,* though, Grosz returned to the theme of degenerate bourgeois eroticism that had marked his perhaps most notorious portfolio, *Ecce Homo* of 1922–23; but he recast the grotesque horror of that earlier work into the satirical mode of grotesque humor.

The subject of *Circe* is revelation of private bestiality beneath the public mask. Its method is a satire of simple displacement in which is presented a topsy-turvy world dominated by low passions, and it is left to the observer to make the necessary comparison between the fantasy that he sees and the moral norms by which it is judged. As with many of the most successful satires of this sort, the form of the displacement is extremely primitive, and comes down to a kind of visual name-calling that relates to the use of taboo animal categories for verbal abuse. What is strange about the work, however, at least in the context of Grosz's earlier indictments of bourgeois animality, is its expression of this subject through the Circe legend. This would seem to deflect responsibility for what we see from the prosperous bourgeois to his presumably paid companion (since it was Circe in the story who through her temptations transformed men into swine) and therefore to soften the social implications of the work. And yet, the moral remains ambiguous, for this Circe is not a very convincing temptress. Much of the color of her flesh seems to have been drawn out of her body (through some sort of capillary action, perhaps, at the touching of the two tongues), and as the sanguine and anemic faces meet, it is difficult to be sure whether it is the blank boredom of Circe or the ogling thirstiness of the bore which is to be held accountable for the change from man to beast. In treatment, certainly, this is a softer and more ambiguous work than previous Grosz versions of similar themes, replacing the earlier acidic Expressionism with an almost sensuous fluidity in the use of the watercolor technique, which dissolves in its wetness the cutting edges of Grosz's misanthropy.

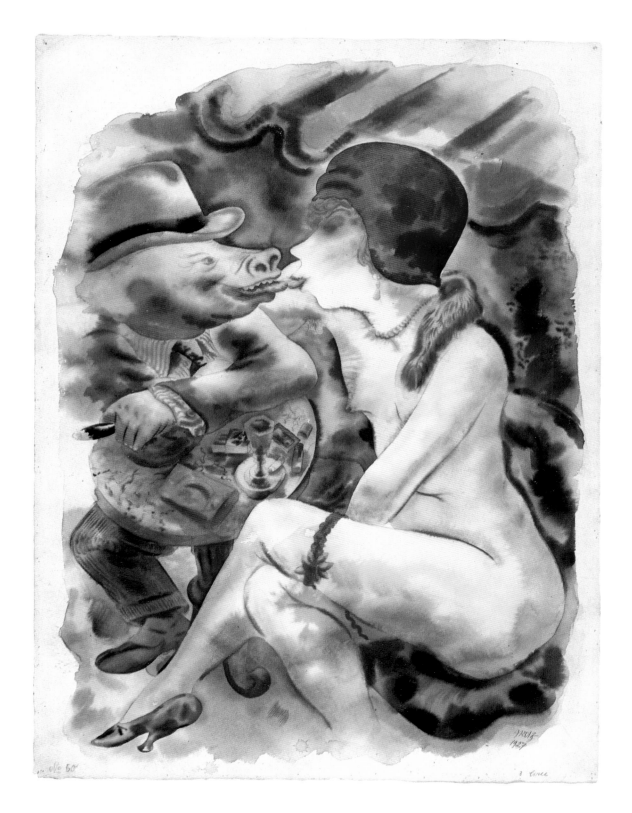

Emil Nolde

GERMAN, 1867–1956

MAGICIANS. (1931–35.) Watercolor, 20⅛ x 14⅜″ (51.1 x 36.5 cm)
Purchase

Although known as *Magicians,* this watercolor may be simply a picture of two peasants. Either way, a narrative relationship between the figures is implied, but not specified, although it has something to do, clearly, with a sleight of hand involving a snake.

Nolde is usually associated with Die Brücke, the Dresden Expressionist group to which Pechstein (p. 53) belonged. He was, however, only briefly a member (1906–07) and more properly should be considered a solitary, independent—indeed, fiercely independent— Expressionist, who maintained the original heatedness of its pre–First World War form in the face of its cooling by virtually all of his contemporaries. Although, then, briefly an "avant-garde" artist, he resisted the momentum of the avant-garde—and thereby (as Harold Rosenberg wrote of artists of this kind) "recovers the moment which avant-gardes have passed over, bringing to light the demons lurking in it to frustrate the forward march of the idea." He specifically recovers, and preserves, that explicitly Germanic ideology of Blood and Soil that was so essential a part of the early moment of Expressionism. It was a reaction against materialism and a return to the primitive, the *Ur-,* and to an indigenously Nordic idea of "community" *(Gemeinschaft)* apart from corrupt "society" *(Gesellschaft)*—an earthy, earthly Paradise where instinct, emotion, and simple religion reigned. But also one whose picturing—in Nolde's art, at least— reflects the repression from which it escapes, and even a sense of guilt at its enjoyment.

I draw attention to these matters because Nolde's art is at once earthy, physical, and spontaneously sensual and curiously coarse in its execution, in oil painting at least. And it is not simply Expressionist rawness. The paint in his oils is heated, rich, and "expressive," but often (though not as often as in Rouault's art, of which Clement Greenberg makes this point) "seems to have a life independent of the subjects to which it is applied. We come away remembering *paint* instead of single pictures." This is indeed curious, and seems to reflect almost contempt for things material. Expressionist art in general frequently opposes the material and the spiritual, conceiving the former as a rigid crust containing the force of the latter (see p. 98). Nolde's work reveals such opposition; but more than that, it seems to reflect repression in its very surfaces, which are so brutally blunt as to be simultaneously expressive of the sensual and disdainful of it.

This is not the case with his watercolors. The lightness of the medium escaped that dangerous physicality. Though not by any means guilt-free, they show such command of and sensitivity to what watercolor can and cannot intrinsically do that the medium at once is exposed for itself and exposes in itself the depth of Nolde's mixed emotion. Necessarily made quickly, watercolors satisfied his moody, impatient temperament, which itself prevented his falling into mere facility. Difficult to revise, they preserved the freshness and vividness of his conceptions. Allowing dissociation of line and color, they give to both increased expressive force: the brilliant linear hardness of this work fixes its spreading sonorous color. His close-to-the-surface, tightly composed style is saved from airlessness as a wonderful silver, cool Northern light breathes through the densely mottled surface. Nolde's watercolors are beautifully sensuous in their view of the world. And when, as here, they are tense and somewhat troubling, they never confuse the expression of confused emotion with the creation of a confused art.

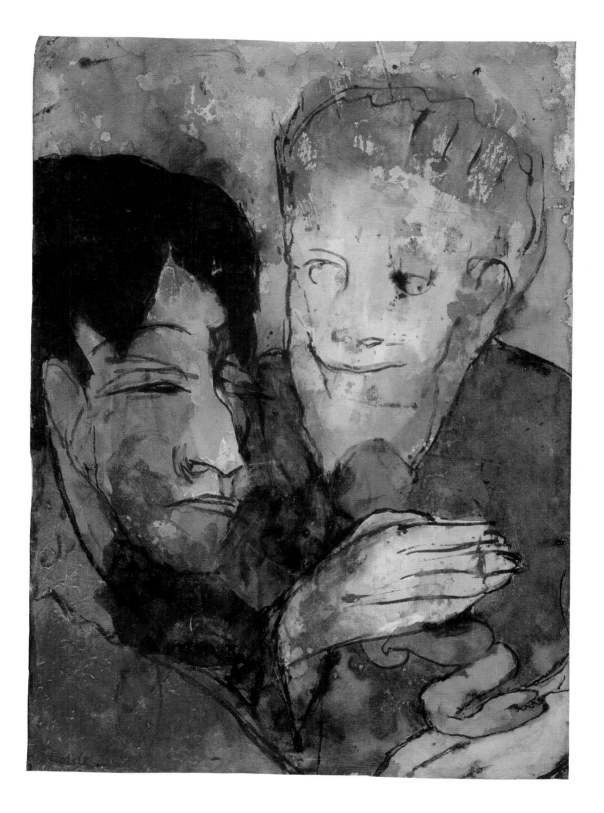

Christian Rohlfs

GERMAN, 1849–1938

MAN IN A TOP HAT. 1935. Watercolor and crayon, 19⅞ x 13″ (50.5 x 32.8 cm)
John S. Newberry Collection

This technically original and extremely mysterious work—at once realistic and removed entirely from the world—was made by Rohlfs three years before his death at the age of eighty-six. A full decade older than Seurat and the contemporary of Gauguin and van Gogh, Rohlfs lived virtually without contact with the world of advanced art these artists and their successors formed, and (until his marriage at the age of seventy) alone, in relative seclusion even from the social world. Schooled in nineteenth-century naturalism, he was in his mid-fifties before he fully confronted modern art. In 1906, he came to know Nolde (and therefore early Expressionism) and began to teach at the Folkwang school at Hagen (where there was an important international collection of Symbolist and early twentieth-century art). Having taken this dose of modernism, he increasingly withdrew into his isolation, as his art moved from—and occasionally combined: he never settled into a singly sustained style—naturalistic preoccupation with objective appearances to an almost visionary interpretation of what he observed. In his old age, these obvious opposites harmonized—at which point his art recalls, more directly than it had done since his exposure to modernism, the naturalism of his beginnings. What, however, is recalled is not so much the objective naturalism of immediately premodern painting but that of comparable literature, where objectivity was applied to more intrinsically dramatic and emotive subject matter. Just as naturalism in literature fixes precisely in place scenes whose drama is partly older and woodenly stylized and partly newer and psychological, so Rohlfs seems to combine the anecdotal and the ominous. A cross between Mr. Micawber and Edvard Munch's early top-hatted specters, the figure shown here, as if behind a pane of rain-streaked glass, is at once a bourgeois citizen, formally dressed, and a shadowy apparition, shallowly suspended in the unreal space of his surroundings.

Rohlfs was consistently more successful as a draftsman and printmaker than as a painter. Historically, his anticipations, in painting, of Feininger's visionary architectural style (p. 99) are of considerable interest, but their dematerialized transparencies seem clumsy and forced. His graphic work, until the 1930s, does not fully address the issue of dissolution of form, tending to an uneasy linearity and often, in his prints, to the grotesque. But in his mysteriously lit watercolors of the 1930s, he finds finally a way of evoking, on paper, a shimmering, unreal, and otherworldly atmosphere within which forms give up their palpability but never their sense of objective presence, and one that incorporates, but not egregiously, the bizarre aspects of his prints. Here, the looming, uneasily mute figure quietly conveys a brooding sense of menace, even. Flattened to fill out the frame of the drawing, and thereby advanced, close up to the viewer, it projects a shadowy, smudged world; but modestly. The sensitive fusion of dry and wet media in this drawing, smeared and rubbed into the sheet, creates a masterpiece of virtuosity, but does not proclaim itself as such. There is something exemplary in the patient, steadfast, and obviously doubting personality that Rohlfs presents in his art, which criticizes the gregarious loudness that forms part of what modernism is. This he had to reject, finally, even if it meant rejection of the more obviously modern features of his art as a whole. His was not a major art, but in the end it was a scrupulously honest one.

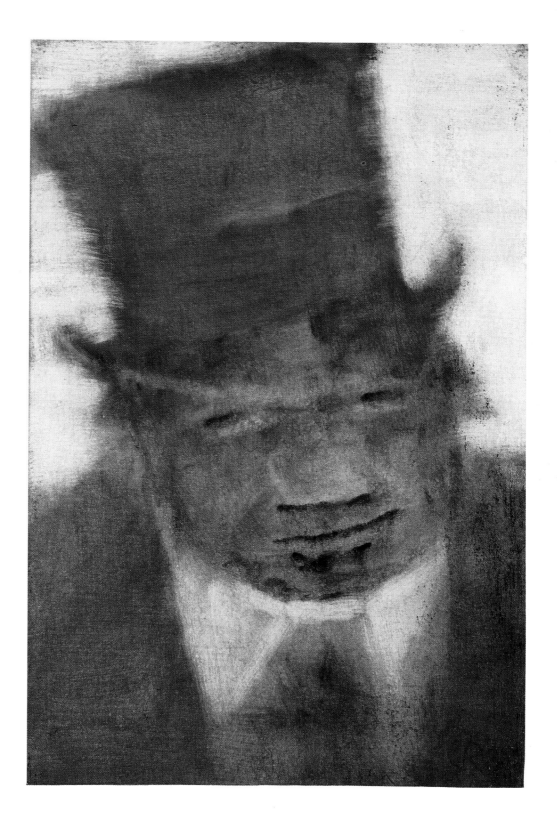

Salvador Dali

SPANISH, born 1904

STUDIES OF A NUDE. 1935. Pencil, 6⅞ x 5½″ (17.5 x 14 cm)
James Thrall Soby Bequest

"Modernism" is a selective but not a voluntary term. It is selective in usually admitting, say, Camille Pissarro but not Léon Gérôme; Andy Warhol but not Andrew Wyeth. It is not a voluntary term, however, in that (to alter one of Northrop Frye's sentences on Romanticism) it does not see Cézanne as the successor to Poussin or Dali as the successor to Vermeer, which filiations would have been acceptable enough to both artists; it associates Cézanne and Dali, to their mutual disgust, with each other (and all kind of superficially incompatible figures beside).

The principal subject of this sheet of studies bears a general resemblance in pose to the Cézanne *Mercury* reproduced on page 21. It is a common enough pose, and Dali's work would seem to have nothing at all to do with the deeply formal and specifically modern concerns that animate the Cézanne. While an extremely beautiful drawing, it appears to be a very conservative one. And yet, though Dali is a much slighter as well as later modernist, he too addresses that issue central to many modern representational works of art: the reimagination of sculptural illusion on a surface grown so sensitive in its flatness as to squeeze volumes virtually out of existence except in a highly schematized form.

The art that accompanied the First Surrealist Manifesto of 1924—notably Miró's (p. 155)—was excused from addressing this issue because, while representational, it was nonillusionistic. In 1929, however, the date of the Second Surrealist Manifesto, when Dali burst on the scene, the earlier "abstract" form of Surrealist art, based in automatism, was finally superseded in popularity by its more academic opposite pole, "dream image" illusionism. Since after the First World War, illusionism had returned in avant-garde art, in reaction to the increasing autonomy achieved by art of the Cubist tradition (see p. 118). Throughout the 1920s, abstraction and illusionism of different kinds competed for importance. After 1929, however, and not only in Surrealism, illusionism emerged actually to dominate modern art for the first time. The same problem which obsessed Cézanne—how to provide an illusion of volume that did not disrupt the surface continuity of the sheet—was therefore Dali's problem. He too provides what seem to be fully rounded illusions yet turn out to be illusions of bas-relief: none of the forms appear truly to have backs; nor, despite the tantalizing shadows, do they create the illusion of space behind them. And in the case of the principal subject, the accommodation of modeled form to the two-dimensional surface is reinforced by the distortions produced by shifting viewpoints on the figure—which accounts for the unnatural protrusion of the far breast and the forward bending of the leg—while the hardly accidental elision of figure and independently floating foot emphasizes the freakish unreality of this highly self-conscious work.

Dali's self-conscious manipulation of ambiguous volumes represents an indirect study of the same formal questions that obsessed Cézanne: indirect, because it is self-conscious. Self-consciousness about styles and methods is an essential part, indeed a defining characteristic, of earlier, classic modernism. But in a neomodernist art like Dali's, which refuses—as unduly traditional—earlier formalist belief, it reaches the extreme of sheer technical introversion, manifesting an ironical, distanced self-awareness with regard to artistic language that approaches, here, the supreme modern irony of historicism.

Joan Miró

SPANISH, born 1893

SELF-PORTRAIT, I. 1937–38. Pencil, crayon, and oil on canvas, 57½ x 38¼″ (146.1 x 97.2 cm)
James Thrall Soby Bequest

The collapse of self-portraiture is one of the most curious, indeed definitive, features of modernism, not entirely to be explained by the growth of abstraction, for other traditional genres that remained potent at the beginning of the modern period have not fallen into decline in quite the same way. Since Post-Impressionism, or perhaps a little later, self-portraits have rarely been among the greatest modern works. Expressionist self-portraits are only apparent exceptions—an artist like Dix (p. 127), for example, produced what are, in effect, persona-portraits that hide the self behind self-confident masks, at least always dramatic ones, which like the masks of ritual possess the man who assumes them. They present an aggressive face to the world. And far more frequent among successful modern self-portraits are those that ironically distance the genre itself. Sheeler's (p. 147) is an extreme example of this. In Dix's aggressive and Sheeler's effacing views of themselves we see, perhaps, no more than the two common and traditional ways of opposing self and the world. But we expect of art that it join, not oppose, and are surprised when the modern self-portrait opposes.

Drawing, in its own private way, has produced more authentic modern self-portraits than has public painting—often, however, at the expense of a certain largeness of conception that privacy itself seems to disallow. This Miró was begun with the intention of producing a painting (hence its canvas support) and coopts from painting its ambitiousness along with its size, but it remained a drawing: one of the finest of all modern drawings and probably the greatest self-portrait drawing this century has produced. It too opposes itself to the world, but with a version of the self drawn from within the crevices of appearance, and enlarged. From the very contours of his features Miró extracts an aggregate of details—stars, sparks, flames, and suns—which, magnified, materialize a burning and imaginary world. This world seems more real than the apparitional figure that releases them, fades transparently into smoke, and leaves of itself (beside these details) only those wiry outlines and folds of itself that can survive such conflagration. To remember the date of this work, and Miró's nationality, and what had been happening in Spain, is necessarily to discover connotations of tragedy in this image of apocalypse. And to remember the context of Miró's art is to see here his art personified, and revealed, through this revelation of the self, as an art essentially of the grotesque—in its correct technical sense as a kind of swarming, organic ornamentality; and in its accrued modern sense as something that extracts pleasure from the fearful and solace from tragedy. The artist's social and aesthetic worlds find complementary expression in this fantastic and moving self-image. If it renounces the color we associate with Miró, it does so to return to the grays of Spanish memory.

Clearly, the freedoms achieved by modern art are partly responsible for the demise of the self-portrait. All art is self-portrait, apparently, but not private disclosure, for modern art tends usually to support Mallarmé's requirement "that the poet vanish from the utterance." Here, Miró vanishes *into* it. This drawing recalls another famous modern portrait, Hans Castorp's "transparent portrait" of his unattainable beloved in *The Magic Mountain* which he found far more intimate than the "exterior portrait" painting he had once admired. It was her X-ray. It is to the condition of this kind of intimacy that Miró's work aspires.

Henri Matisse

FRENCH, 1869–1954

RECLINING NUDE. 1938. Charcoal, 23⅝ x 31⅞″ (60 x 81.3 cm)
Purchase

Since his famous "Notes of a Painter" of 1908, Matisse had regularly talked of his wanting to produce a "condensation of sensations" that would express in the most economical way the "essential character" of beings and things underlying their "superficial existence"; also, how he deployed his pictorial means to do so. Fauvism (p. 43) finally seemed to produce too fugitive renderings of subjects. He therefore developed an abbreviated linear vocabulary that studied subjects for analogous forms, thus to reveal their "essential character" (p. 57). During his so-called Nice Period (1917–30), this approach was tempered by more naturalistic renderings. By the mid-1930s, however, a new version of the earlier, simplified style was firmly established. Drawing as a means of condensing was therefore brought back to importance. Indeed, drawing itself carried more of the impetus of his art than it had done for many years. If anything, the importance of drawing was greater than at any previous moment. Before the 1930s, Matisse had drawn as he painted (and vice versa) as he formed imagery on the canvas. By the date of the work reproduced here, drawing in his canvases often acted in counterpoint to large areas of intense color. More even than before, drawing is isolated as an image-condensing act.

Matisse tended to use softer, more pliable media—like pencil or charcoal—for explorative drawings. "A less rigorous medium than pure line," he wrote, "...enables me to consider simultaneously the character of the model, the human expression, the quality of surrounding light, atmosphere, and all that can only be expressed by drawing"—and from these things condense the essential character in line. To wrest from the process of drawing his models' linear images that signified not merely their appearance but "the emotional interest aroused in me by them" was the purpose of works such as this. Subsequently, he would make pen drawings—"no correction possible"—and there reimagine the purified images he had discovered. These finished products Matisse himself prized most. It is certainly arguable, however, that witnessing the struggle to achieve purification is more rewarding an experience than sight of the chaste result. The sublimity of Matisse's charcoal drawings, in which he searches and erases, and rubs down the forms, only to draw them again and again, tends certainly to support that proposition. In this audacious work, a true picture of creation and, superimposed, of its realization is revealed. "I am driven on by an idea," Matisse wrote, "which I really only grasp as it grows with the picture." We see in this drawing exactly what he means. It takes astonishing liberties with representation in order to channel and condense feeling in its linear armature. The emotional interest created in him by his models "does not appear particularly in the representation of their bodies, but often rather in the lines or the special values distributed over the whole canvas or paper, which form its complete orchestration, its architecture." Again, these are Matisse's words, to which he quickly adds, "It is perhaps sublimated sensual pleasure..."

All the foregoing quotations derive from an essay, "Notes of a Painter on His Drawing," that Matisse published the year after this drawing was made. In it he elaborated, for the first time, not only the methods but the results of his condensing drawing process. He aimed to produce, he wrote, a kind of "plastic writing," a language of "signs"—signs that inhabit a new kind of spatial planar perspective. This he called "a perspective of feeling."

Paul Klee

SWISS-GERMAN, 1879–1940

HEROIC STROKES OF THE BOW. 1938. Tempera on paper on cloth, 28¾ x 20⅞″ (73 x 53 cm)
Nelson A. Rockefeller Bequest

Klee's line is the notational line of writing that signifies without describing. Technically, then, this particular Klee is a boustrophedon, with lines written alternatively from right to left and left to right as in ancient Greek inscriptions. The lines cut furrows in the blue ground as backward and forward they plow up the height of the sheet. I stress the inscriptive and associated agricultural connotations of this work (boustrophedon is literally "ox-turning") before mentioning the allusion to violin-playing provided by its title because the signs that Klee used no more imitate movements than they imitate objects, or than a footprint imitates a foot. They do, of course, refer to movements in space as they refer to objects in space, but they belong to surfaces and carry meaning simultaneously with their division and transformation of surfaces: indexically, just as furrows refer to the plow, and hence to the culture and associations that attach to it. Klee's titles are important. But Klee, here, is not simply asking us to see the zigzag lines as capturing the rhythms of violin-playing. He is calling our attention to how signs that are internal to a pictorial space allude, by virtue of their being traces of inscriptive movement that produces pictorial meaning, to other such meaning-productive movements and signs. Here, we are directed to musical performance; also, by implication, to musical notation. A composition closely related to this, from the same year (*The Gray One and the Coast*, Felix Klee Collection, Bern), refers us to the pattern of a coastline, and the interpenetration of movement between sea and land. But that too creates a nonspecific pictorial mobility in which the systole of the line condenses its energy, forcing it onward—only to be checked at certain diastolic turns, where the line, by dilating, spreads its energy into the surrounding space, opening and expanding its flatness, which it animates, even as line itself stays separate and apart.

In the 1930s, Klee's art becomes broader in scope, and shows an even greater range of pictorial and thematic inventiveness than it did previously. Something was lost by this. His very fertility of vision seemed to have led to a willful experimentality that destroyed the unity and coherence of his style. Out of this, however, came some extremely moving and more serious pictures, which set aside most of the whimsy of the earlier work along, often, with its miniaturist scale. In 1932, he began to develop the new kind of heavy, brush-drawn line that we see here: by expanding his usually delicate calligraphy (p. 135) into thickened, barlike symbols as he increased the size of his works to accommodate them. This gives a new autonomy to his line drawing. Each line is now a shape in itself, one of a number of flat, drawn elements that are laid out across the flat surface. And the surface itself receives more emphatic attention, appearing now not an opening onto an illusionary space (though it does open a limited space), but a richly nuanced and sonorously colored skin, with the tautness of a drum and a liveliness of handling that makes it seem to breathe, exhaling its color into the air around it. This combination of painterly line and responsive surface was one of Klee's most productive discoveries. For the first time he could lay out his compositions rather than draw them in. In works of this kind, which are among his most solemn and most resonant, Klee liberated himself—in a way, more completely than he had ever done before—from Cubist-derived conceptions of drawing and space, and pointed the way to the expansive "fields" of post–Second World War art.

Joan Miró

SPANISH, born 1893

THE BEAUTIFUL BIRD REVEALING THE UNKNOWN TO A PAIR OF LOVERS. 1941. Gouache and oil wash, 18 x 15″ (45.7 x 38.1 cm). Acquired through the Lillie P. Bliss Bequest

The word "revealing" that is traditionally used in the title of this work paraphrases Miró's *déchiffrant:* "deciphering." His beautiful bird (in the upper right, with yellow eye) is deciphering the unknown to: a huge woman (below the bird) with a white eye, targetlike breasts, black and red vulva, and buttocks in the form of a black double crescent (these latter three features also combining to suggest a face); and to the left of the woman, her little blue-eyed lover. Above the man's head, a worm-bodied snail approaches a crescent moon. Above and below the bird, a star and a ladder can be found. But the rest of the signs refuse deciphering. They are the unknown.

The Constellation series, twenty-three gouaches made between January 1940 and September 1941—of which this is the twenty-first—were based on the idea of reflections in water. The same subject that informed Mondrian's Pier and Ocean drawing of 1914 (p. 103) here too provides an allover system of flickering signs (which looks back, ultimately, to Impressionist alloverness), but one that rejects the geometry of Mondrian's post-Cubist style for a freer morphology of curlicue tracery and atomized, spotted forms laid out on a misty ground. Miró spread oil wash on moistened paper, scraping and abrading it to give it texture. This gives the surface at one and the same time an illusion of optical, unreachable space and a sense of resistant tactility—but tactility that is felt as if actually behind the spatial illusion. It is palpable enough to disembody, by contrast, the foreground figuration, which therefore flickers and dissolves across the ground, but intangible enough to be distinguished, by contrast, from that figuration, whose relation to it is therefore analogous to that of highlights sparkling on the surface of water.

The Cubist, geometric underpinning that had stabilized Miró's arabesque drawing in *The Family* of 1924 (p. 155) had gradually been surrendered in the later 1920s. Simultaneously, he opened his compositions so that they typically comprised a few disembodied sign-lines and shapes floating across a single-color field. These so-called Magnetic Field pictures—while stunningly audacious and exhilaratingly open—are less tautly stretched as compared to *The Family* and preceding works, and their drawing—though more fluid than hitherto—slows in momentum as it has to find its way alone across the surface. Furthermore, the crisp ornamentality that had characterized his episodically composed earliest mature pictures (c. 1919–23) had completely disappeared. In the early 1930s, however, Miró began to fill out his pictures more, while usually reducing their size. As a result, the slow arm drawing required by the large, spare 1920s compositions gave way again to the quicker hand and wrist drawing that we see used here. Not only does this tauten Miró's art, reintroduce the ornamental, and give more for his draftsmanly sensibility to work on; it also serves to affirm the hieroglyphic, handwriting aspect of sign-making, which is finally its most appropriate form. In the Constellations, it overruns smaller-sized versions of the open fields of the 1920s. These works in effect superimpose the episodic ornamentality of Miró's art before *The Family* on top of the openness that came after it. But having dispensed with the Cubist geometry that accompanied his early ornamental style, he transforms the episodic into a kind of alloverness, reminiscent of Analytical Cubism and of the Pier and Ocean Mondrian, but in his own curvilinear terms. Works like this had a profound effect on the development of allover Abstract Expressionism.

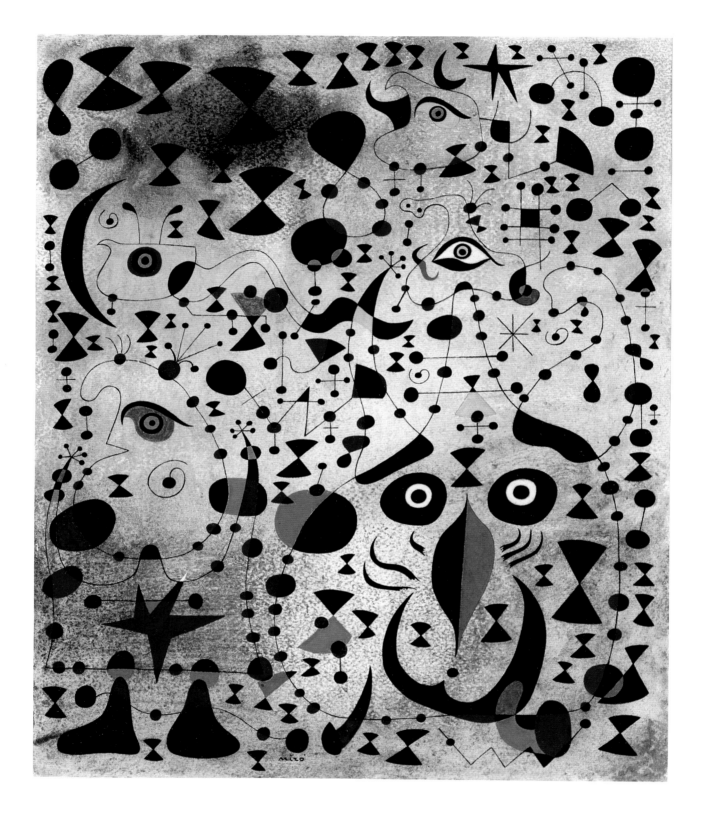

André Masson

FRENCH, born 1896

STREET SINGER. 1941. Pastel and collage of paper, leaf, and dragonfly wings, 23½ x 17½" (59.6 x 44.7 cm)
Purchase

The Masson shown here is by no means typical of its artist. The hard, "slow" lines, the geometric stability, and the topical, urban subject—indeed, the collage method itself—are all very far from the restless linear automatism, metaphoric of violent biological growth, that we associate with Masson, even in this transitional period of his career. It is often, however, in untypical works that artists, though seeming only to reveal unusual aspects of themselves, actually betray their most personal traits. In fact, next to mediocre works of art—which are the most personal of all (because most peripheral to the total structure of art to which they are attached)—it is untypical works that most readily betray their creators' idiosyncrasies: because they are not as constrained by the impersonal logic of a particular, developing oeuvre or by the tradition to which that oeuvre belongs. More often than not, however, to reveal the personal is also to reveal what one shares with the rest of one's generation. This unusually playful Masson reminds us that the Surrealists were inheritors of the hedonism of the School of Paris, although unable to discover it in the hostile external world. Art itself therefore became a kind of play.

This collage was made in July 1941. Masson had arrived in New York (via Martinique) at the end of May, driven to America by the fall of France, after having been driven from Spain (where he lived from 1934 until 1936) by the Civil War. It fills a Cubist grid, reminiscent of Masson's earliest work, with elements that are used—as is usual in Surrealism—as much for the surprise of their juxtapositions as for the objectlike presence that "real" materials confer. (Juxtapositional surprise extends even to the superimposition of Surrealist on Cubist forms, which makes the work at once objectlike and illustrational.) Given the detail of the dress, the singer would seem to be Spanish. Her torso, however, comprises a line-by-line pun of imitation brick wall and real sheet music, proclaiming a song that warns of "strange things on the Bowery." Her head is an American maple leaf and her bust a set of dragonfly wings, recalling Masson's absorption in the more exotic forms of nature, recently reinforced by his stay in Martinique. Given the topical and autobiographical connotations of the work, it is entirely appropriate that the title of the song is *Our Times.*

Even the plural pronoun is appropriate, for the playfulness revealed in this work is indeed personal not only to Masson but also to his times. "Playfulness" may not be the first word to come to mind when we confront his own more violent productions or those of the other Surrealists. They, however, constitute a play with the terrible in nature and with its element of the unknown. In making this point, Clement Greenberg observes that the post-1918 School of Paris in general exhibits a disillusioned view of the world. No longer confident that man's art could control physical nature for the sake of man's well-being, the Surrealists (he notes) escaped into play—play with the dangers and mysteries of an uncontrollable world. The escape, in abstract Surrealism, is from the physical itself: into the "poetry" of nature as if seen on the inside. In illusionist Surrealism, a form of external reality is presented, but in a dramatized way. The former makes art from play, from automatism; the latter uses art to make life look like a play. Masson, in this exceptional work, precariously balances the two approaches, presenting an internal and poetic version of reality as if on a stage.

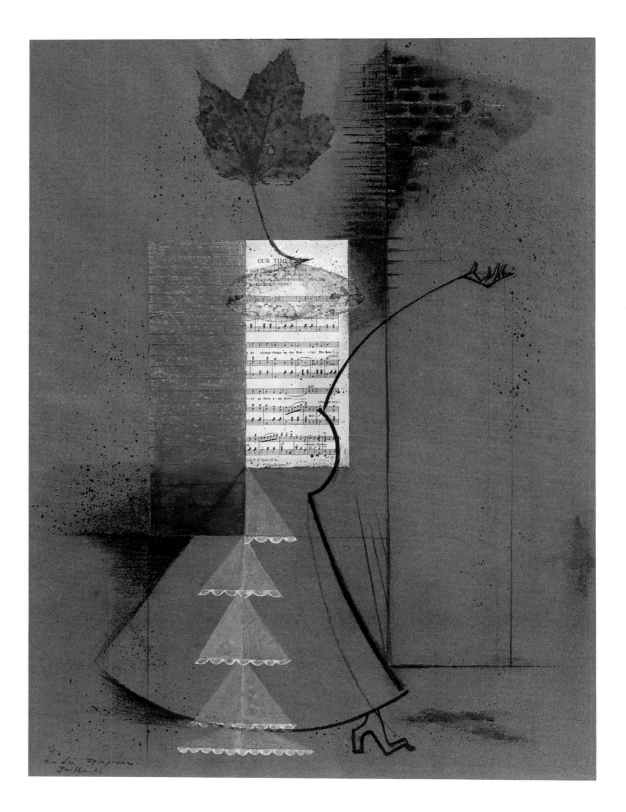

Julio González

SPANISH, 1876–1942

STANDING FIGURE. (c. 1941.) Watercolor, brush, pen and ink, 12½ x 9⅝″ (31.8 x 24.3 cm)
Gift of James S. and Marvelle W. Adams Foundation in honor of Andrew C. Ritchie

Drawing is integral to González's sculpture. Drawings, however, were secondary, and usually subsequent, to it. "What is peculiar to González," William Tucker observes, "is the *identification of drawing with making.*" His sculpture is usually summarized as "drawing in space," and indeed it involved absorption of drawing as well as of construction into the welding process he used. In Tucker's words, "The action of the sculptor's tools *becomes* the form of the end material." The cutting, rolling, bending of metal, as well as the discovery of already drawn shapes in found pieces of metal, when followed by improvisatory assemblage of these components, produced images that were drawn—with an oxyacetylene torch rather than with pencil or paint—in the very medium of sculpture itself. González did make preliminary drawings for particularly complex sculptures, but never followed them exactly. His more finished drawings were certainly made after the sculptures were completed, or—like that reproduced on the opposite page—imagined sculptures he was unable to build.

In January 1940, prior to the German occupation of France, González moved from his studio at Arcueil, outside Paris, not to return there until November 1941. Unable to work as a sculptor in this period, he produced many drawings. The same modern preoccupation with "truth to materials" (see p. 88) that prohibited González from fully conceiving his "drawn" sculptures in two-dimensional drawings meant that the finished drawings of this period, while indeed imagining sculptures, are two-dimensionally conceived: the sculptures they imagine finally are inseparable from the plane surfaces on which they are drawn. This watercolor shows an image generally related to the series of "cactus" figures that González had been working on before 1940. It flattens, however, to the stylized domestic setting: the hatching within the sculpture echoes the pattern of the tiled floor, and its twin vertical movements defer to a centralized alignment of sculpture and architectural background that merges figure and ground, rendering ambiguous the precise perimeters of the sculpture itself.

González died in 1942, the year after this drawing was probably made. He had an extremely short career as a mature artist, for he was fifty-five when he truly hit his stride as a sculptor in 1932, after collaborating with Picasso, from whom he learned the assemblage technique and from whom he derived certain specific formal motifs (such as the linear "finger" and "hair" motifs we see here). The suddenness, however, even more than the lateness, of González's artistic maturity is what is surprising: virtually nothing, except his consummate craftsmanship, in his work prior to around 1930 prepares us for what follows. We are used to late developers, but González is different in that his mature work does not culminate but repudiates, and is discontinuous with, what preceded it. Before around 1930, his originality as an artist was simply invisible: it took discovery of a specific technique to reveal it. This particular kind of "breakthrough" becomes more common in later modernism; indeed, it helps to define it. The very form of González's career is as prophetic as the work it produced.

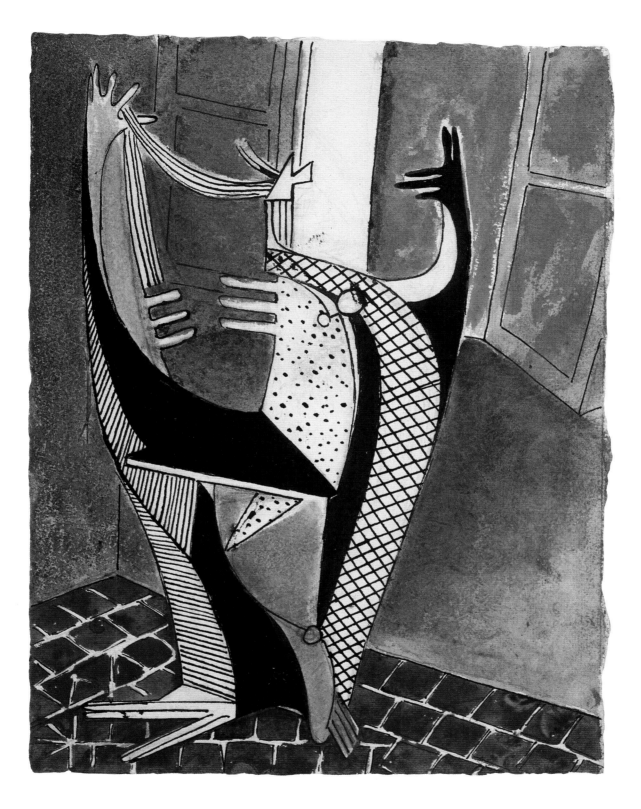

Paul Delvaux

BELGIAN, born 1897

COMPOSITION (THE SIESTA). 1947. Watercolor, pen and ink, 23½ x 30⅞" (59.5 x 78.3 cm)
Kay Sage Tanguy Bequest

The four most important "dream image" illusionists of the Surrealist movement—Magritte, Tanguy, Dali, and Delvaux—established their characteristic styles in the order their names are listed. The first three emerged in the period 1925–29, Delvaux in the middle 1930s. Delvaux's art is closest to that of his fellow Belgian, Magritte, but draws even more explicitly on de Chirico's deserted piazzas (p. 115) and uses the more detailed illusionist style that Dali (p. 163) popularized. He is very much a synthesist, benefiting from his lateness in the Surrealist movement by being able to modify tried styles to suit his particular vision. The other new Surrealist recruits in the 1930s were often more original than Delvaux and nearly always more technically inventive. Their greater ambitiousness, however, produced art that was unrealized in a way that Delvaux's more modest aims did not. He was the only fulfilled painter to be produced by 1930s Surrealism and therefore the last when Surrealism was based in the School of Paris.

As is usual in dream-image Surrealism, Delvaux's world is a world of fantasy: that is to say, separate from external reality but confusable with it. But since it seems closer to the world we know than do those of the other dream-image Surrealists, the force of Delvaux's representation depends even more crucially than theirs on the contrast afforded between the expected and what actually is shown. Of course, such contrast is a part of all realist art; and all realist art shows us fantasy, as defined above. And fantasy itself—was Freud's message—is normal in the world. Delvaux, however, uses realism to escape into fantasy, whereas realism as such seeks to escape from it. The point of his art is not, as in realism, to provide a vision of the world that seems more "real" if anything than the external world, thereby offering a relief from normal worldly fantasy in the security of its wholeness. It is to exacerbate such fantasy by showing to us a "real" world that is even more precarious in its reality than ever we feared—and keeping us outside it, so that it is utterly beyond our control, indeed, so that it seems to control us, as theater does. This is why traditional tonal modeling is used: not because it provides a more coherent or more comprehensible illusion, but because it creates a highly dramatic one. This is also the reason for the meticulous finish, the clean perspective, and the exactly plotted internal relations; the ambiguous scene they create is static, dead silent, and serves to distance the spectator, who is forced back into the role of voyeur. The teasing subject, of course, capitalizes upon this effect— and Delvaux realized this more completely than anyone else. (Balthus's art comes nearest, while catering to a more specialized taste.) But without the teasing form to separate the subject from us there would be no sense of frustration in the contrast provided by our seeing a world we know yet beyond our control. It is a world of masculine frustration: of lax, voluptuous bodies, with a promise of passion in their coldness, passively suspended in unreachable ease.

There is a note of nostalgia in Delvaux's art, which is not entirely to be explained by his classical settings or by the sense of regret that images of frustration convey. It is a broader kind of resignation; and the temptation arises to see in it the waning of an age. I said that Delvaux was the only significant Surrealist painter to emerge in the 1930s. In terms of new art, the School of Paris had, indeed, all but ended by the middle 1930s when Delvaux emerged.

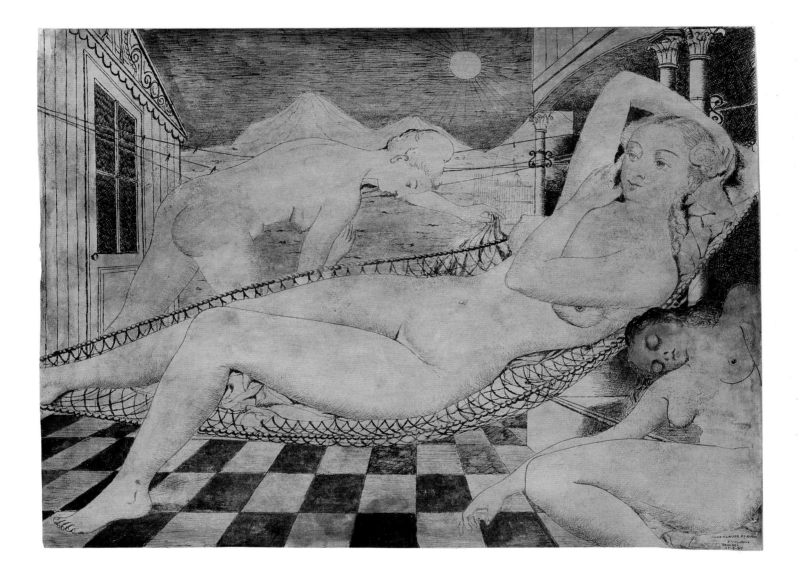

John Graham

AMERICAN, 1886–1961

Study after CELIA. 1944–45. Pencil, 23 x 18⅞″ (58.2 x 47.7 cm)
The Joan and Lester Avnet Collection

In an essay written a year or so after this drawing was made, the critic Clement Greenberg observed that "black-and-white has, since Impressionism, always remained somewhat behind painting and therefore more responsive to academic tendencies." By 1950 Pollock's black-and-white style of painting as well as of drawing (p. 191) would challenge the first part of this statement. The rider, however, is continually proven true. An artist's work in black-and-white is often ahead of his or her painting; that is common enough, especially in provincial situations. And often—again, in such situations—work in black-and-white exceeds in quality that in color, even (especially, at times) stylistically similar work. That seems to be a function of the greater security offered by monochrome, which carries the tradition of Western pictorial art—of all pictorial traditions, the most oriented to sculptural illusionism—more directly and openly by requiring concentration on value contrasts and modulations between them. The same set of circumstances that led to an increased use of color in much of this century's most ambitious drawing produced a situation in which work of higher quality and conviction that is unashamedly traditional, even academic, can far more readily be produced in black-and-white than in color. Delville (p. 35) and Dali (p. 163) show this in their different ways. So does Graham. And while, like Delville or Dali, Graham is obviously modern, his modernity is of a kind that, far from asserting itself as theirs did (in stylistic dissonance that forced the issue of opposition to the traditional), is simply given. At least it is here. He tries to draw like Ingres, but he is drawing in the middle of the twentieth century.

Like the aforementioned artists, Graham necessarily addresses questions that concern the accommodation of sculptural illusionism to modern, flat surfaces. These need not be discussed again. What especially does deserve mention is Graham's role in fostering what was virtually an Ingres revival in the early 1940s, and finding in Ingres's work a way of achieving accommodation of this kind. His 1937 *System and Dialectics of Art* was a call for "pure" painting, without resort to pictorial illusionism. However, he found acceptable what he called "planimetric" or "extensive" painting, which "can be three-dimensional in so far as detail modeling is concerned but remains within the plane, neither protruding nor receding." This, effectively, is what we find here. The shallowly modeled face is returned to the plane by the positive tonal shading that surrounds the neck, seeming to embed the image within the sheet; and the flatly stylized hair holds it in place. Such restriction of detailed modeling to certain specified areas of a composition is not so distant from Ingres's work, and indeed Graham cites Ingres in his book as the principal exponent of this "planimetric" method. This drawing relates to a painting in The Metropolitan Museum of Art that generally recalls Ingres's portrait of *Mme Moitessier* (National Gallery of Art, Washington, D.C.). If the astonishing eyes have no precedent in Ingres, the frozen, static mood conveyed by their stare does. "A great work of art is always static," Graham insisted. It was the immobility of Neo-Classic art that rendered it compatible with modernism, whose coolness stills it even more. Whether the reverse Pygmalionism that obtains here is also to be associated with our modern century or merely with traditional attitudes to feminine beauty is necessarily a matter of speculation. Perhaps it is simply this particular artist. But the woman does turn into stone.

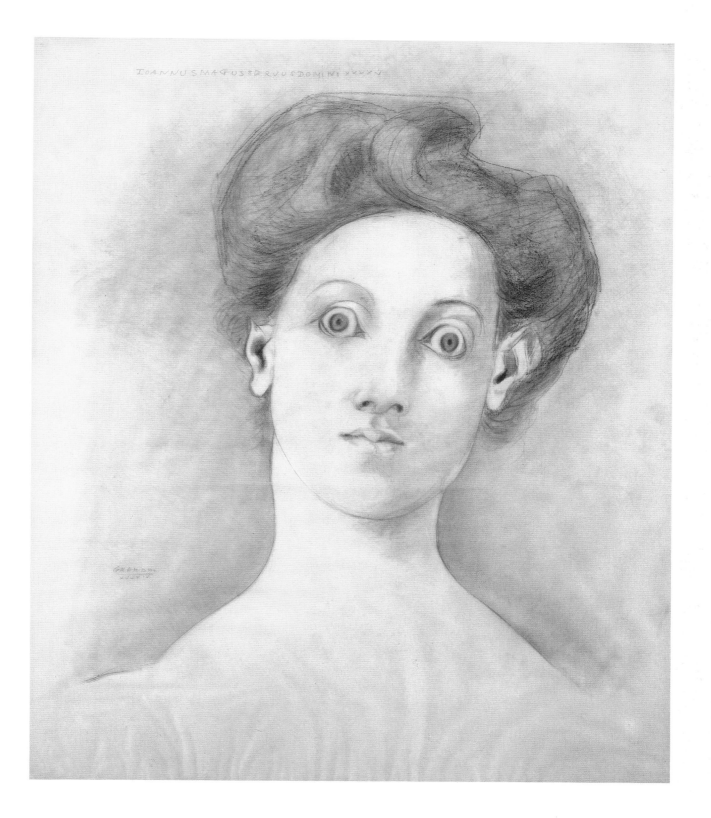

Robert Motherwell

AMERICAN, born 1915

PANCHO VILLA, DEAD AND ALIVE. 1943. Gouache and oil with collage on cardboard, 28 x 35⅞" (71.1 x 91.1 cm)
Purchase

The fate of collage after the Cubist epoch has been a curious one. So central is its constructional method to the modernist aesthetic that it continues to be one of the most popular media in the art of our time. And yet, so easily it seems can competent collages now be produced that it has virtually returned to the craft status that it had before the Cubists reinvented it in 1912. Media as well as genres of art can and do decline. But what is strange about collage is that its principles remain authoritative while most of its manifestations (in two-dimensional form, at least) do not. The first and principal victim, perhaps, of the democratization of modernism, only in very few hands has it escaped academicism and been preserved as a vehicle for major art.

Motherwell's importance to the history of collage is as a transitional and remedial as well as innovative artist. In the sequence of collages that he began in the late 1940s, he initiated a new, distinctly painterly form of the medium in which "the tearingness of collaging" (to borrow one of his titles) is exploited, along with rich and sumptuous color and expressive brushwork, as never quite before. Previous to that, however, his first group of collages, begun with *Pancho Villa, Dead and Alive,* grafted an effect of painterliness onto geometric structures indebted to Picasso and Mondrian, but opened out more flatly to the surface, thus rejuvenating the then moribund form of Cubist-style collage as well as preparing for the more informally composed painterly collage that Motherwell pioneered and that was subsequently revised by younger artists like Johns and Rauschenberg.

The composition of *Pancho Villa* is generally based on Picasso's 1927–28 painting, *The Studio,* in The Museum of Modern Art, but enforces a more dominant verticality in its drawing (indebted, perhaps, to the Matisse of *Bathers by a River,* then in New York), which seems not so much to echo the frame—as happens in Cubist art—as to recapitulate it, discovering in the interior of the work the complement of its external geometry. As a result, the edges that frame the collage function just like the edges inside them: not as enclosures but as elements of distinctly compositional importance in modular organization of the richly detailed field.

This collage is unique to Motherwell's important works in its allusion to a specific historical figure. The subject had personal relevance to him, for he was then engaged to the niece of a general in the Mexican revolution, and had studied its developments closely. We see two figures of Pancho Villa: at the right, alive; and in the center, dead, with blood stains left by bullets showing on his body. The dappled paper that dominates the composition, seemingly hinged to the surface along its internal edge, suggests comparison to those in Picasso's collages of 1914. It also, however, has Pointillist connotations; and Motherwell, we know, had photographs in his studio of Seurat's *Grande Jatte* and *La Parade* while working on this collage: for "technical reasons," he has said, and for "the spirt of *La Parade*"—with which it indeed shares, for all its sumptuous detail, a certain and severe gravity.

Mark Rothko

AMERICAN, 1903–1970

ARCHAIC IDOL. (1945.) Wash, pen and brush and ink, and gouache, 21⅞ x 30″ (55.6 x 76.2 cm)
The Joan and Lester Avnet Collection

A striking resemblance exists between the Rothko seen here and Miró's *The Family* of 1924 (p. 155). Both works show a trio of primitive life forms on a broad, horizontally divided field. Even the anatomy of these creatures is comparable. And the atypical blurred softness of the Miró finds its equivalent in Rothko's translucent haze. Robert Rosenblum, who pointed out the importance of the Miró for Rothko's works in his so-called Surrealist period, notes that Rothko could have seen it in the Museum's Miró retrospective of 1941. The middle 1940s—"the biomorphic '40s"—were the years during which Surrealism, banished from France by the war, colonized America. Automatism would turn out to be Surrealism's most important and lasting contribution to American art. Biomorphism, however, was first on the beaches—a metaphor inescapably suggested by much of the new art of the middle 1940s, but especially by Rothko's, whose Surrealist creatures look as if they have landed in America by submarine.

Biomorphism, in fact, is generated by automatism—and had been since it emerged in the work of Arp (p. 113). In Rothko too, highly generalized biological forms are produced by a kind of wandering of the hand. But automatism for Rothko—unlike Arp, and unlike Pollock later— is not the organizing basis of drawing, but rather the means of producing imagery within drawing. In this regard, he is indeed closer to Miró of *The Family,* also to Klee, for he takes from these artists (among others) a flexible interpretation of Cubism that accepts its underlying geometry along with its two-part division of signifying line and shaded surface but loosens up its regularity and opens its space to greater illusion of depth. The early Kandinsky (p. 67) was important to a number of the soon-to-be Abstract Expressionists. The luminous internal space of this Rothko—indeed, the wirelike drawing that hovers in front of it—is generally indebted to Kandinsky, and it is what gives room enough for the line to move as freely as it does here. The horizontal geometry that divides the space opposes its recession, and as it advances to the surface it seems to trap there the imagery this work contains. But since the imagery is translucent, it never exactly seems stranded on top of the surface: the "bodies" of these creatures fuse with the internal space, and openness is restored. We do, of course, see separately the three loose images and the horizontally banded ground. The extent to which we separate them, however, owes much to the power of hindsight as we recognize the characteristic Rothko of the 1950s waiting to be discovered in the background of works such as this. For in fact image and ground blend in the cool hazy light and in the fluidity of the water-based medium. While using a two-part pictorial structure developed from Cubism, Rothko seeks reconciliation of signifying imagery and illusionary ground: in order to give to the ground the kind of meaning traditionally associated with image-making. This view is supported by hindsight too, but does not, I think, require it. For here, imagery dissolves into the wetness of the ground, interfusing its ampleness with a sense almost of solidity that replaces, as it were, the sculptural illusion that has been drained away. Surface and space are thereby made to do what mass and volume did for earlier art. And in the absence of mass and volume, images are not objects. They are subjects (and therefore capable of very flexible interpretation); here, they are the subjects of archaic myth, and primitive life forms emerging from within a primordial sandy sea.

Arshile Gorky

AMERICAN, 1904–1948

SUMMATION. (1947.) Pencil, pastel, and charcoal on paper mounted on composition board, 6′ 7⅝″ x 8′ 5¾″ (202.1 x 258.2 cm). Mr. and Mrs. Gordon Bunshaft Fund

"The Ingres of the unconscious" was how Gorky's biographer, Ethel Schwabacher, characterized him. It is an apt description. Drawing was indeed the probity of Gorky's art. He was essentially a draftsman of the wrist and hand, and at his best, line is given priority and the other pictorial components support it. Color is tinted or scumbled around line, and shading offsets and enlarges it. Moreover, he was obsessed by the exactness that line drawing allowed. Adoption of Surrealist automatism in 1944–45 freed Gorky's line, dissociating it from color and shading, and giving to it specifically the kind of mobility and fluency that had been developing in his art as a whole since he passed into maturity two years before. But by the date of the drawing shown here, it had recovered its contouring function and was again at the work of exactly identifying forms, albeit forms that defy exact identification. Even in 1944, in fact, Gorky was using his new linear mobility not to enlarge the spontaneity of his art, but rather to recover from within an already spontaneous art, which had subsumed line in painterliness, a kind of drawing that was at once compositional and episodic and that was precise and ambiguous at the same time.

What I mean by this—and we see it in *Summation*—is the following. Gorky's drawing creates clusters of incident. It creates them precisely, but they are ambiguous. It is the mobility of the line that allows them to form what Breton, the Surrealist leader, called "hybrids"—linear units with multiple metaphoric meanings. This same mobility allows their association. Although this work is episodic, the drawing that creates its separate episodes accumulates them. Gorky's is an additive, constructive art, conceived not as a whole made up of parts, but as individual parts (often the subjects of separate studies) that combine to make up a whole. We see and easily read (if not quite decipher) the separate, distilled motifs; and by recognizing the formal and familial analogies in the treatment of these motifs, and the soft continuity of the shading that surrounds them, we also read them together: as one single and richly detailed image, whose force is strengthened by the variety of incident it contains. The immense size of the drawing meant that Gorky could move out his composition toward the framing edges rather than having to order the work in their terms. This carries him beyond Cubist design. However, the play of soft against hard in the shallow monochrome space almost as completely brings him back. And the sheer grandness of the work returns him yet further, and adds justification to his biographer's characterization. Gorky did indeed make of automatism an art with the monumentality, as well as precision, that we associate with the classical masters of the past.

Summation, as is often observed, though not the artist's title, is entirely appropriate to this work, which represents the very apogee of Gorky's late style. We know that Gorky made full-sized cartoons for a number of his major works. It has been suggested that *Summation* was intended to prepare for what would have been his most ambitious oil. This, however, is unproven. Gorky admired Ingres's *Odalisque en Grisaille* at The Metropolitan Museum of Art and had seen Miró's large grisaille *Self-Portrait, I* of 1937–38 (p. 165). *Summation* combines the hard-line eroticism of the former with the sparkling fantasy of the latter. Invoking their painstaking detail, it creates a strained, nervous, and extraordinarily sensuous bonding of sexual and visceral images, and of images that refer to the natural world—but to nature as if felt inside.

Jackson Pollock

AMERICAN, 1912–1956

UNTITLED. 1945. Pastel, gouache, pen and ink, 30⅝ x 22⅜″ (77.7 x 57 cm)
Blanchette Rockefeller Fund

The allover poured or drip paintings that Pollock made in the years 1947 through 1950 are widely acknowledged as his greatest works. It was with these that "Pollock broke the ice," as de Kooning generously put it, and established Abstract Expressionism in its mature form. The importance of drawing to these works is paramount. Painting itself became a form of drawing in a way it had never quite been before.

This pastel and gouache, with pen and ink, predates Pollock's mature style. It anticipates it, as we shall see; but its presence here is for intrinsic, not historical reasons, for it is one of those works (there are many in this book) that help to convince us that quality and progress are better kept apart. Its sources are multiple—Picasso, Kandinsky, Miró and Masson, the Mexican mural-painters—and yet it is entirely Pollock's own. Two totemic sentinel figures are presented, the one on the left seeming to have a double-faced head and that on the right bending its leg along the base of the sheet. An incipiently violent and sexual relationship is implied. The figures' identity, however, and their relationship are subsumed by the charge of the drawing that "veils" them (to use Pollock's own word). A conflict exists between two forms of expressed emotion: one is discovered in the shape of images and is released in their distortion; the other is released, almost automatically, in line, and discovers itself in the cancellation of images. The former is more literal (as well as literary). The latter, though equal in its intensity, is somehow more disengaged, for the drawing that carries it manifests the physicality of the surface, enlivens its spatiality, and submits to the pictorial the passion that it too certainly holds.

Pollock began by forming the two flat figures (whose planarity recalls Synthetic Cubism) and starkly contrasted them against the blue ground—except that the uncovered ground of the paper created their bodies and the covering blue the ground. This ambiguity in reversal is further enriched by Pollock's having drawn the figures so that they surround and entrap the blue ground (thus creating abstract pictorial "figures" down the center of the sheet) and by his blurring, by means of allover hieroglyphic drawing, the boundaries between figure and ground. It is impossible to know whether this form of drawing began to be added before the blue ground was put in, but it is certainly what completes the work. It serves to dissociate, and disperse into the blue ground, the contours of the figures from the shapes they bound; to push and to pull the space of the whole work to greater openness; to bridge and to bind figure to ground; and to atomize, almost, Synthetic Cubist planarity, dissolving as well as twisting it into a nonhierarchical, allover space that seems to oscillate between surface and shallow illusion of depth. The scribbled and shredded signs allow multiple and even bright colors to serve the demands of a tonally conceived work in quite a new way. Interfusing these colors both with one another and with the exposed white of the paper cancels out most of their value contrasts and dissipates their inherent sculptural illusions. Opposition of figure and ground returns value contrasts and with them sculptural illusions, but we begin to see in works like this the future of Pollock's art. Literally drawn with color, it is historically extremely important as well as intrinsically so.

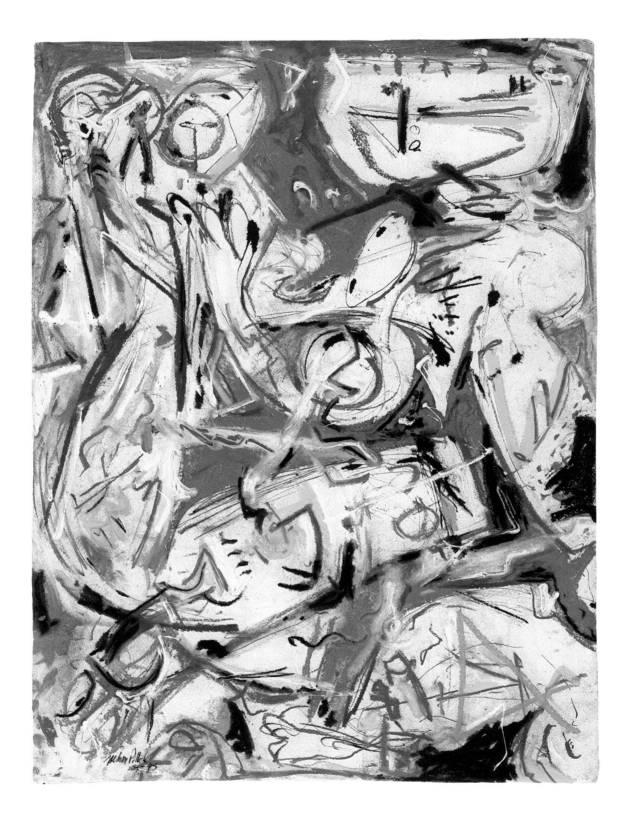

Jean Dubuffet

FRENCH, born 1901

CORPS DE DAME. 1950. Pen, reed pen and ink, 10⅝ x 8⅜" (27 x 21.2 cm)
The Joan and Lester Avnet Collection

A quarter of a century, almost, separates Dubuffet's emergence in the middle 1940s from Miró's in the early 1920s. In that period, the School of Paris and its immediate satellites produced only six artists of significant status: four painters—the dream-image Surrealists Magritte, Tanguy, Dali, and Delvaux—and two sculptors—Giacometti and González. Comparison of these names with those of the pioneers of this school tends to the inevitable conclusion that Miró was its last truly major artist. Remembering that except for Miró and a very few others even the pioneers declined in the later 1920s tends to the equally inevitable conclusion that the heroic age showed signs of ending then. Perhaps it did, for it was only the renewal of experimental vigor in a few of the pioneers (notably Matisse) in the 1930s—and the persistence of this quality in Miró and a very few others—that breathed new life into the School of Paris in that decade. I introduce these pessimistic facts only to point out how astonishing Dubuffet's appearance now seems. Certainly the most original painter to emerge from the School of Paris since Miró, he retrieved and revived the "poetry" of Miró (in particular, its element of the grotesque), and added to its playfulness and ornamentality a new sense of the physical.

In art, as in literature, the successful strategy of the grotesque is usually somewhat reserved, a certain matter-of-factness in style being required to provide a sense of perspective on its incongruity. When Dubuffet's Corps de Dames series (ironically, Bodies of Ladies—not of women) appeared, it was received as a cruel attack on the female form. Dubuffet himself encouraged this interpretation by saying that he was protesting against traditional notions of beauty. However, he also insisted that his intention was to generalize and immaterialize the figure, not give it a particular form, and that line drawing was his means of achieving this. He does indeed stand back from his subject, and uses line to render it flat and incorporeal, spreading it out across the sheet like a landscape composed from the whole substance or corpus of fertile femininity (this content being implied by the punning title of the series). Obvious reference is made to children's drawing, to graffiti, to the various "primitive" forms of art that Dubuffet opposed to the decadence and attenuation he found in the high culture of his own time. But reference also is made to Miró and Klee, and to the handwriting line of Surrealist automatism. Dubuffet speeds up this line into a kind of obsessive scribbling. And yet, the effect is not finally a heated one. The broader and blotted lines of ink stabilize the implied movement of the thinner and wiry ones, while the image as a whole—which stretches to brace itself against the perimeters of the sheet—is calm in its monumentality. This is not to diminish the extraordinary vigor of the drawing; only to say that while Dubuffet's draftsmanship is restless, violent, and unrestrained, his drawings themselves are not. Because Dubuffet's Corps de Dames appeared at the same time as de Kooning's Women (p. 197), the two series have often been compared. In fact, Dubuffet's drawings have more in common with Pollock's contemporaneous works, such as that reproduced on the following spread. Both offer volatile fields in stasis. It would be wrong to suggest that there is nothing of the violent and the brutal in Dubuffet's work. The pleasure, however, that we derive from it is unconnected with sadism. The grotesque has always a certain coefficient of playfulness in it, which is there to oppose the fearful.

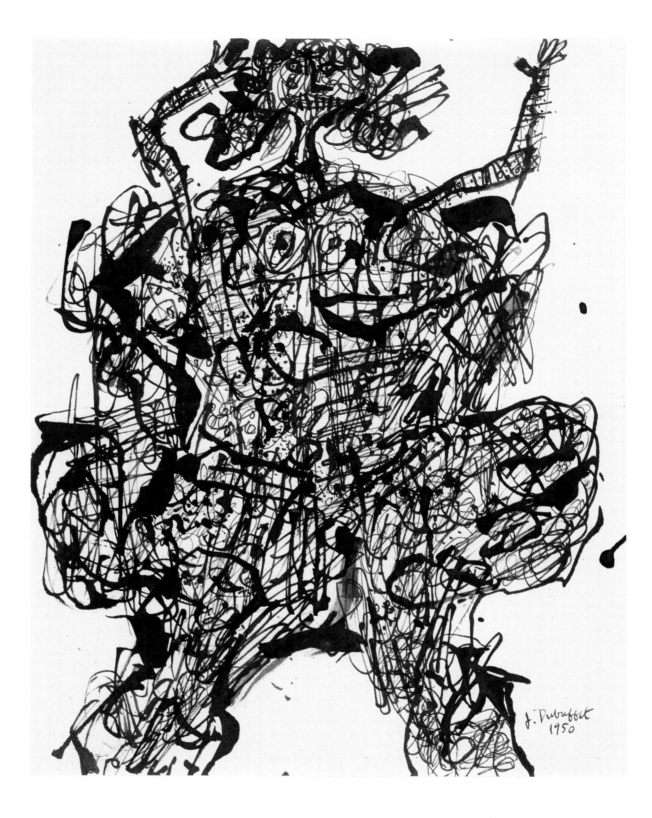

Jackson Pollock

AMERICAN, 1912–1956

UNTITLED. (c. 1950.) Ink, 17½ x 22¼" (44.4 x 56.5 cm)
Gift of Mr. and Mrs. Ronald Lauder in honor of Eliza Parkinson Cobb

In 1950, Pollock's most productive year in painting, he seems to have made very few drawings. Those that he did make established a new direction in his art. Even as he was producing the greatest of his allover paintings with layered poured skeins of black, colored, and aluminum paint, he restricted his drawings to a single layer of black on the white sheet. His paintings of 1951, which adopted this approach, were even more purely "drawn" than before.

Many of Pollock's allover paintings had been begun with the black layer, and all were tonal in conception despite their multiple colors. As often observed, while their technique is based on Surrealist automatic drawing, their effect is reminiscent both of the poetic chiaroscuros of Analytical Cubism and of the atomized, light-filled surfaces of Impressionism—but suggesting a far more purely optical kind of space. The poured linear trails, abstracted both from representation and from the bounding of shape, fuse with one another to produce a shimmering, homogeneous, and monochromatic field, which seems to dissolve the physical surface of the painting, then to restore it in its own physicality, oscillating between surface and an indeterminate shallow space, quite unlike anything in the tangible world. Pollock, in effect, isolates and abstracts the components of traditional modeling—shadow, color, and highlights—in his black, colored, and aluminum skeins, and recombines them in such a way as to dissipate the sculptural from illusionism, bunching together value contrasts to the light side of the tonal scale.

This drawing uses the most extreme statement possible of the components of traditional modeling—stark contrasts of black and white—and wrests from this basic substance of sculptural illusionism (and of drawing itself) a new kind of optical space: one that admits "figuration," but figuration of an entirely new kind. It is at once less local to the surface than Pollock's earlier poured skeins (because charged with a force and tactility that isolate it), and yet it seems actually to have grown there. While the Rorschach-like configurations themselves read as drawn, their drawing does not cut back into the surface or pry them palpably away. We can see their separation from the surface but not feel it. They are as much continuous with the surface as floating upon it, for they read alternatively as figure and as ground, seeming at one moment the only truly physical components of the drawing (the ground dissolving, in contrast, away) and then almost voids or absences in a very tangible ground. Surface and space oscillate, but not as they did before. They do so schematically and decoratively in the patterned contrasts that black and white provide. This was one of the reasons why black-and-white became central to Abstract Expressionism: it was suited to the piece-to-piece compositional method used by many Abstract Expressionists, a method to which Pollock here somewhat defers. It also allowed very spontaneous working without loss of control, and had associations with writing and sign-making that seemed appropriate to symbolically conceived art. Additionally, black spread out evenly and flatly across the surface. Here—even more than in Arp's automatic drawing (p. 113)—lines literally have been expanded into shapes, and shapes thus created by expansion seem unbounded and unenclosed. Black-and-white was the way back into figuration, and to that post–Abstract Expressionist concern with joining imagery to the allover field. Pollock begins that in 1950. But his new "figural" drawing does not denote objects. Drawing names space.

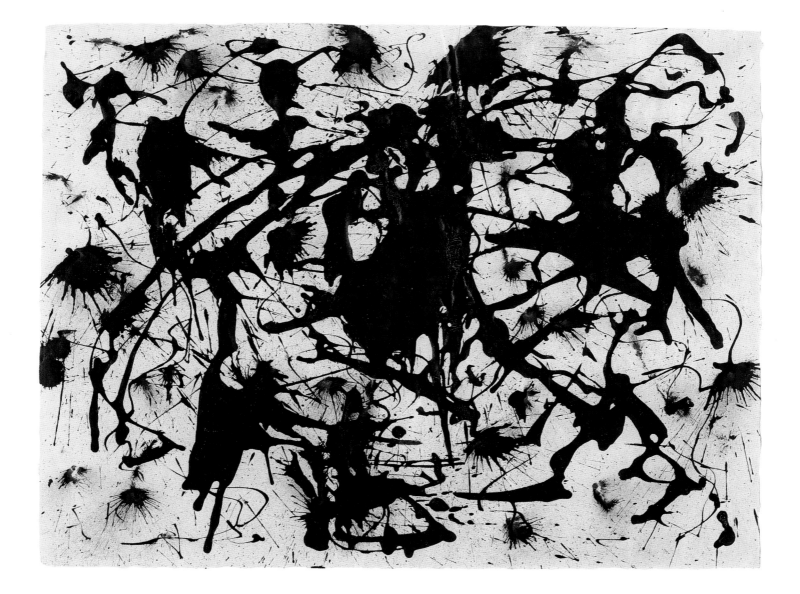

Helen Frankenthaler

AMERICAN, born 1928

GREAT MEADOWS. 1951. Watercolor, 22 x 30" (55.9 x 76.2 cm)
Purchase

This watercolor predates by exactly one year Frankenthaler's famous painting, *Mountains and Sea,* which initiated what became known as "color field" painting when it dominated the pictorial abstract art of the 1960s. The extent to which such painting transposed to canvas a watercolorist technique is made evident by this work, for it prophetically rehearses what would become characteristic of Frankenthaler's mature style: thin washes of color soaked into the very surface, thus literally identifying figure and ground and thereby allowing color to spread uninterruptedly across the surface as pure hue (even when shaded), unimpeded by the tactile associations that figure-ground divisions normally create. The whiteness of the surface not only breathes through the color, bringing depth to its flatness; it also functions as color itself, and gives to the thinned prismatic and earth colors that soak into it something of its own disembodied form, creating an extraordinarily open and unimpeded pictorial surface with a Fauvist variety of color, but leveled down in an Impressionist, close-valued, and seemingly allover space, such as we see in the work of Pollock. Indeed, the principal historical importance of what Frankenthaler achieved at the beginning of the 1950s was to find a place for multiple and affective color in advanced art without sacrificing the continuity of surface and allover optical, intangible space that Pollock had achieved. Taking her lead from the black-and-white Pollocks of 1950–51 (such as that reproduced on the previous spread), Frankenthaler thinned her pigment further than Pollock had done, and drew with it more broadly, to form areas—which admitted color as lines could not—that gave her both the imagist quality of the 1950–51 Pollock (but in color) and the openness of Pollock's preceding, allover art.

One thing that distinguishes Frankenthaler in the early 1950s not only from Pollock but also from later color-field art, including her own, is the particularized form of imagery her work contains. The early 1950s saw a reaction against the absolute nonfiguration achieved in Abstract Expressionism by 1950. Of its many products, de Kooning's Women series (p. 197) is certainly the most celebrated, but Frankenthaler partook of it in her own way. This watercolor was drawn from a specific motif on a farm in New Jersey. Its forms are extremely generalized, yet legible, and float free of the edges of the support to provide a simulacrum of open-air, illusionist space, but one that belongs to the surface, into which these forms are puddled and stained. The play of harder drawing and softer toned color recalls Gorky, and before that the early Kandinsky (p. 67), to whose rising, plumelike mountains and flowing organic pastures this work makes compositional reference too. But because the Frankenthaler is damper in effect than anything these artists made (the sheet was wettened before working), its picture of the world seems disembodied, further removed from the tactile realities we know, and curiously still and suspended, for all the implied momentum provided by the cursive lines. Pollock's allover style had bequeathed to Frankenthaler an art that transformed drawing into painting to transcend the traditional dualism between the linear and the painterly in being both at the same time. Frankenthaler's art is the same. It dissolves the linear in an illusion of painterliness. But in addition to that, it transcends another traditional dualism: that between drawing and color. Color is drawn.

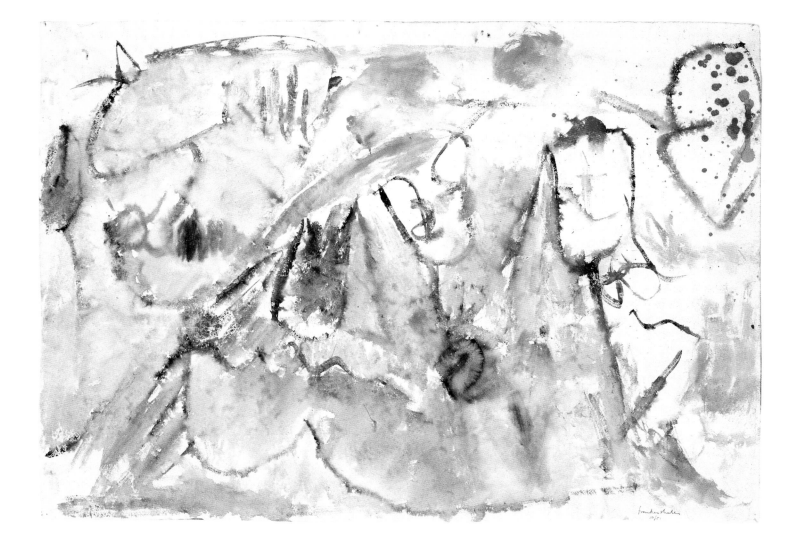

David Smith

AMERICAN, 1906–1965

Untitled (Tanktotems). 1953. Brush and ink and gouache, 29¾ x 42⅜″ (75.6 x 107.5 cm)
Gift of Alexis Gregory

Drawing, Smith said, was where his sculpture came from; but "not specifically." He did, in fact, begin to assemble some of his sculptures on top of chalk drawings he made on his workshop floor. Many of his drawings, including this one, explore imagery that would be transformed into sculptures (here, into his so-called Tanktotem sculptures), but not specifically. And often (as here) he seems to have drawn from the memory, at least, of existing sculptures even as he prepared for new ones. Many of his drawings are entirely unrelated to sculpture. Even, however, when they are related, they use drawing as a form of independent linear invention. This, finally, is its relationship to his sculpture. He wanted, he said, "to make sculpture as free as drawing."

The pictorialism of Cubist sculpture is that of pictorial surfaces: originally, of the plane surfaces of collage removed, as it were, from their background and opened to divide real space. They make reference both explicitly, in their surfaces, and implicitly (more often than not), in their arrangement, to the bounded pictorial field. Around 1950, Smith repudiated such reference, to create independent, free-standing images of the kind we see drawn here. The revolution of Cubist sculpture consisted in using the new object-quality that collage introduced to modern art (see p. 76)—potentially a hindrance to sculpture (since sculptures, after all, were already objects)—against the object-quality of sculpture itself. The lessons of Cubist painting were used to oppose sculpture's monolithic form. Smith, at first sight, seems to have brought it back. He did, indeed, return the force—the emotional force—of the monolith, and its associations with the human form. But he did so without returning its volume. He retained from Cubist sculpture its essential qualities: its openness of articulation; its abstract, internally generated relationships; its suggestion of transparency, where forms seem to divide space rather than fill it; its aerial, seemingly incorporeal drawing; its utter self-sufficiency as a special kind of aesthetic object in a world of weighty, obdurate forms; and its two-dimensional, visual address to the viewer that marks it out as a special object of this kind. However, even more than González, who adumbrated this possibility, Smith gave back to sculpture the traditional sense of presence that image-making provides. González had already shown that the new constructed sculpture could suggest figurative imagery without seeming illusionistic: because sculpture, no matter how pictorial, is inherently a literal art. Smith, however, brought to his sculpture a literalness of emotion more charged and aggressive than González's. It is a kind of emotion closer to Pollock's. Just as Pollock, around 1950, forced abstract line to support figuration (see p. 190), so did Smith. But whereas Pollock, a painter, spread out line to achieve this, Smith, a sculptor, compressed and contracted it. Line that is abstract clenches in itself the memory and presence of the body, and becomes the raw material of Smith's art.

Line, in this drawing, is precisely of this kind. Some of the images shown here suggest tools hanging on Smith's workshop wall. Most relate to the Tanktotem sculptures, each of which contained a concave end section from a cylindrical tank drum. All carry a nervous current in their painterly form. "Drawing," Smith insisted, "is the most direct, closest to the true self, the most natural celebration of man—and if I may guess, back to the action of very early man, it may have been the first celebration of man with his secret self—even before song."

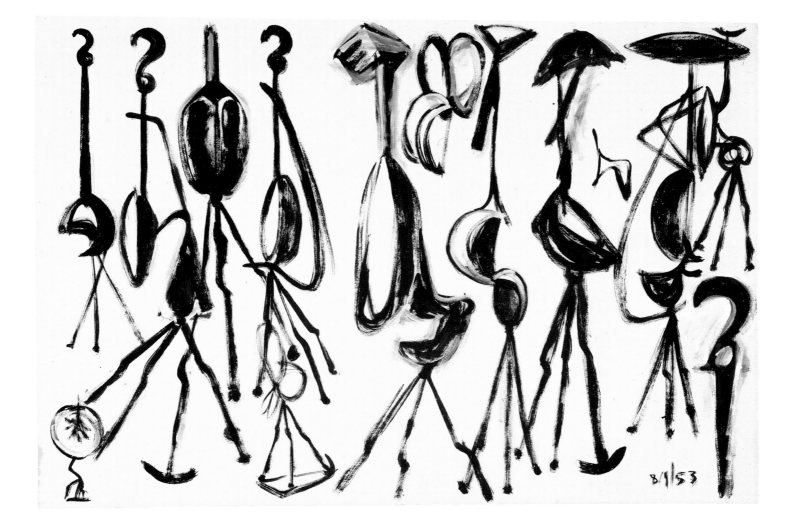

Willem de Kooning

AMERICAN, born 1904

STANDING WOMAN. (1952.) Pastel and pencil on cut and pasted paper, 12 x 9½″ (30.3 x 24.1 cm)
The Lauder Foundation Fund

Drawing was always crucial to de Kooning's art, but never more so than in the famous Women series of 1950–53. The first of the six paintings of the series was begun in drawings on paper, and throughout its two-year development de Kooning regularly studied aspects of the figure in independent drawings, made tracings of sections of the painting (usually before he was about to wipe them out—in case he wanted to reinstate them), and collaged papers onto the canvas to introduce new ideas. This collage method he took from his contemporaneous works on paper, made by cutting drawings of the female figure into halves and recombining mismatched images. The work seen here belongs to a group of pastels of this kind, made during the finishing of *Woman, I* in the summer of 1952. The blurred and sketchy brushwork which brought that painting to a conclusion—and dominated its successors—was probably adapted from the dematerialized fusion of colors in de Kooning's use of the pastel medium. Moreover, while earlier mismatched drawings had already suggested a montage effect for painting (produced by masking), these pastels—being closer to the medium of painting than the earlier pencil or crayon drawings—consolidated it, and it became an especially important element of *Woman, II.*

The literal collage element of this pastel fulfills at least five distinct functions. First, as with the *cadavre exquis* method of Surrealism the division of the sacrosanct body creates juxtapositional surprise, even implies mutilation. Second, it flattens and elongates the figure, causing us to look up at the head and down at the body, as happens in Gothic-derived drawing (p. 125). Third, by presenting a figure that is complete but not designed as complete, it unbalances it toward the dramatic. Fourth, by eliminating the neck, it speeds in a quick visual jump the relationship of head and body even as it separates them. And fifth, because it is difficult to control pictorially the associations of a head in a flattened and generalized art, to place it on its own plane is to contain it and hem it in, as well as to defuse it somewhat by the act of decapitation.

That one cut is crucial. But collage is even more important to this work in other ways. Since the 1930s, de Kooning's art had used the principle of collage in the sense that the parts of a represented figure were often treated as separate compositional elements to be arranged at will. By the late 1940s, this element of his art was preeminent, and by 1950 had produced the form of drawing we see within the body of the work shown here: manipulation of flat, transparent, and overlapping planes in a way that clearly recalls a collage process. Even the sudden insertion of realistic details evokes Cubist collage—as do the crisper, split-seamlike contours that appear amidst the looser, more painterly lines of the drawing. De Kooning's art is essentially a painterly transformation of the Synthetic Cubist piece-to-piece method of composition, but one that— by reducing the relative size of the individual units, by restricting and loosening their color, and by energizing their contours with biomorphic and with "frayed" drawing—coopted something of the liveliness of touch and poetic chiaroscuro typical of Analytical Cubism, and even something of the velocity of abstract Surrealism as well. It is an art of great mid-century synthesis that draws together in a new way the more extreme possibilities of the Cubist tradition— and merges them, in the Women series, with a grandeur that consciously recalls the art of the Old Masters and a rawness that necessarily evokes the popular culture of mid-century America.

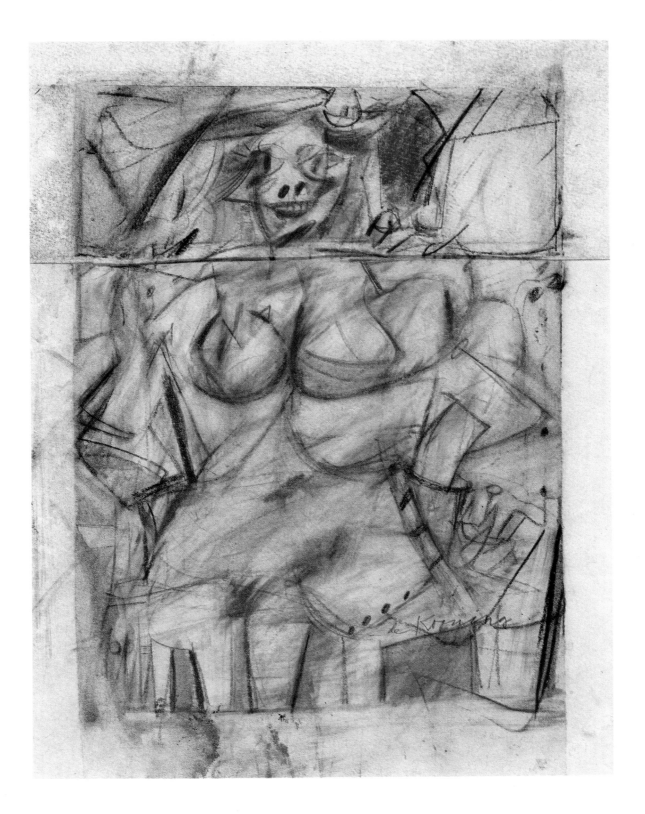

Franz Kline

AMERICAN, 1910–1962

UNTITLED, II. (c. 1952.) Brush and ink, and tempera, on cut and pasted paper, 11 x 9¼″ (28 x 23.5 cm)
Purchase

The overwhelming importance of drawing in Kline's art is unusual, even in Abstract Expressionism. Kline made, in effect, paintings that were monumental line drawings, and began to do so, apparently, by literally amplifying a drawing (using a Bell-Opticon projector) onto a monumental scale. Subsequently, he worked from drawings like this one—made by the hundred on telephone-book pages, then edited—fastened beside his easel, and successfully managed to transform their hand and wrist drawing into the broad arm drawing required by the large-sized canvases he used. Painting was simply a form of drawing, Kline himself often said.

But it was not, he insisted, calligraphy or symbol-making. He was responding, in part, to the frequent association of his art to Oriental calligraphy, and he rightly observed that it never presents forms that float as if in infinite space. (Robert Goldwater has suggested that Kline's choice of telephone-book pages on which to make his drawings may have been affected not only by their being obtainable free, but also because the conspicuous print pattern "prevents any mistaken perspective recession." The paintings, of course, included thickly applied, not merely reserve whites, so that problem did not arise there.) Kline might well have added that he used few fully cursive forms, and when he did braced and buttressed them with the roughly angular carpentry we see here. Kline's art is one of solid Cubist rectangles, firmly and tightly shored with geometric drawing, but it is a radical version of Cubism where drawing is used to expand the rectangle as well as support it. Space is pushed outward, and opens across the sheet. Space of a kind is given within the work (as it must be for it to cohere), but it is given in the planar relationships (for the lines do read as planes), which compose space and do not inhabit it. In the absence of even Cubist illusionism and because the drawn lines refuse to be considered as symbols—being too obviously architectural for that (symbols tend to float)—internal scale references that relate to the external world are effectively removed. (The print pattern here is only a partial exception to this.) As a result, even a drawing of this small size (only three inches taller than seen here) achieves an absolute scale, which accounts for its seeming monumentality. It presses out visually and (curious though this is) appears to expand the sheet, while the print, of course, remains the same size (but, oddly, clearer; even reduced the exactly one dozen Beautys above Kline's name can be read).

Kline's emergence in 1950 brought to a climax the phenomenon of black-and-white Abstract Expressionism. Some of the reasons for this phenomenon (which did not end in 1950) have been discussed elsewhere (p. 190). To these should now be added that Kline used black-and-white in a form that owed more to Synthetic than to Analytical Cubism and therefore emphasized compositional placement; it allowed him to exaggerate value contrasts to an extreme degree because, in effect, he was placing broad planes of black on white (here print-pattern tone). Also, we should add that their placement is based on a system of directional thrusts normative to drawn lines. No other Abstract Expressionist combined these features as Kline did. At a time when traditional placement drawing and traditional value contrasts were both being threatened with extinction by the more revolutionary among his colleagues, Kline insisted on both as expressive devices and won for them a new lease on life.

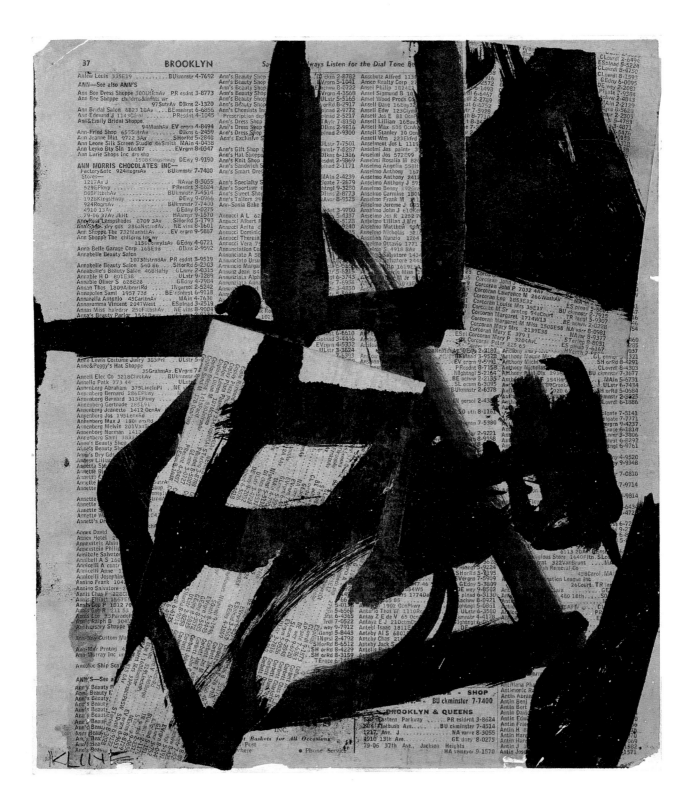

Henri Matisse

FRENCH, 1869–1954

MEMORY OF OCEANIA. 1953. Gouache and crayon on cut and pasted paper over canvas,
9′ 4″ x 9′ 4⅞″ (284.4 x 286.4 cm). Mrs. Simon Guggenheim Fund

In the *papiers découpés,* or paper cutouts, that Matisse made during the latter part of his career, his preoccupation with the creation of condensed "signs" for objects reached an audaciously inventive conclusion. It had originally been through the use of line, the inherently symbolic aspect of drawing, that he had found abstracted pictorial equivalents for his experience of objects—"signs coming from feeling"—which distilled their essential characteristics (see p. 166). When using color in the creation of these signs, he had been worried about the relation of color to drawn lines; color should not "simply 'clothe' the form: it must constitute it," he insisted, if the sign was to seem whole. With the cutout technique, however, "instead of drawing an outline and filling in the color—in which case one modified the other—I am drawing," he said, "directly in color… This simplification ensures an accuracy in the union of the two means." Color and contour, that is to say, are made coextensive: by "drawing with scissors on sheets of paper colored in advance, one movement linking line with color, contour with surface."

In this process, figure is liberated from ground because the signs thus formed are created independently of the picture support. Drawing takes place in the air. Though based on objects in the world, the signs were not drawn in front of objects. They are sheerly mental images released between thinker and thumb (to borrow a Nabokov phrase) from pure color into free space. Subsequently arranged across brilliant white grounds, like the shadows of objects cast upon a flat surface, these silhouetted forms analogize the static, characteristic images of memory cut out from the flux of the passing world. Projected, however, into their new dimension, they render pictorial the whiteness that surrounds them, giving to what Matisse called this "white atmosphere" a sense of dazzling light from the reflected radiance of their color. This was a truly radical conception—which returned to the roots of that part of the history of modern drawing that began with Cézanne's watercolors and their synthesis of drawing and color in color drawn out over an incorporeal whiteness indicative of nature's light. Matisse's cutouts are more purely abstract, of course. Their color-contrasted whiteness is not that of the natural world. He had been searching, he said, for "a very pure, nonmaterial light, not the physical phenomenon, but the only light that really exists, that in the artist's brain."

Memory of Oceania indeed records a memory: that of a visit to Tahiti Matisse had made over twenty years earlier, and specifically of a schooner seen on the lagoon outside his window there. (The upright, fuschia-colored strip in the cutout suggests a mast and the large green rectangle the top of the ship itself, with the black curve of a mooring rope crossing its blue prow.) Not part of the memory, however, but serving rather to distill its meaning for Matisse is what seems to be shown at the upper left: a figure seen from the back, with raised left arm and prominently defined spine surmounted by yellow hair, a figure rising from the waves (indicated by charcoal lines) into the "pure light, pure air, pure color" that made up the chief memory of Tahiti. The cutout technique is very far indeed from traditional drawing, even as Matisse had previously conceived it, and especially so when used on as monumental a scale as it is here. But it shares with traditional drawing that desire to gain possession of experience before it has faded and give to it stabilized form.

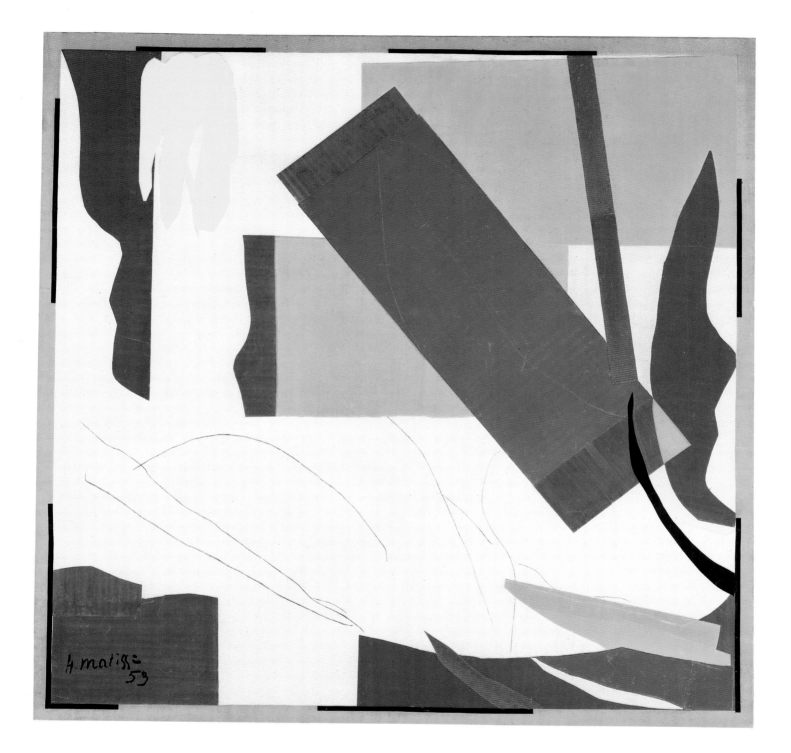

Joseph Cornell

ALLEGORY OF INNOCENCE. (1956.) Cut and pasted paper on paper mounted on masonite, covered with antique glass, 15¼ x 12¼″ (38.5 x 31 cm). Purchase

This collage, unlike any other image in this book, is reproduced here both framed and glazed, since Cornell intended it thus. The glass, in fact, is of a pale blue tint, and serves to soften the brightness of the collaged fragments while also imparting a sense almost of luminescence to the black-and-white repeated British "starlet," Jackie Lane—that moonlight kind of monochrome associable with film and television in the days before color. Cornell's broad frame isolates and contains, so that experience of this work is analogous to that of his boxes of three-dimensional materials, specifically his aviary boxes with images of tropical birds.

In some of those boxes, the birds seem imprisoned and the effect claustrophobic. More often, however, they present what we see here too: imaginary, escapist habitats connotative of some dreamy, magical land removed from present time. An important theme in Cornell's diaries is escape from his suburban home to wander around Manhattan collecting materials for his art, and looking in shop windows. Pet shops were among his favorites. One entry reads: "magic windows of yesterday . . . / pet shop windows splashed with white and tropical plumage / the kind of revelation symptomatic of city wanderings in another era." This work clearly suggests a window, looking onto some other, earlier era of existence: the innocent past.

Cornell describes it as an *Allegory of Innocence,* not merely a personification. So while we can indeed think of the starlet as personifying innocence in her newness, we are encouraged also to look elsewhere in the work for signs of that extended metaphor the concept of allegory requires. Not much looking is required, for this is a classic representation of the paradisal garden of prelapsarian bliss. As such, it shows us not only the garden's topography—a domesticated nature of friendly birds and healing waters—but also indications of how this Golden Age will come to an end. For the fact that it will (and has) come to an end is an essential part of its nostalgic meaning. Knowing sexuality and commerce are the two inadmissible activities in the Golden Age. The conventionally phallic key and the two-franc coin (punning on the double image of the starlet-nymph) remind us of these things, while the figures of unclothed innocence, seeking a reflection in the pool, see only an image of fashion. Even the monochrome form of the figures seems cold and alien within this colorful world. To know that Cornell entitled a similar collage, with this same double image, *The Sister Shades,* is to be reminded that connotations of the elegiac were often traditionally attached to images of Arcadian bliss.

"The more you love a memory, the stronger and stranger it is." These words (from Nabokov) are appropriate to that obsession with souvenirs of the past that informs Cornell's art as a whole. Time, travel, something preceding the here and now, dreams (but gentler than those of the Surrealists), naive and sentimental attachments: all of these are passages of return. It often is insisted that what Cornell returns to is the innocence of childhood. He does, indeed, evoke that (or more precisely, a state of innocence symbolized by childhood), especially in works like this. And yet, in works like this, we sense, I think, also something that truly is stronger and stranger than innocence. A state of innocence is presented, but through adolescent, not childhood eyes. Cornell's journey of return is troubling and frustrated because it is incomplete. It therefore is closer to us: not quite an allegory of innocence but of its difficulty to attain.

202

Robert Rauschenberg
AMERICAN, born 1925

Illustration for Dante's *Inferno,* CANTO XXXI: THE CENTRAL PIT OF MALEBOLGE, THE GIANTS. (1959–60.)
Red and graphite pencil, gouache, and transfer, 14½ x 11½" (36.8 x 29.3 cm). Given anonymously

In 1953, Rauschenberg asked for and received from de Kooning a drawing to erase. This is usually interpreted as a symbolic act of tabula rasa: wiping the slate clean of the Abstract Expressionist past. But this act did not erase Rauschenberg's debt to de Kooning, which manifests itself here in a painterly transformation of the human figure, organization of the pictorial surface by directional, thrusting forms, and division of that surface by the remains of a Cubist grid. De Kooning was indeed important to many of the younger artists who emerged in the 1950s because his Women series had demonstrated how image-making could be reconciled to the allover Abstract Expressionist field. Many new artists of the 1950s set that as their goal. Those who were successful realized that image-making had to be reformulated in order to achieve it.

I bring up the famous erased de Kooning for another reason: as a reminder that while much of Rauschenberg's art is tangible to an almost aggressive degree, another part of it is fascinated by ghosts. The sequence of thirty-four illustrations to Dante's *Inferno* that Rauschenberg made (in strict chronological order, canto by canto) in an eighteen-month period beginning early in 1959 involve transformation of the tangible into a world of shadow. They use preexisting three-dimensional imagery already in two-dimensional form and remove them yet further from the palpable world by means of a unique transfer technique. Rauschenberg took reproductions from magazines, moistened the drawing surface with a solvent for printer's ink (cigarette-lighter fluid, usually), placed a reproduction facedown on the moistened area, and by scribbling on the reverse side of the reproduction with a pencil or other pointed instrument transferred it, color and all, to his drawing—where the displaced imagery exists within the traces of the scribbling that released it. The effect (often reinforced by pencil and gouache) is richly ambiguous. Line is independent of imagery but creates it. Line does not contour, but it produces images that have contours. It is a "cool" line, because it seems remote and yet it is autographically heated. It is line, but it functions as tone because it is hatched and modular. While technically a version of monotype printmaking, this transfer method more immediately recalls Surrealist frottage and photomontage, combining the "marvel" of displacement of the former (together with its associations with automatic drawing) and the latter's sense of documented fact. A somehow verified fantasy is thereby produced—one that seems to be literally a trace or tracing of the "real" world, that illusory entity; but of course only turns out to be as deceitful as any art can be. In this case, it is literally (not Platonically) the shadow of a shadow. Imagery belongs to the surface because it has no other existence than there.

It is impossible, of course, to judge the narrative effect of this series from one isolated example, especially since the artist, by freely relating the incidents in Dante's text to modern imagery, allegorized an allegory. The journey of discovery told by Dante is told by Rauschenberg as a journey of artistic discovery in which Dante's protagonists change their identities along with Rauschenberg's form. Fairly standard, however, is the three-strata arrangement, intended to be read in lines from top left to bottom right, and meant to recall Dante's *terza rima* form. Also common is the identity accorded here to Dante (he is in the top left corner). This earthly witness in the *Inferno* is a man in a towel from *Sports Illustrated* just come out of the shower.

204

Claes Oldenburg

AMERICAN, born 1929

Flag to Fold in the Pocket. (1960.) Ink, 29½ x 47″ (74.9 x 119.4 cm)
Purchase

Oldenburg himself has described his art as parody. He insists, however, that this means putting an imitated thing in a new context, not necessarily making fun of it. Parody, indeed, is analytic as well as subversive mimicry that searches out what has been called "lack of self-awareness in its original." What this phrase means for Oldenburg is this: Latent within the object there are certain normative properties that analysis of the object will reveal and that the artist will exaggerate (as a caricaturist will) as he copies the object. To do so is to manifest something of which the creator of the original object seemed to have been unaware, which gives to the copy a sense of ironical distance from the original. But parody is different from caricature. Caricature addresses the world directly and subverts it through style. Parody addresses itself to style and indirectly subverts the world. The subject of its artifice is artifice itself. It depends on a more subtle balance between resembling and altering the original. It replicates not so much the original object but the original circumstances of its creation, showing us the different kind of object that they could conceivably have produced. This Oldenburg is not an imitation of a flag but in imitation of one.

It inevitably recalls the American-flag paintings that Jasper Johns began around 1955 and exhibited three years later, similarly offering a new kind of realist art made by choosing a flat object as a subject and making the limits of the depicted image and of the pictorial field the very same. And yet, this crumpled work informs us, flags may under some circumstances be flat but in others wavy. As an object, this work comes closer to its subject than do Johns's heavy, thick paintings—almost as close as it can without actually being a flag itself. Being paper, it is thin and flexible as well as flat, and resembles the kind of tattered flags to be seen displayed in historical museums, bleached by time and therefore ghosts of their former patriotic selves. Being so close to its subject allows its parodic function. But it maintains, through parody, distance enough from its subject to provoke questions about its status similar to those raised by Johns's flags (and to answer them—for parodic works, by their self-conscious nature, carry their own criticism inside them; which accounts for the fact that what they do ask for is their explication).

It has been said of Johns that he presents a flat object in which everything that usually serves the abstract or the decorative—flatness, linear simplicity, allover design—serves the representational; and that what usually serves representation and illusion—the mottled lights and darks derived from tonal modeling—serves flatness and abstraction. This also is true of the Oldenburg: because representation is disengaged from illusion and aligned instead with the literal, object character of the whole work, leaving illusion a restricted and abstract function, to open a very limited pictorial space. At the very beginning of the 1960s, that quintessential 1950s concern with the ambiguous produces a work in which is recapitulated the traditional modernist dilemma—to what extent can art become object without surrendering its pictorial nature (see p. 140)—before the 1960s themselves saw very firm divisions being made between art as object and art as pictorial field. But this Oldenburg flag is metaphorically as well as morphologically ambiguous. Its abstract mottling suggests clouds, making it seem transparent, and a picture of its own flying. It is a flag, but it is also to fold in the pocket, like a handkerchief.

Philip Guston

AMERICAN, 1913–1980

Wrapped. 1969. Charcoal, 17⅛ x 21⅜" (43.3 x 54.2 cm)
Purchase

"It is the bareness of drawing that I like," Guston once wrote. "The act of drawing is what locates, suggests, discovers." 1966 and 1967, Guston made many hundreds of drawings, and no paintings. "Clearing the decks," he called it. After it was over, the allusive painterly abstraction that had characterized his art since the early 1950s was replaced by a rawly figurative style, almost caricatural in its simplifications, of strange-seeming commonplace objects—boots and clocks and bottles and books—and landscapes of a sort, with such objects, and figures in bed, smoking, and figures painting, and some less commonplace objects, like hoods.

This drawing was made in 1969, the year that this strange new style was consolidated. It looks back to Guston's early preabstract work, specifically to a *Drawing for Conspirators* of 1930 that shows a gathering of the Ku Klux Klan. Similar stubby cones, explicitly identified as hoods, appear in a number of contemporaneous paintings, some of which place the cone on top of the kind of base that we see here, identifying the base variously as: a mound, which makes the whole image (as here) resemble a primitive piece of architecture; the artist's torso, which raises too obvious an interpretation of this drawing to deserve mention; and so on.

While the relationship of Guston's early and late figurative styles is often noticed, rarely addressed is the continuity of the new paintings with those that preceded them—though, obviously, they share a generally similar palette and comparable enjoyment of juicy paint (but more evenly laid in the new work). More separates them, it seems, than joins them. Their drawing certainly does. The preceding paintings had been drawn; the paint itself seemed drawn—or scribbled—as it filled in areas (or better, filled them out). That effect virtually disappeared in the new, more evenly painted works; and painting was changed from being a form of drawing (in paint) to become an amplification of drawing in a more traditional way—or so it seemed. Drawing in its most primitive function—image-making—replaced drawing in its recent, Abstract Expressionist function—allover field-making—as the generating force of Guston's art. And yet, while our attention seeks out the depicted objects because they interest it more, each of them owes its existence to the continuity of the surface that together they combine to create. Like other artists who emerged in the 1950s after Abstract Expressionism was essentially formed, Guston wanted to restore image-making to advanced art and to reconcile it to the allover field. But he did so much later, with different methods and results.

Drawing, for Guston, is enclosure contour drawing that studies objects for structurally analogous forms. It is a new version of Matisse's sign-making drawing (see p. 166) and similarly deals with forms in isolation before integrating them (or forms that derive from them) as elements of an allover designed surface—where depicted drawing is conceived as integral to the painting process. As Bernice Rose has observed, to use enclosure drawing as a tool for structural analogy is to be able to move easily between the descriptive and the abstract. In 1970, Guston told an interviewer: "You're painting a shoe; you start painting the sole, and it turns into a moon; you start painting the moon, and it turns into a piece of bread." This too is what such drawing offers: a bare form of drawing that locates, suggests, discovers; but especially suggests.

Richard Diebenkorn

AMERICAN, born 1922

UNTITLED (OCEAN PARK). 1977. Gouache, watercolor, and oil on cut and pasted paper, 18¾ x 32¾" (47.6 x 83.2 cm)
Purchase

The linear scaffolding that opens across this large watercolor articulates a space whose emptiness is made pictorial by proxy, as it were, almost entirely from the outside. The grid maps out the space, tightening then loosening it, checking its expansion and then letting it go. But the space is made pictorial because the drawing of the grid repeats the shape of the whole watercolor and makes it one with its outside. Symbiosis of this kind allows such emptiness as we are given here, for it snaps space up to the surface wherever it is felt, while allowing the lines that carry its message to remain as isolated as sometimes they are. The drawing neither floats free of the surface nor does it break through the surface, and it does not cut up the surface into separate planes. Avoidance of razor-sharp drawing undoubtedly helps these causes, but far more important than its "painterly" touch is its direction and its anchoring on the edges of the support. The diagonal "ghost" drawing the artist has put in opposes its bodily counterpart, thus animating it unexpectedly. It also, however, recapitulates it; and stretches the sheet with a complementary set of stresses that also serve to direct the eye to the chromatic anchors through which the symbiosis of which I speak is enforced. We should note that only the blue, the most spatial of the hues, is entirely within the field. The others hold firmly to the edge, and are placed on cleaner, less shaded sheets that mediate between the absolute, literal flatness of the work (of which its clean-cut edges are a reminder) and the depicted flatness of the blue pillar, which we now see is there because it is drawn to be flat and colored to be spatial. Internal space is less divided than activated. The watercolor is exhilaratingly open as well as firmly controlled.

Diebenkorn's Ocean Park series, begun in 1967, to which this work belongs, makes general reference to the beach architecture of that area of Santa Monica in California around the artist's studio that gave the series its name. The abstraction of this series, which followed a decade of realist art, is that of an artist who has synthesized the principal currents of this century's most rigorous abstract art, joined it to a painterly 1950s sensibility, and created in this amalgam a new grand style with the seriousness as well as the decorativeness of his exemplars, and a gentle but firm sensuousness of a kind that is entirely its own. This work uses the very components of Mondrian's mature art, but escapes from the form of geometry that Cubism bequeathed to Mondrian to learn more from the unconfining geometry, and breathing, muffled surfaces, of Newman and Rothko, whose symbiosis of drawing and support prepared for Diebenkorn's. However, he recomplicates the spareness of the Abstract Expressionist field, reintroducing to it a searching, durational record of its creation that does recall Cubism, and before that the watercolors of Cézanne. And clearly, the use of hues at high intensity, set against white and sobered by black, in order to find for art in color a place for exaggerated value contrasts necessarily recalls Fauvism and Matisse. I introduce these names neither to validate nor to circumscribe, but to point to what has been taken and thereby to show what is transformed. We value originality because it is a reflection of authenticity. The past is challenged by truly original art not in some impossible dream of escaping from it, but because challenging it allows the artist to speak frankly and unconstrained. But speaking frankly in art, as well as of it, means telling about the order of the past, in which is latent whatever one hopes to say.

Jasper Johns

AMERICAN, born 1930

SAVARIN. 1977. Brush, pen and ink on plastic sheet, 36¼ x 26⅛″ (92.1 x 66.4 cm)
Gift of The Lauder Foundation

In this drawing, one of the artist's sculptures—a 1960 painted bronze replica of paintbrushes in a can—is seen in front of one of his paintings of the 1970s, composed from the lines of conventional hatching, drawn with a brush. The hatching does not describe sculptural volume, as hatching normally does. Its linear components seem tactile, like sticks, but the pattern they form seems flat. The brush handles look like a bunch of hatch sticks. The interrelation of drawing, painting and sculpture, the kind of illusions provided by each and the properties normative to each; their interrelation in Johns's own art; and the relation of all of these things, internal to art and its objects, to the world and its different kind of objects: these are included in the subject of this work. It overpowers the world with its treatment of it and opposes itself to the subjects it includes. It presents the objects of art as objects of the world, thereby loosening art's control on its own products, which are given the shadowy mortality of the things from which they were made. But it shows us them as still-life objects, and therefore the subjects of art, to which, through art, they are returned. It is an exquisite game with illusion, art, and the world. This is a profoundly pessimistic drawing—dark, silent, and foreboding in the muteness of isolation it conveys—and an extremely playful one, which puts a brave face on the threatening world by presenting it ironically and decoratively. A perplexing moodiness infuses the drawing, a curious twilight kind of unreal light; perplexing, that is, until we remember the soft-toned Symbolist drawings at the beginning of modern art. Then we realize that Johns too stands back from man's works and objects, and sees that they disrupt, in their utility, the wholeness and harmony of our experience of the world, and must, if they can, be aesthetically contained.

"An object that tells of the loss, destruction, disappearance of objects. Does not speak of itself. Tells of others. Will it include them?" These are Johns's words. He is talking of his own work. He could be speaking for his whole generation of artists, who came to maturity in the 1950s and for whom the question of including objects or images in the allover field established by Abstract Expressionism was of paramount importance. And, more generally, he could be speaking for all of the artists represented in this book, for essential to them all is the creation of drawn objects which firmly include that of which they tell. Except for one thing (and this applies to Johns too): the objects thus made do speak of themselves as much as of what they contain; indeed more. At its best, drawing goes through objects with the directness of words, and recalls from the cave of memory shapes and lines and colors that confirm our experience of the world and that reveal worlds the like of which we had thought—until they were made comprehensible to us—we had never known. This is not at all to invoke other than aesthetic reasons for drawings' existence. For by going through objects to the unreal, visual substances that comprise them, all achieved works of art recall the aesthetic spectacle of the world, even in its mute objects, and the final appeal that they make is to the ultimate value of the aesthetic. Alone among objects in the world, they can be valued for their own sole sakes. The final appeal, then, of a work such as this is also its final ambiguity, for it shows itself what in itself it denies: that man's works and objects do not inevitably disrupt the world's wholeness and harmony, but can recall that wholeness in their own harmony and be valued as ends in themselves.

Index of Artists

Archipenko, Alexander, 83
Arp, Jean, 109, 113
Atkinson, Lawrence, 101
Beckmann, Max, 125
Boccioni, Umberto, 93
Brancusi, Constantin, 89
Braque, Georges, 79
Cézanne, Paul, 21, 33
Chagall, Marc, 65
de Chirico, Giorgio, 115
Corinth, Lovis, 47
Cornell, Joseph, 203
Dali, Salvador, 163
Degas, Edgar, 17
Delaunay, Robert, 59
Delvaux, Paul, 177
Delville, Jean, 35
Demuth, Charles, 143
Derain, André, 41
Diebenkorn, Richard, 211
Dix, Otto, 127
van Doesburg, Theo, 105
Dove, Arthur G., 97
Dubuffet, Jean, 189
Ernst, Max, 131
Exter, Alexandra, 151
Feininger, Lyonel, 99

Frankenthaler, Helen, 193
Gauguin, Paul, 25
van Gogh, Vincent, 23, 31
González, Julio, 175
Gorky, Arshile, 185
Graham, John, 179
Gris, Juan, 81, 123
Grosz, George, 129, 157
Guston, Philip, 209
Johns, Jasper, 213
Kandinsky, Wassily, 67, 141
Klee, Paul, 73, 135, 169
Klimt, Gustav, 37
Kline, Franz, 199
Kokoschka, Oskar, 49
de Kooning, Willem, 197
Kubin, Alfred, 29
Kupka, František, 71
Larionov, Mikhail, 63
Léger, Fernand, 153
Lipchitz, Jacques, 87
Lissitzky, El, 139
Malevich, Kasimir, 107
Man Ray, 119
Marc, Franz, 69
Marin, John, 145
Masson, André, 173

Matisse, Henri, 43, 57, 167, 201
Miró, Joan, 155, 165, 171
Modigliani, Amedeo, 91
Mondrian, Piet, 103
Motherwell, Robert, 181
Nolde, Emil, 159
O'Keeffe, Georgia, 111
Oldenburg, Claes, 207
Pechstein, Max, 53
Picabia, Francis, 117
Picasso, Pablo, 55, 61, 77, 121
Pollock, Jackson, 187, 191
Rauschenberg, Robert, 205
Redon, Odilon, 27, 75
Rodin, Auguste, 39
Rohlfs, Christian, 161
Rothko, Mark, 183
Rouault, Georges, 45
Schiele, Egon, 51
Schlemmer, Oskar, 149
Schwitters, Kurt, 137
Seurat, Georges, 15, 19
Severini, Gino, 95
Sheeler, Charles, 147
Smith, David, 195
Tatlin, Vladimir, 85
Vesnin, Alexander, 133